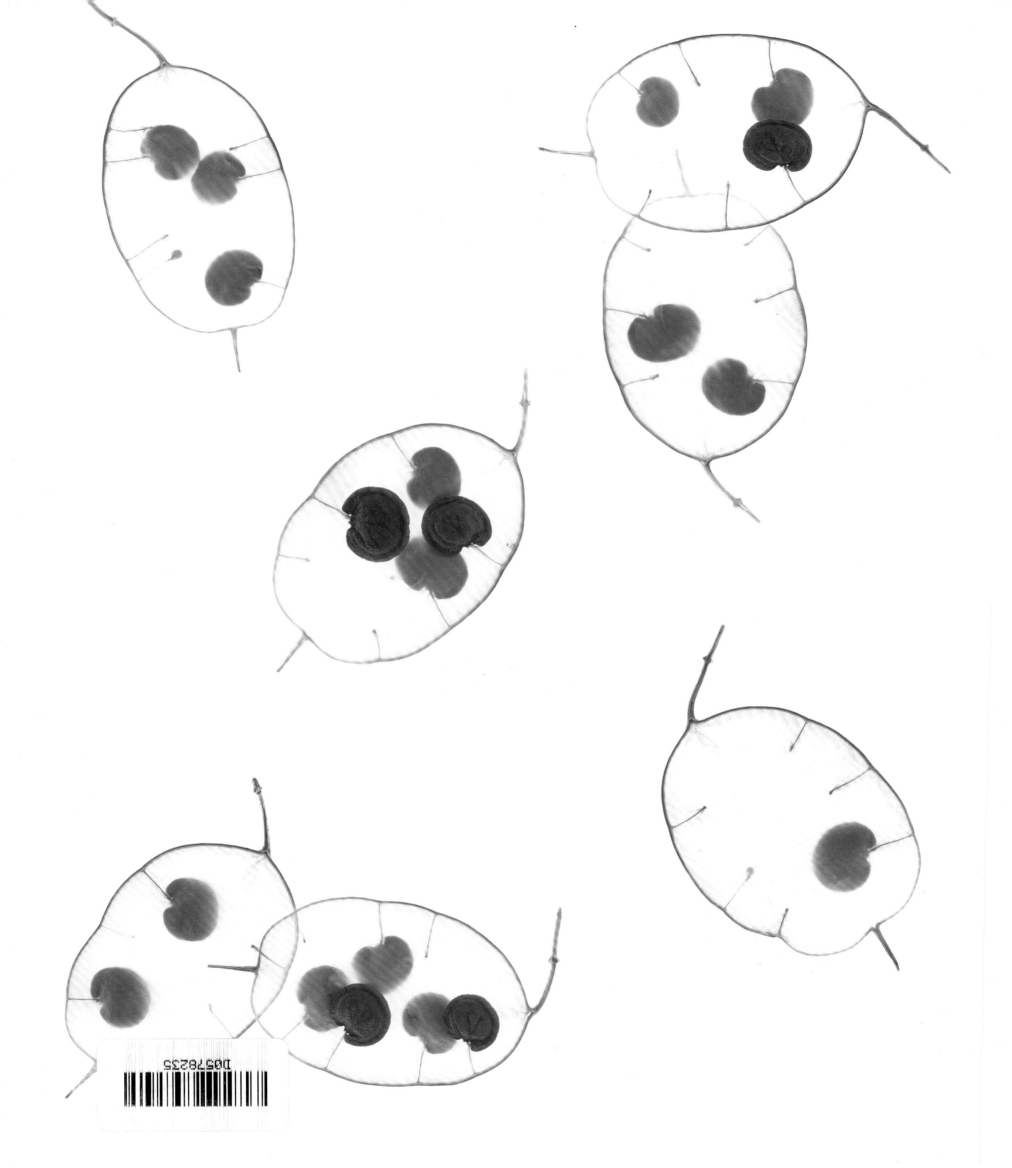

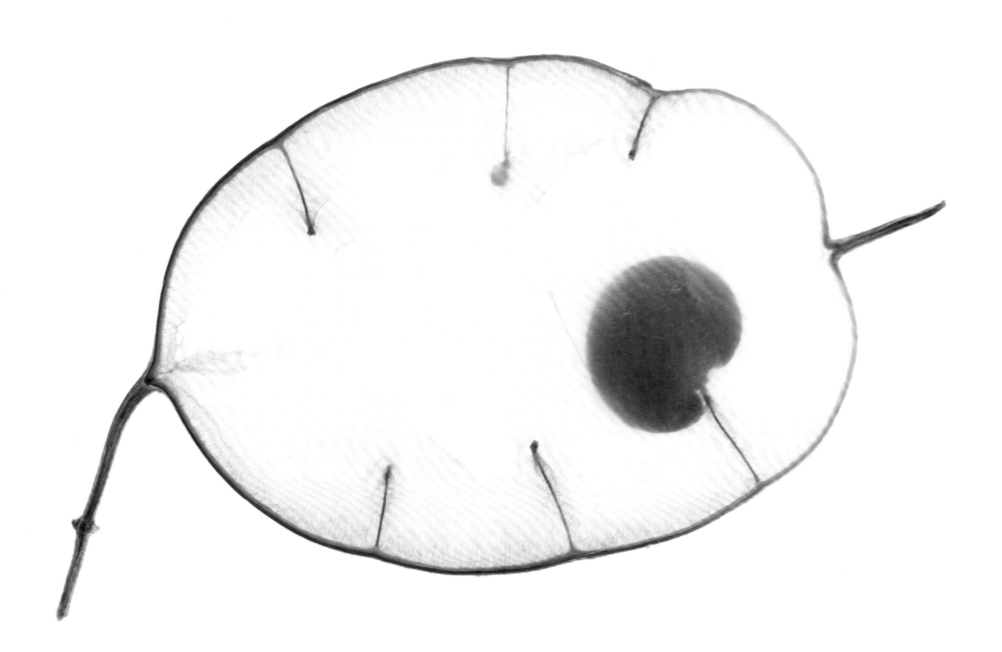

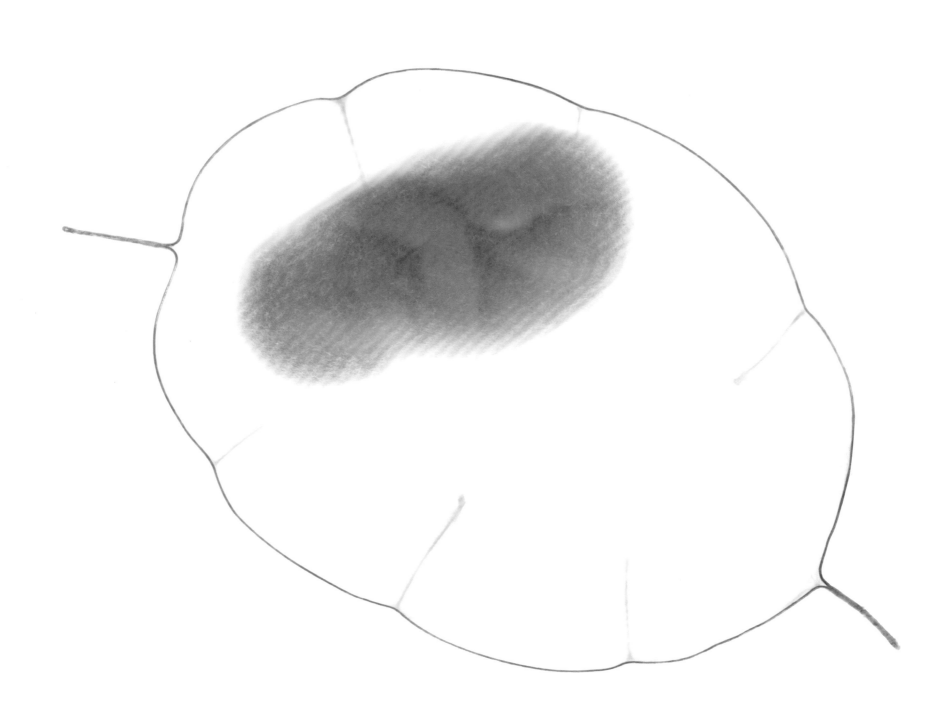

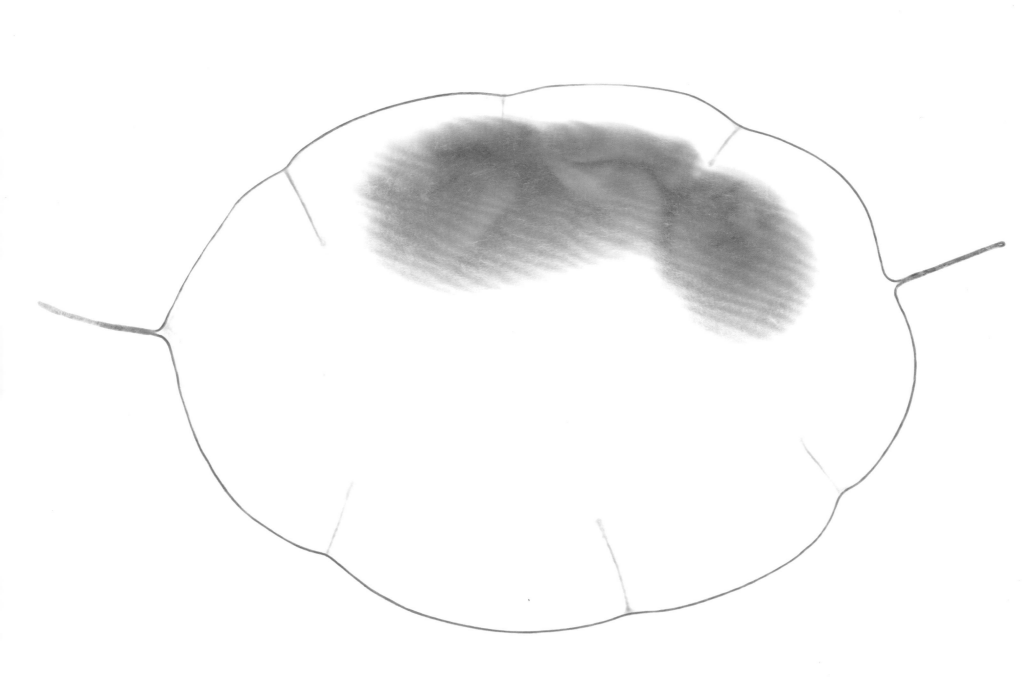

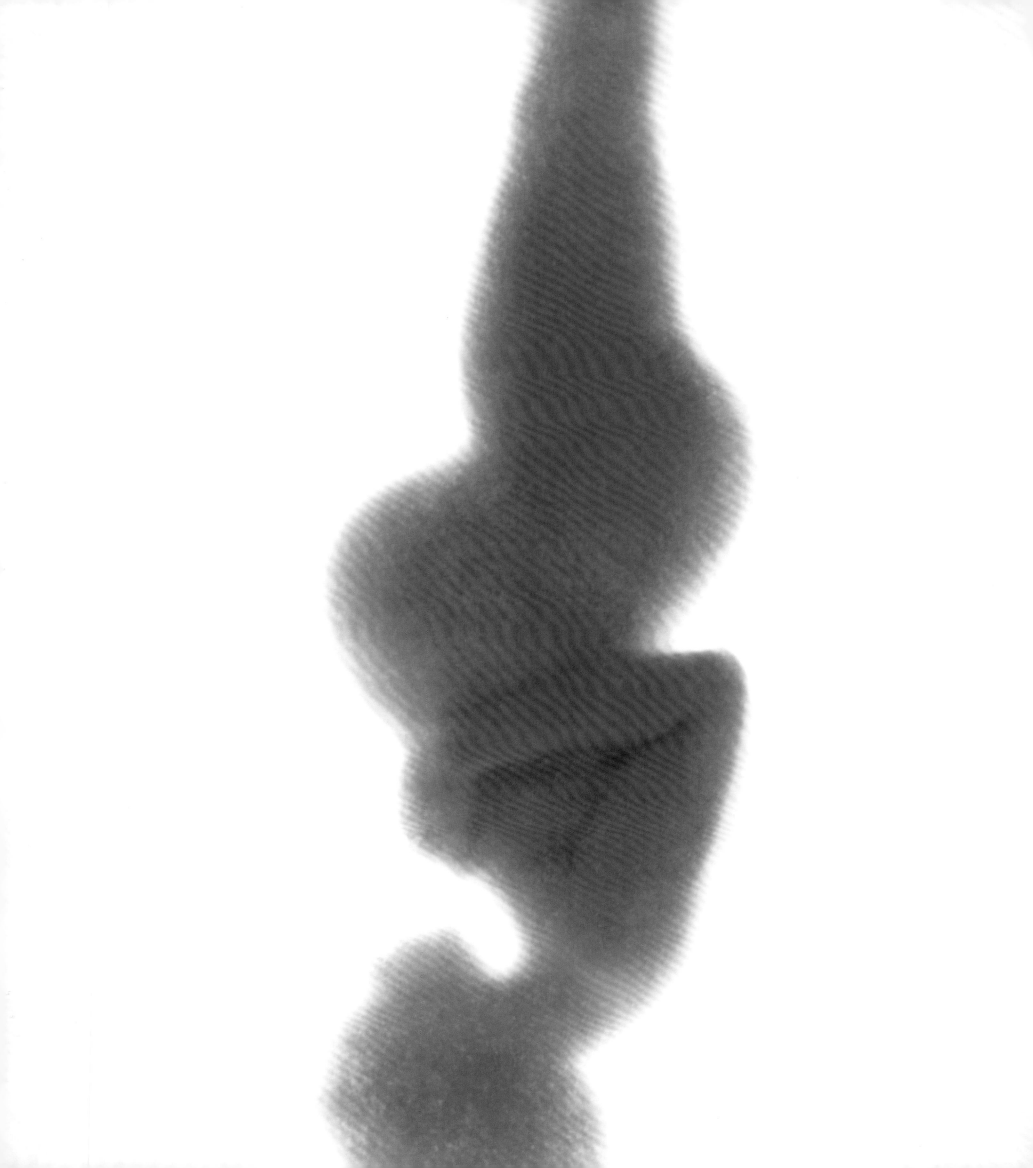

Beginnings

ANNE GEDDES

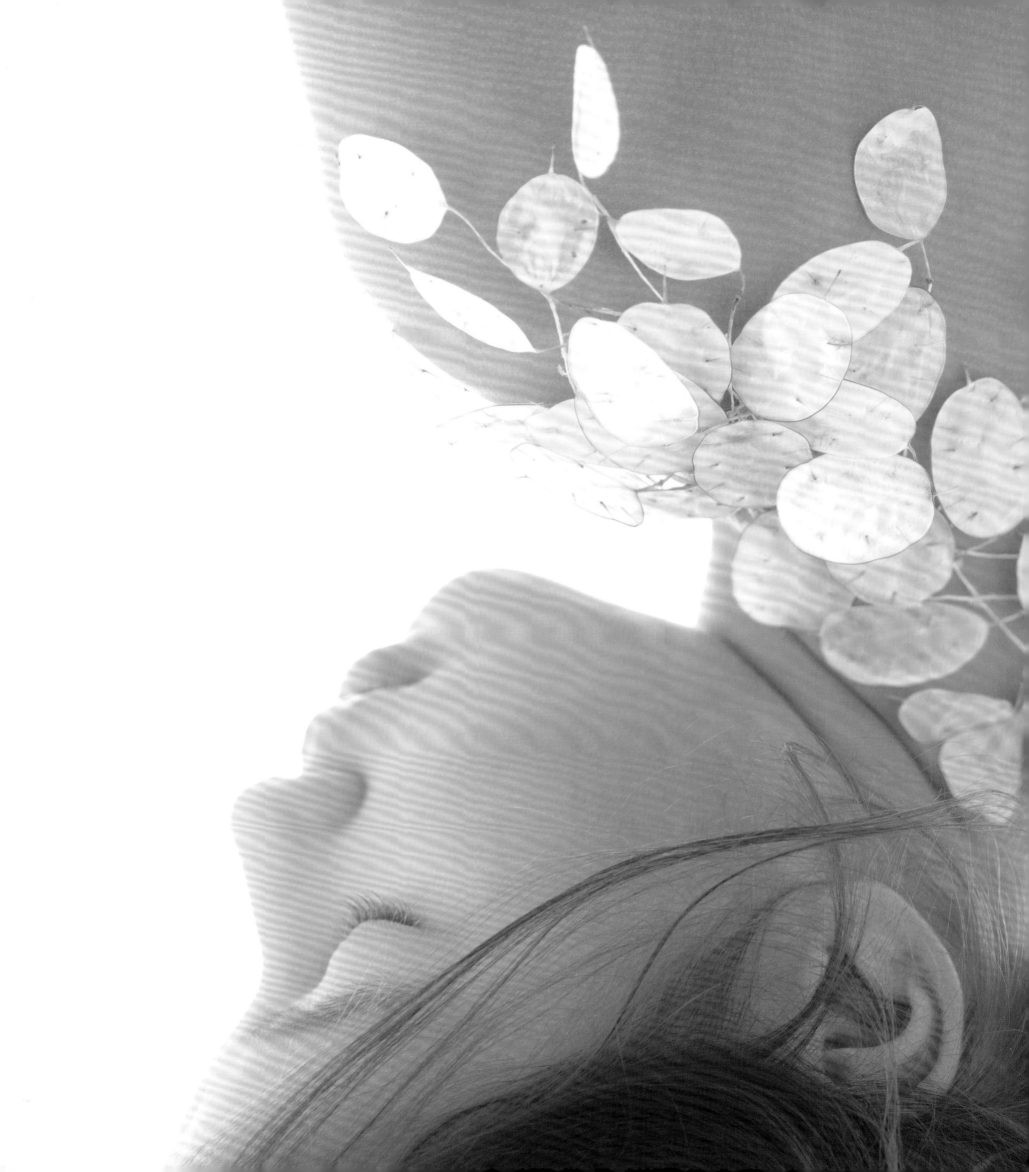

When I returned to the Studio

After spending two years writing my autobiography, *A Labor of love*, I stepped back into an intense and yet familiar world of pregnancy and new life. From the moment they discover they are pregnant until at least a year into the life of their new baby, women experience much that is surprising and unknown as they become swept up in the urgent current of nature. I realized how much I had missed having new and expectant mothers in the studio, as well as regular contact with newborns.

I have always been fascinated by elements of nature at the moment of transformation. Buds, bulbs, seeds, nests, eggs, cocoons (pupa), pregnant women and of course newborn babies, are all inextricably linked in the wondrous cycle of nature that we so frequently take for granted.

Pregnant women and tiny babies are the human face of beginnings, yet all of nature is caught in this insistent stream of seasons, of aging and rebirth, of concealment and bursting forth. Even though I have been photographing babies for so long, every time I unwrap a newborn I am aware of the miracle before me. This book, *Beginnings*, took me on a journey to explore the parallels between ourselves and other everyday miracles of nature, placing these complementary wonders side by side in an attempt to evoke a deeper appreciation of the simple yet deceptively complex beauty of our existence.

For me the publication of *Beginnings* marks almost thirty years of professional photography, and time brings its own gifts. My schedule over the twelve months it took to complete the project went like this. Three weeks of each month were spent researching and photographing the elements of nature that did not include babies. One week of each month I spent photographing newborns every morning and pregnant women every afternoon. By the end of these "baby" weeks, we all found we were exhausted by the sheer amount of energy and concentration it took to be so intensely involved with the "human" aspects of life's new beginnings. Each morning when I am photographing babies can feel to me the way a blank page feels for a writer—there is always a moment of personal doubt, what if nothing comes? However, I've learned over many years that experience, patience, flexibility, and a calm state of mind will not just inevitably lead to the imagery I have planned, but can also del ver surprising and totally unexpected results.

One of the most important gifts to this project came from the pregnant women I had the privilege of photographing. I think of these pregnancy images as a collaboration—as much a gift of the women themselves as the work of my eye. These brave and beautiful women, in that vulnerable period of their final month of pregnancy and in all their different shapes and forms, trusted me with their naked, pregnant bellies and subsequently with their precious newborn babies. To me, *Beginnings* is a culmination of trust built up over a long career.

I don't usually photograph professional models and I don't advertise. Instead, at the beginning of a project, I find a small number of trusted people and ask them to gradually spread the word among those they know. Awareness of the book I'm working on grows very slowly in different directions. We were amazed at the various ways people heard about this project, by word of mouth of course, but also in many other diverse ways, such as from obstetricians and dentists, at the post office, the beach, the laundromat, and one father even called to say he heard about the project while he was at his local blood bank.

Beginnings is the first project that I have shot entirely in my native country, Australia. In the early planning stages I was concerned that I would not be able to find locally enough pregnant women and babies of obviously different ethnic origins, particularly those with very dark skin— apart, of course, from our very beautiful Australian Aboriginal pregnant women and babies. However, through the work of many generous and dedicated people, I was able to reach into the various small African communities of Sydney, enabling me to meet and photograph pregnant African women, some of whose stories of their journey to Australia left me both moved and inspired.

Many of the African women in Sydney are newly arrived. They are often refugees or have experienced great hardship in their journey here. Upon arrival in their new adopted country, encountering various social and language difficulties, a number continue to suffer fear and isolation. It was humbling to meet women from war-torn parts of Africa who were willing to come to the studio, be surrounded by strangers, and photographed naked and pregnant. What a brave step into the unknown. To me this speaks of enormous trust and courage and I felt honored by the gift.

While creating *Beginnings* I loved to watch people react to the photograph of Violet. **Nature makes a newborn baby so magical** to us, and yet also graces Violet, at 107 years of age, with mystery **and beauty.** Violet lives at home, does a lot of her own housework, and volunteers once a week at a local hospital. She filled the studio with delightful energy.

Beginnings uncovers what is concealed. An image of a pregnant woman hints at the promise of a baby within. We can sense this miracle of nature evolving, even though it is enfolded in the mother's body. All around us, marvelous elements of nature are concealed, either deliberately, or because we simply find them too ordinary to notice.

A chance visit to a small gallery in Sydney was the initial inspiration for *Beginnings*. Expecting that I would be visiting a photographic exhibition, I was surprised to stumble upon a collection of birds' nests and was unexpectedly moved by their beauty, their intricate and elegant construction, and the mothering instinct at work. My emotional response to these nests took me completely by surprise. Each in their own way revealed a bird driven by the urge to nurture, channeling the precious energy needed for survival into building a safe and hidden place to raise its young.

Birds create order from the chaos of a tangled mix of what could be considered rubbish: twigs, leaves, paper, horsehair, down. They add their own feathers, some even build using their own saliva, and many of the nests are held together by bits of spider's web. A nest is, in effect, a mixture of detritus and ingenuity sculpted into a nurturing home for the bird's young. Driven by the same natural urges that cause a bird to build a nest, a caterpillar, for instance, creates a cocoon of silk from its own body. Within this protective nest it will transform into a moth or butterfly.

These are elements of nature that are designed to be hidden, elusive. A cocoon (pupa) is cleverly camouflaged with leaves and bark, disguised on the underside of branches. A nest is tucked away within the foliage of a shrub or tree, often built high up, away from predators or hungry eyes. *Beginnings* explores the extraordinary beauty of things that are an everyday part of our lives.

A seed is the beginning of a journey. Seeds are designed to hold life in suspension until they find new and fertile soil where they won't be starved of light by the shadow of their parents. Plants may be rooted in their home soil, but seeds travel around the world. Nature continues to tumble forth in abundance, part of that repeated natural pattern—secrete and store, creating the promise of a future.

I began this book in the Australian autumn, for all gardeners the season for planting bulbs, so every nursery had bulbs in abundance—small, knobbly, and still with the dirt clinging to them. I suspect none of the nursery staff would have believed I was going to make bulbs into photographic models. Yet look at their beauty—pendulous with the nutrients they store through the winter to nourish new life in the spring. In the curves of a bulb, the intricate colors, the patina of layered skin, is the beauty of possibility, of potential and promise.

The great American philosopher Ralph Waldo Emerson said, **"Nature is loved by what is best in us."** There is sometimes a challenge to see the beauty in the ordinary, yet we are surrounded daily by the most remarkable aspects of nature. What a shame they often seem to us too commonplace, too unspectacular.

Passion has sustained my career over thirty years. When seeking out birds' nests, cocoons, seeds, and flower collections, I met people with a passion equal to mine. I was shown the intricacy of a very old and carefully constructed Norfolk Island Pacific Robin's nest (this bird is currently vulnerable to extinction), and the seemingly chaotic, yet surprisingly complex nest of the Spotted Dove. I met people who may spend every day cataloguing insects, or looking at seeds through a microscope, yet would look at each specimen with a sense of wonder. I recognized in them my own joy in inspiring others to see beauty in the miracles that surround us.

Each book is a journey. I was afraid when I started *Beginnings* that the journey could not be encapsulated in the twelve months I had available to shoot. However, creative intensity pushed me into deeper and deeper territory, the layers bundled onto each other, gifting me something far richer than I could ever have anticipated, and enabling me to reach beyond existing boundaries into unexpected revelation.

There are many who have been part of the journey of *Beginnings*. A project such as this is never a solo trek, but I thrived on the generosity and creativity of numerous travelling companions—some who have shared many such journeys with me, and some whose few steps were still memorable and lively. To each and every one of you, a very sincere thank you.

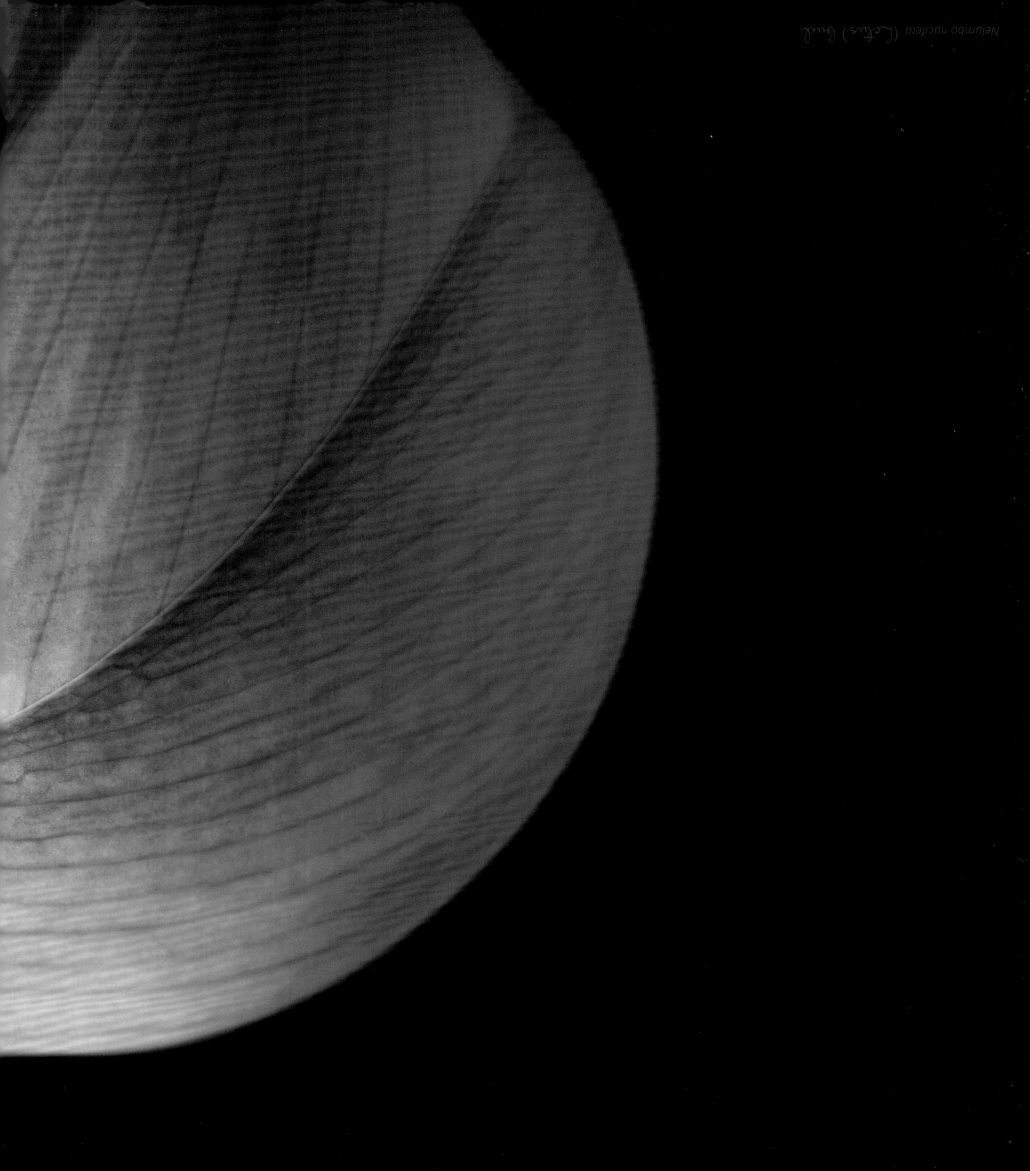

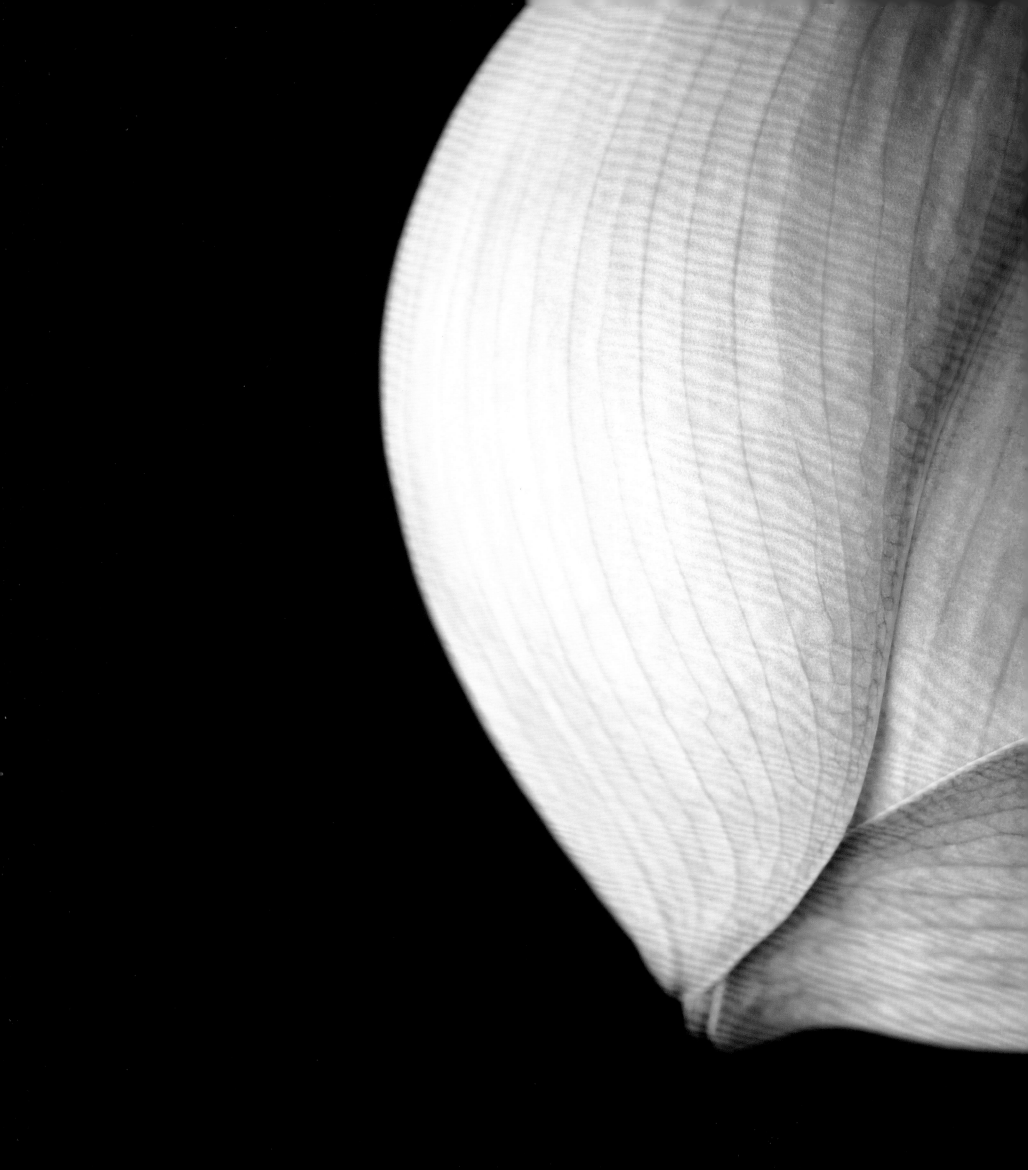

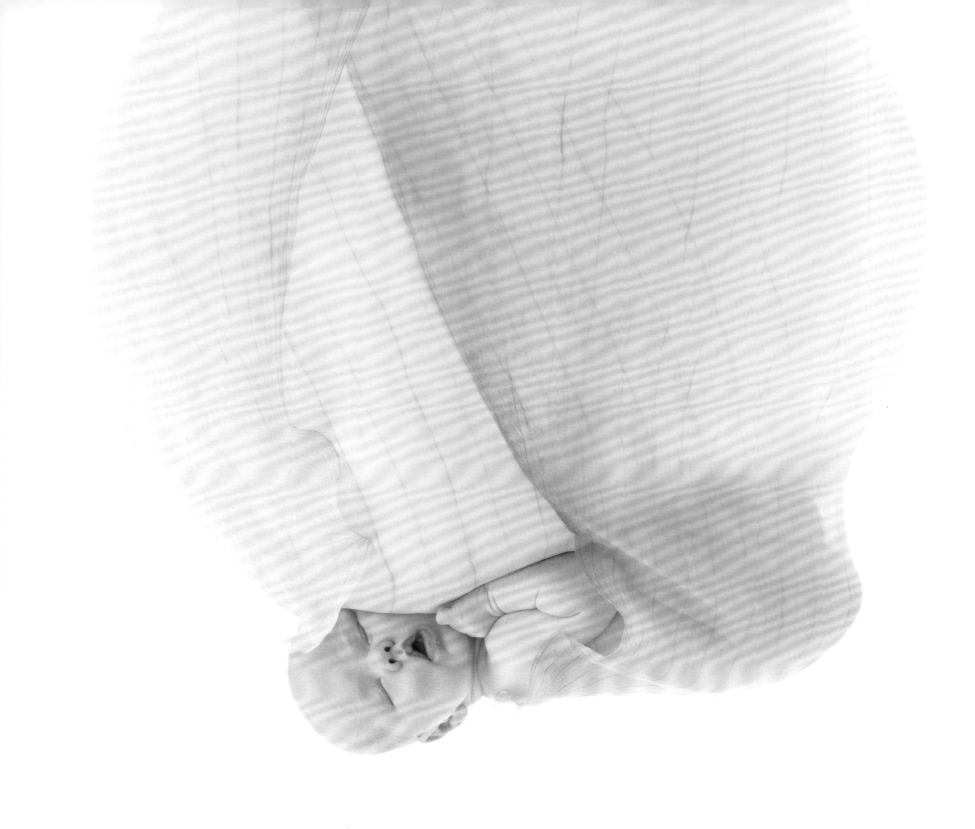

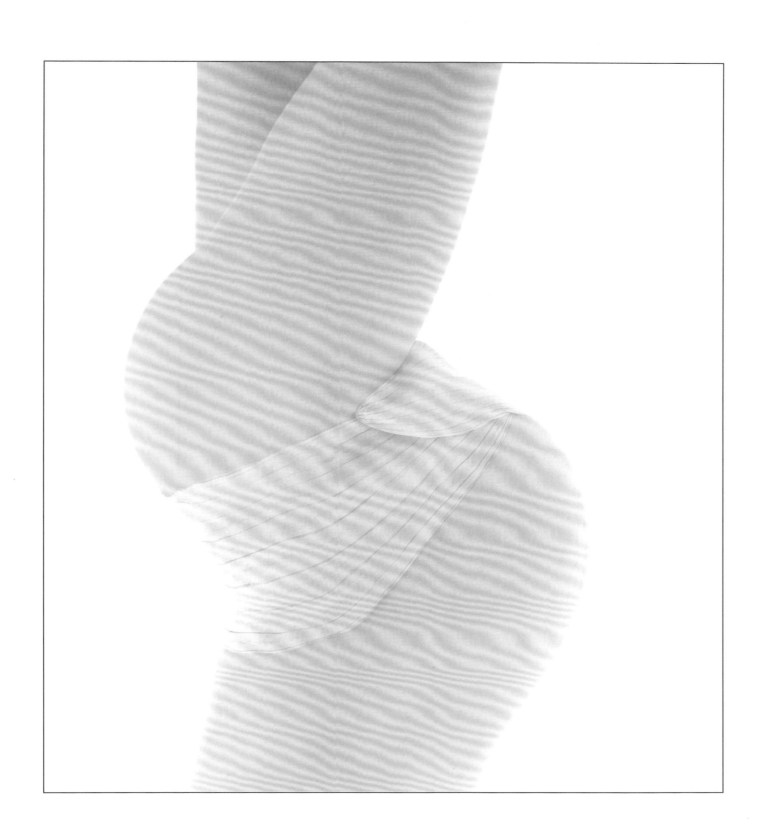

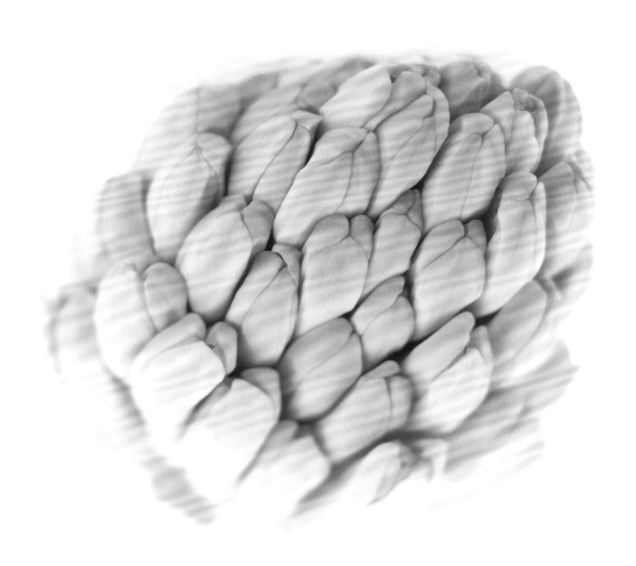

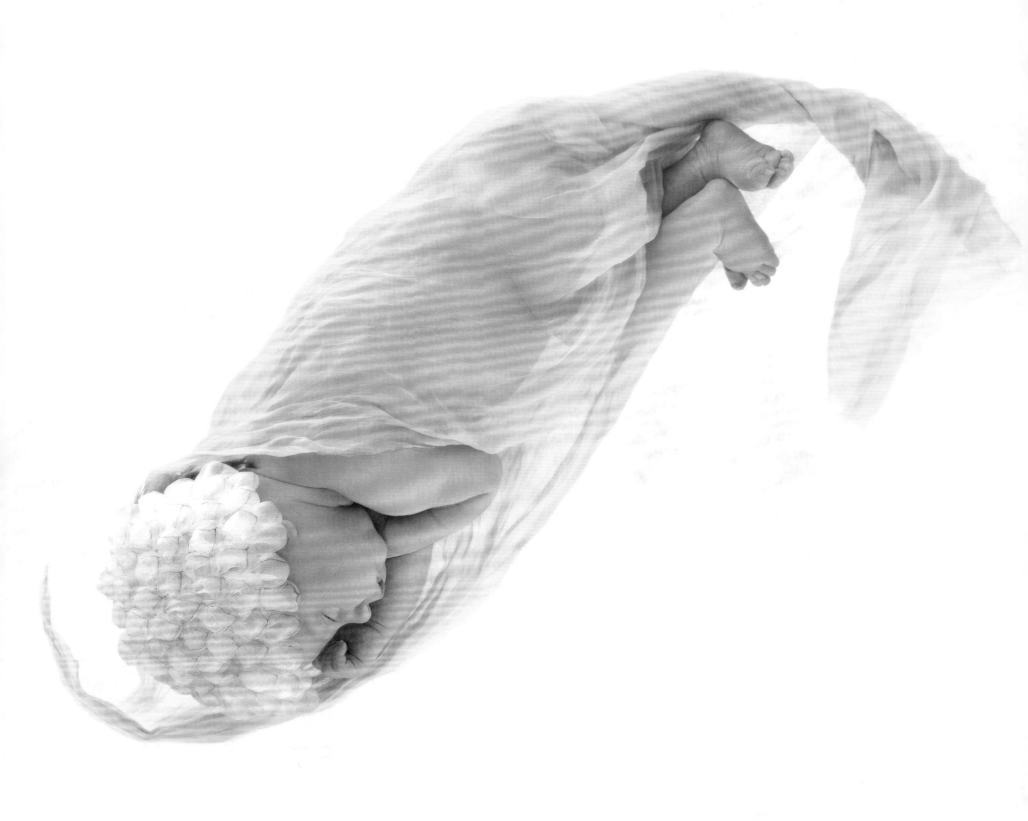

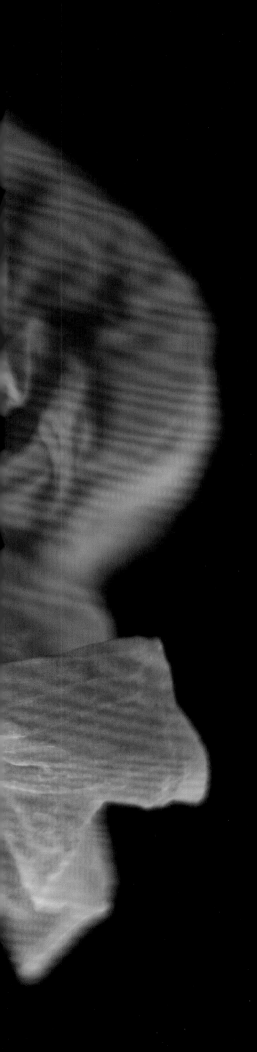

Papaver nudicaule (Iceland Poppy) bud

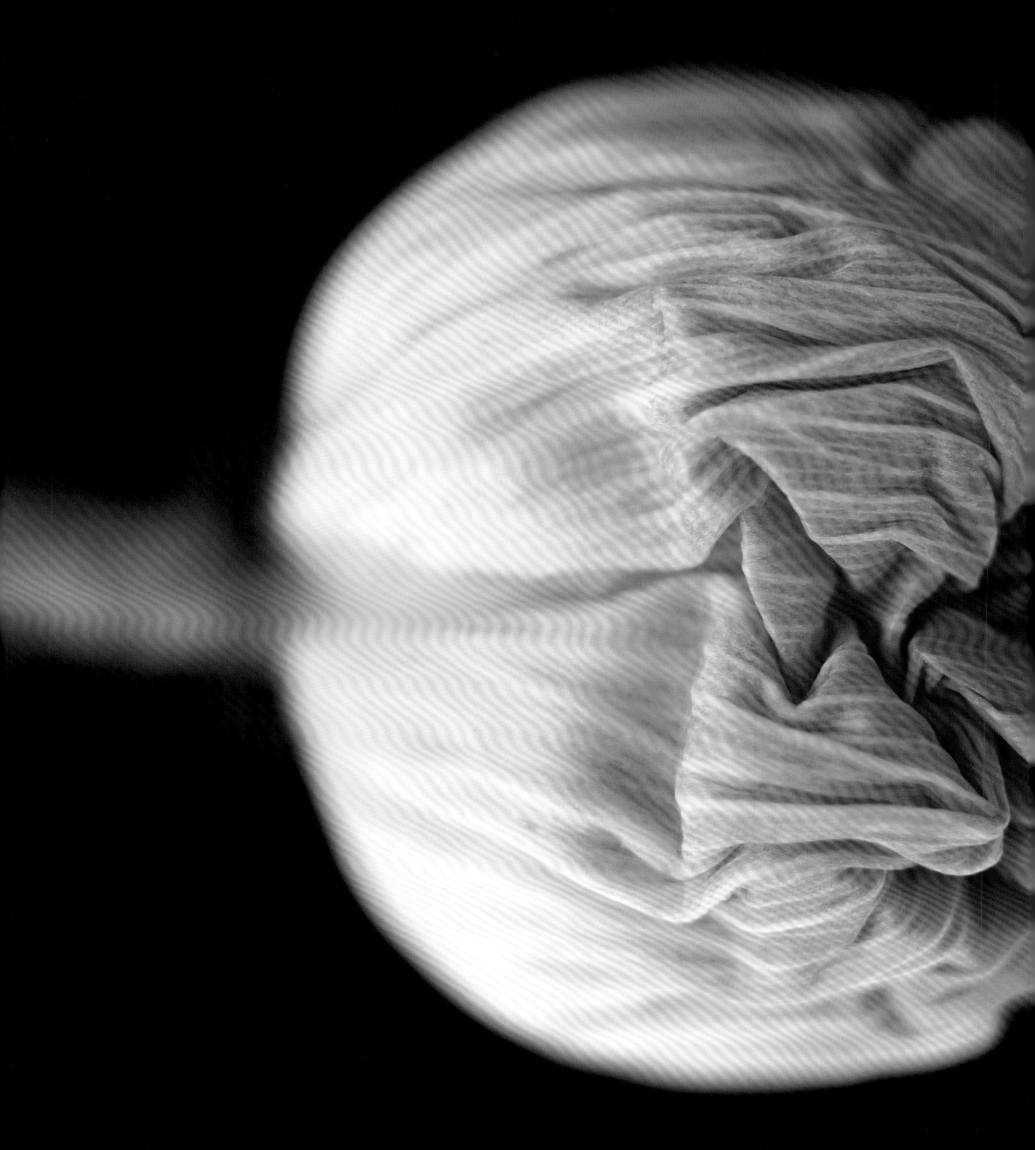

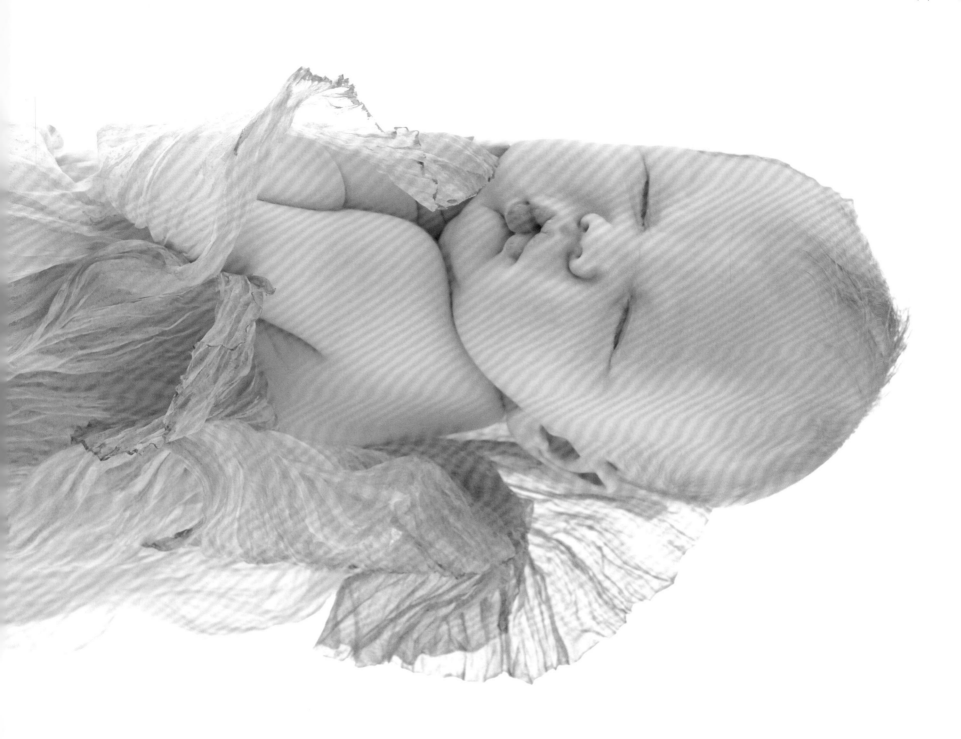

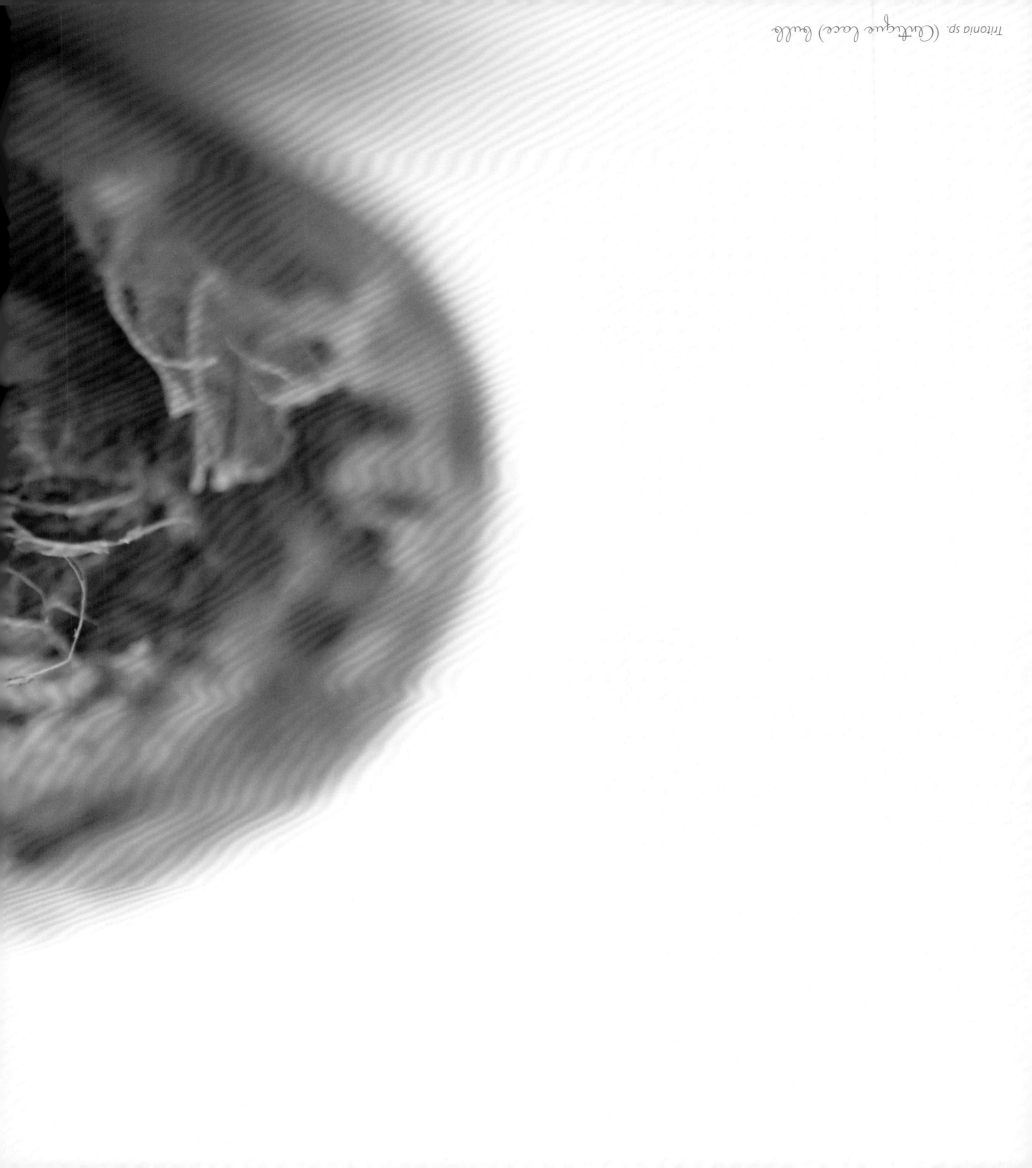

Tritonia sp. (Cacharque Laces) bulli

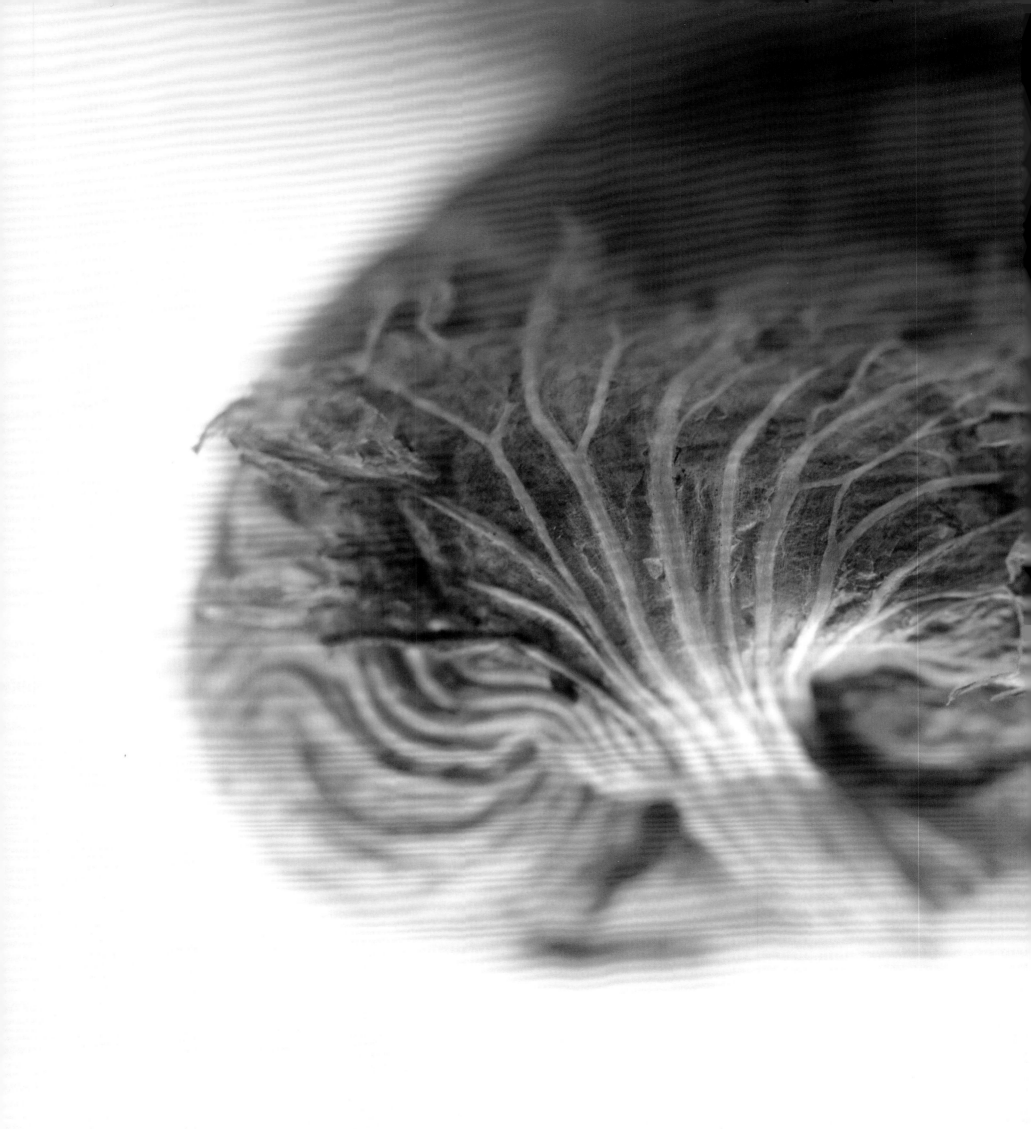

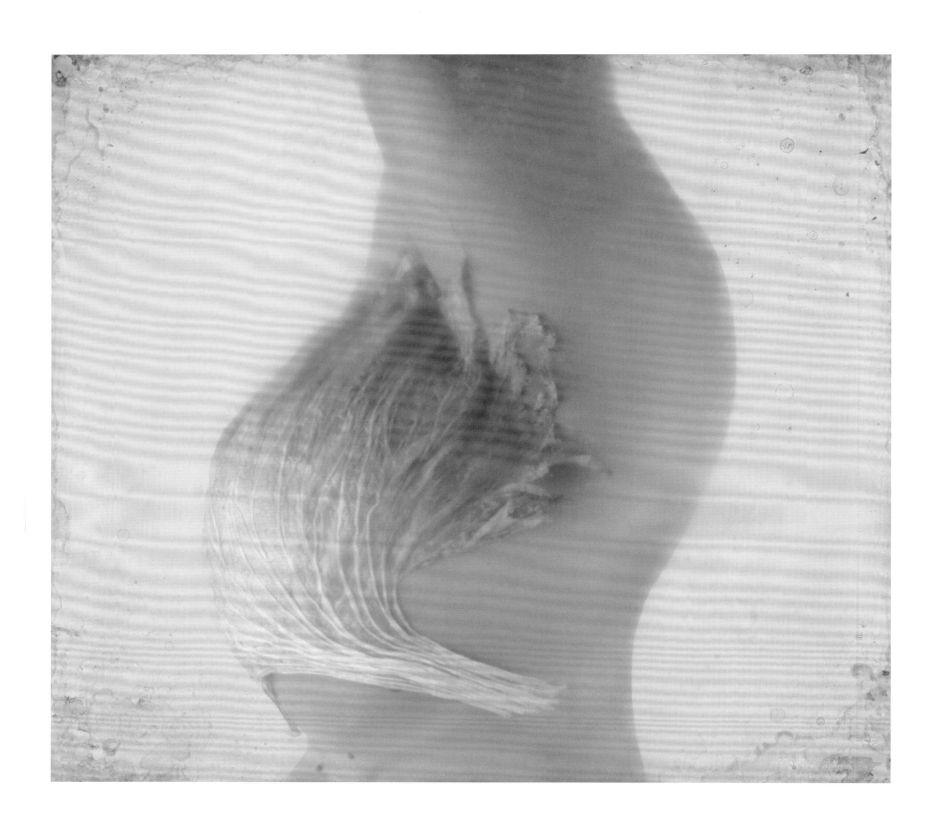

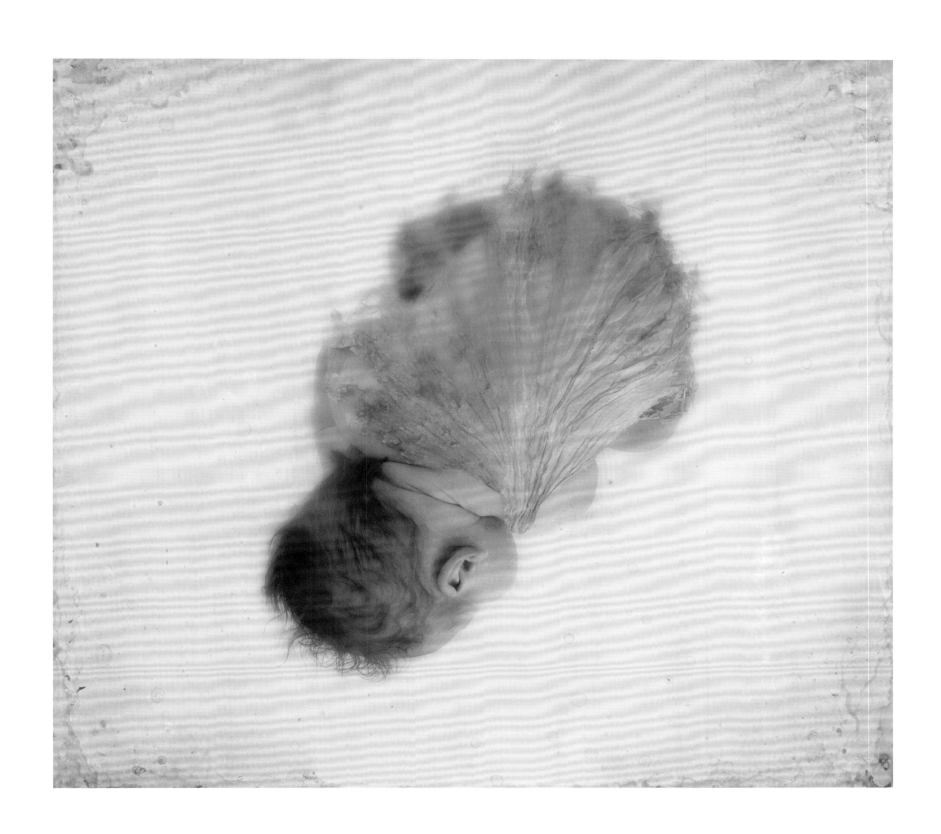

antecedent, bloom, bud, *cocoon*, connection,

essence, existence, fountain, generator, impulse, inception,

mainspring, motive, nucleus, occasion, *origin*, parent,

seedling, source, *spring*, stock, well.

Acknowledgements

Anne's Studio Team: Dawn McGowan, Kerry Wapshott, Stephanie Geddes, Kelly Geddes, Natalie Torrens, Jo Gray, Relda Frogley, Jalna Horn, Rosemary Latter, Jane Atherton, Sally Farrant, Erin Fairs, Valerie Williams

As always, special thanks to my husband Kel, for his endless encouragement, love and support.

Thanks to

Australian Museum, Sydney: Walter Boles, Jaynia Sladek (Ornithology), Dave Britton (Entomology); **Royal Botanic Gardens Foundation:** Pauline Markwell; **Royal Botanic Gardens Trust (Mount Annan Botanic Gardens):** Caz McCallum, Peter Cuneo, Cathy Offord, Leah Seed; **Sydney Wildlife World:** Boris Lomov; **PoHo flowers, Potts Point, Sydney:** Tim Baber; **Somali Welfare and Cultural Association:** Fatma Isir; **Anglicare Migrant Services:** Monica Biel; **African Community contact:** Malika Tusiime; **NSW Children's Guardian; The Grace Unit at the children's hospital at Westmead; Plant Identification:** Margaret Hanks; **Epson** (Dan Steinhardt)

Gary Brown, Carl Anderson, Stephanie Baker, Nicki Brown, Kirsten Bryce, Sophie Djura, Rebecca Douglas, Sue Forsyth, Janelle Fox, Ardeshir Gheidian, Tonya Jenne, Betty Leiataua, Warren Mattmann, Marian Read, Claire Robertson, Melva Saavedra, Katherine Shanks, Marie Shannon, Melanie Strand, Rebecca Swan, Ron Talley, Holly Vaihu, Rachel White, Sue Wright, Adam Yang.

Also: Sandy Burcul, Brenda Hayward, Bernadette Jones, Heather Kennedy, Allison Meadows, Greg Waters, Dr. Gil Burton's office, Dr. Geoffrey Paul's office.

ANNE GEDDES®

www.annegeddes.com

ISBN: 978-1-921652-30-1

First published in 2010 by Anne Geddes Publishing
Geddes Group Holdings Pty Ltd
Registered Office, Level 9, 225 George Street
Sydney 2000, Australia

Images, text and layout: Anne Geddes
Design: Claire Robertson
Publisher: Kel Geddes
Printed in China by 1010 Printing International Limited, Hong Kong

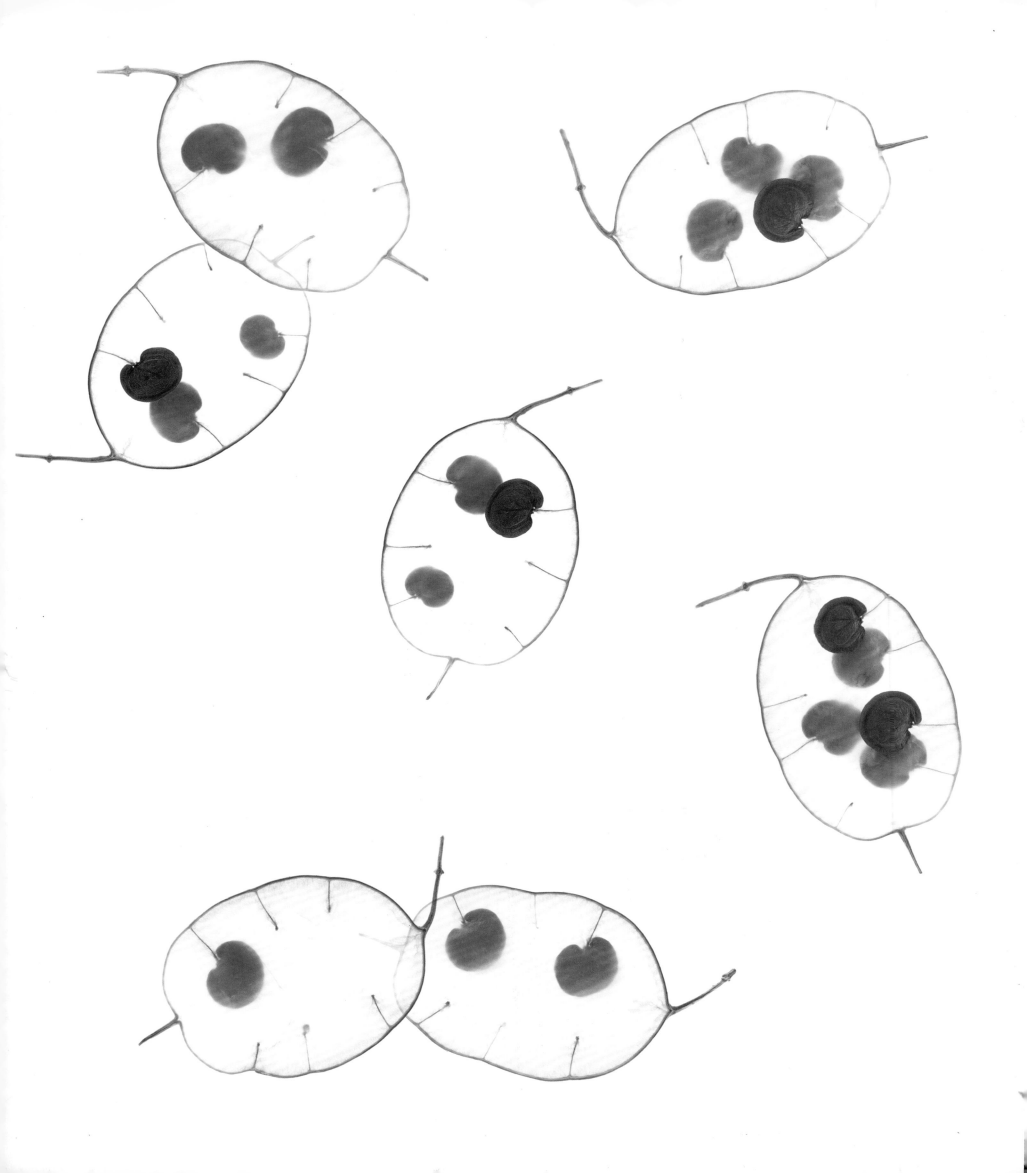

Beginnings: ancestry,

creator, creation, determinant, egg, element, embryo,

inducement, influence, inspiration, life,

parentage, principle, progenitor, producer, root, seed,

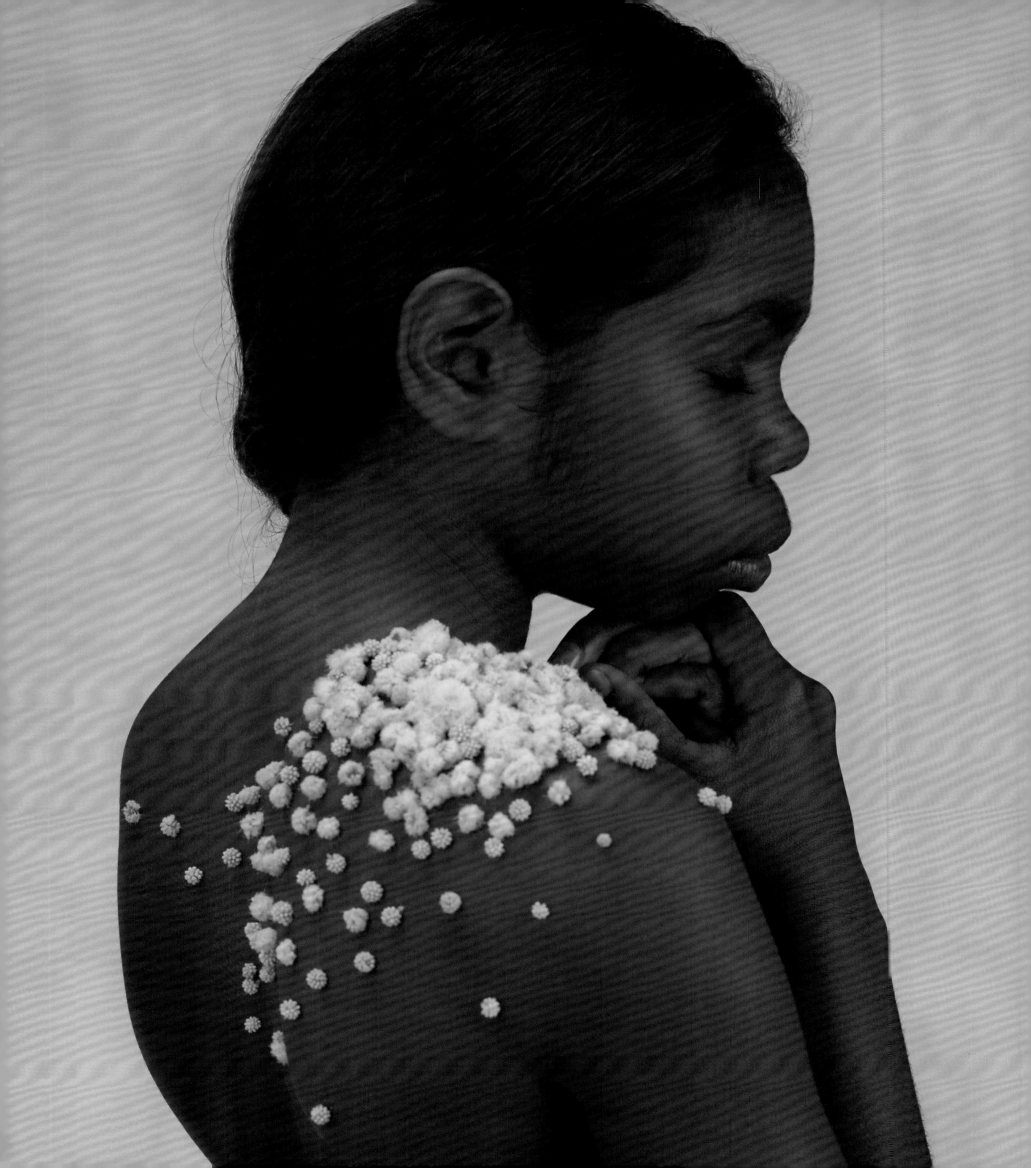

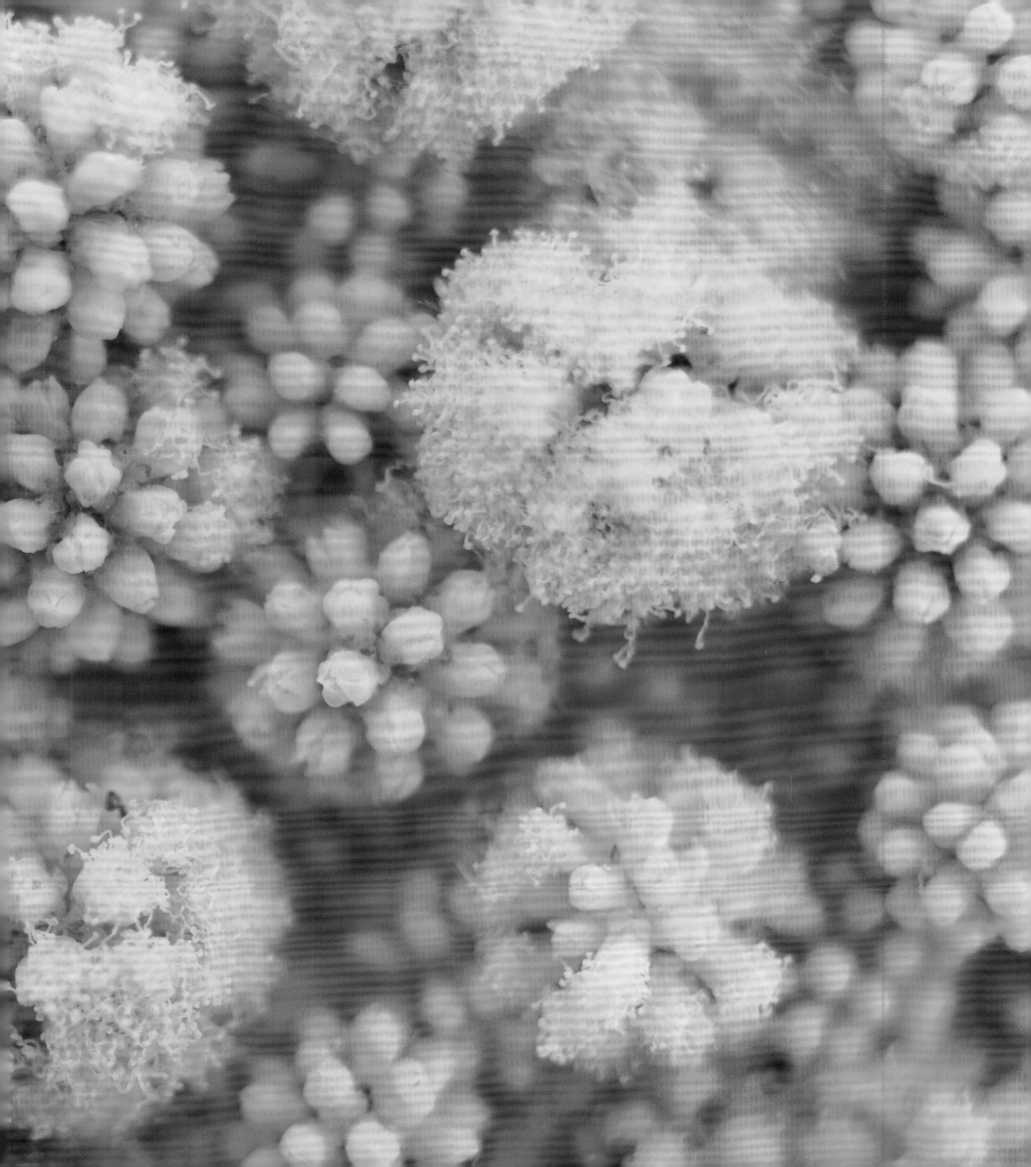

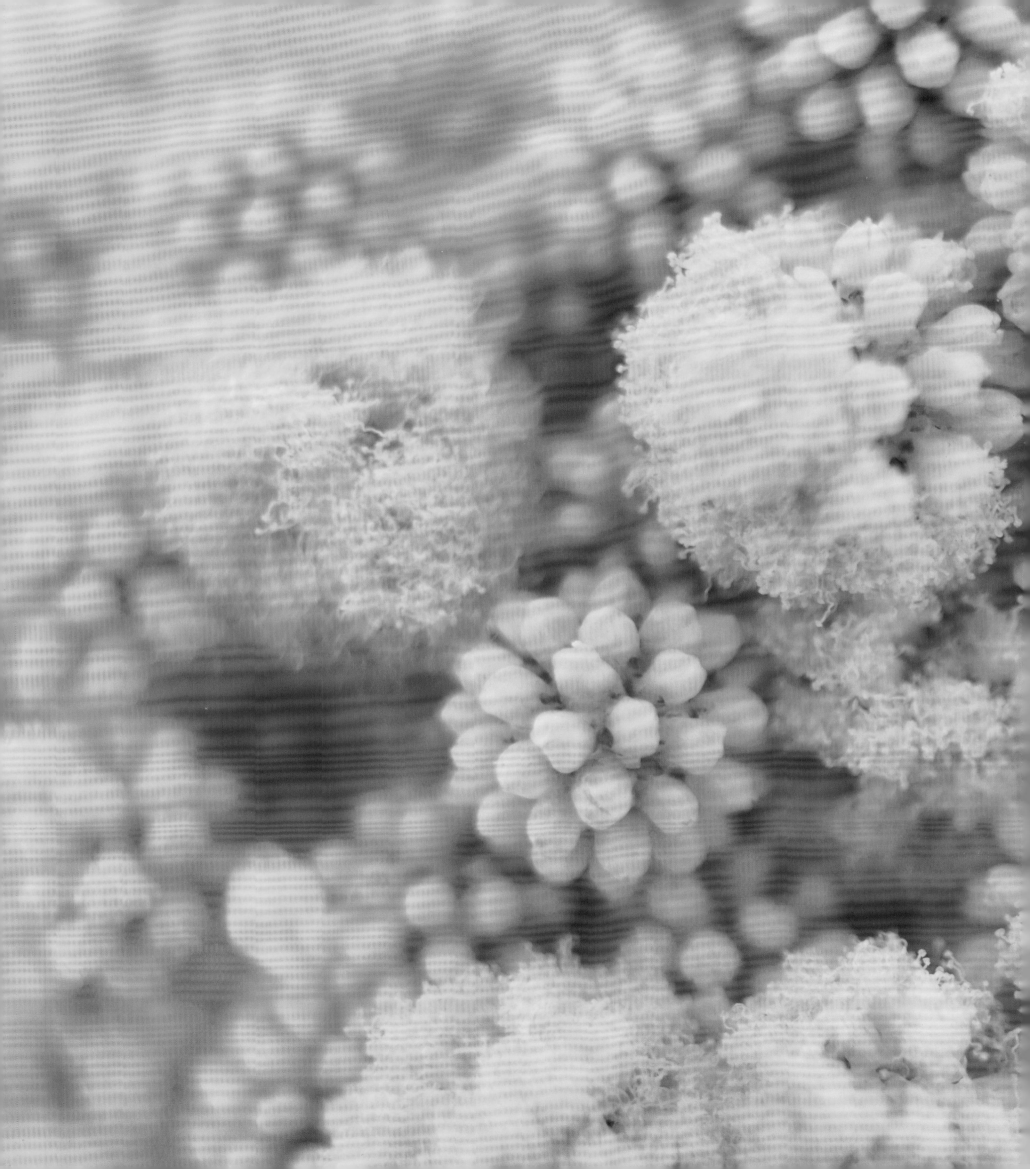

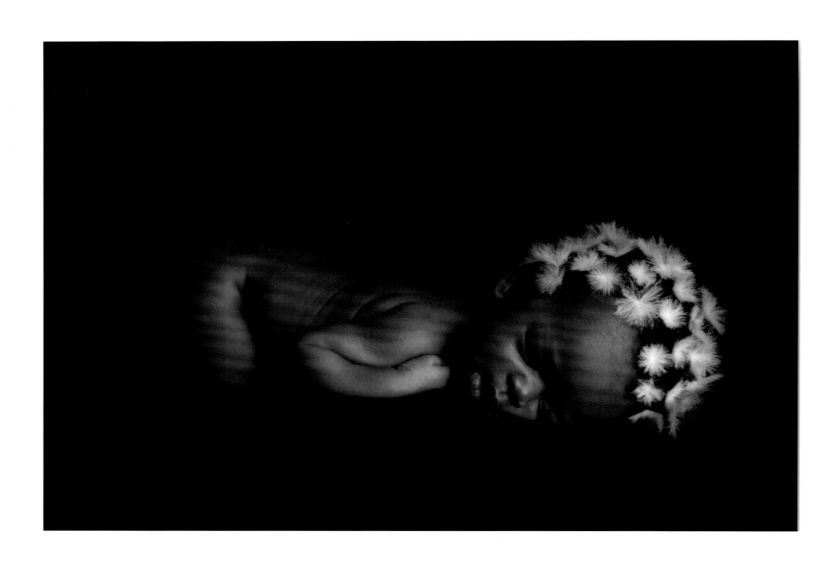

this page N'nadie (4 weeks) opposite Pamela (37 weeks pregnant)

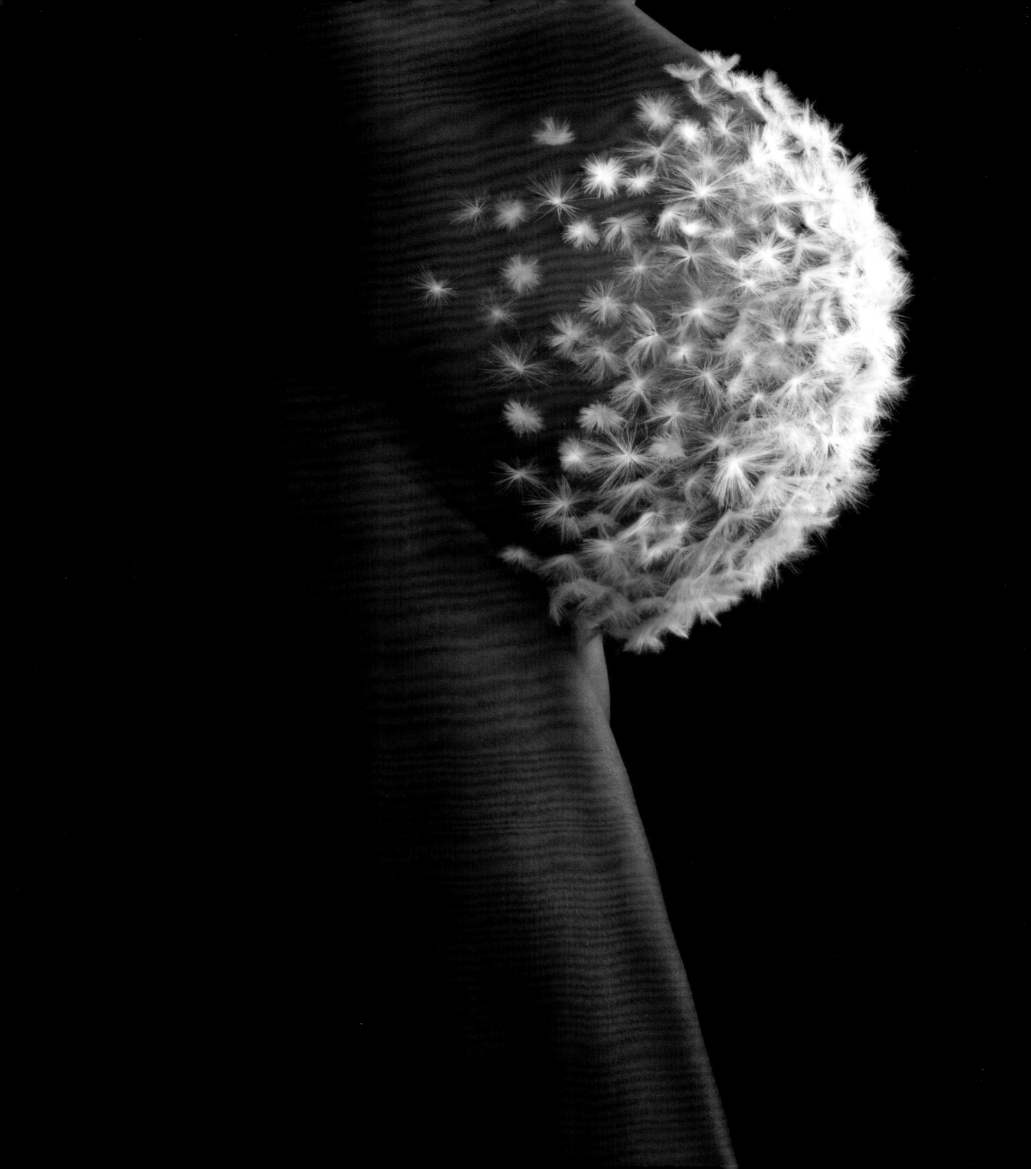

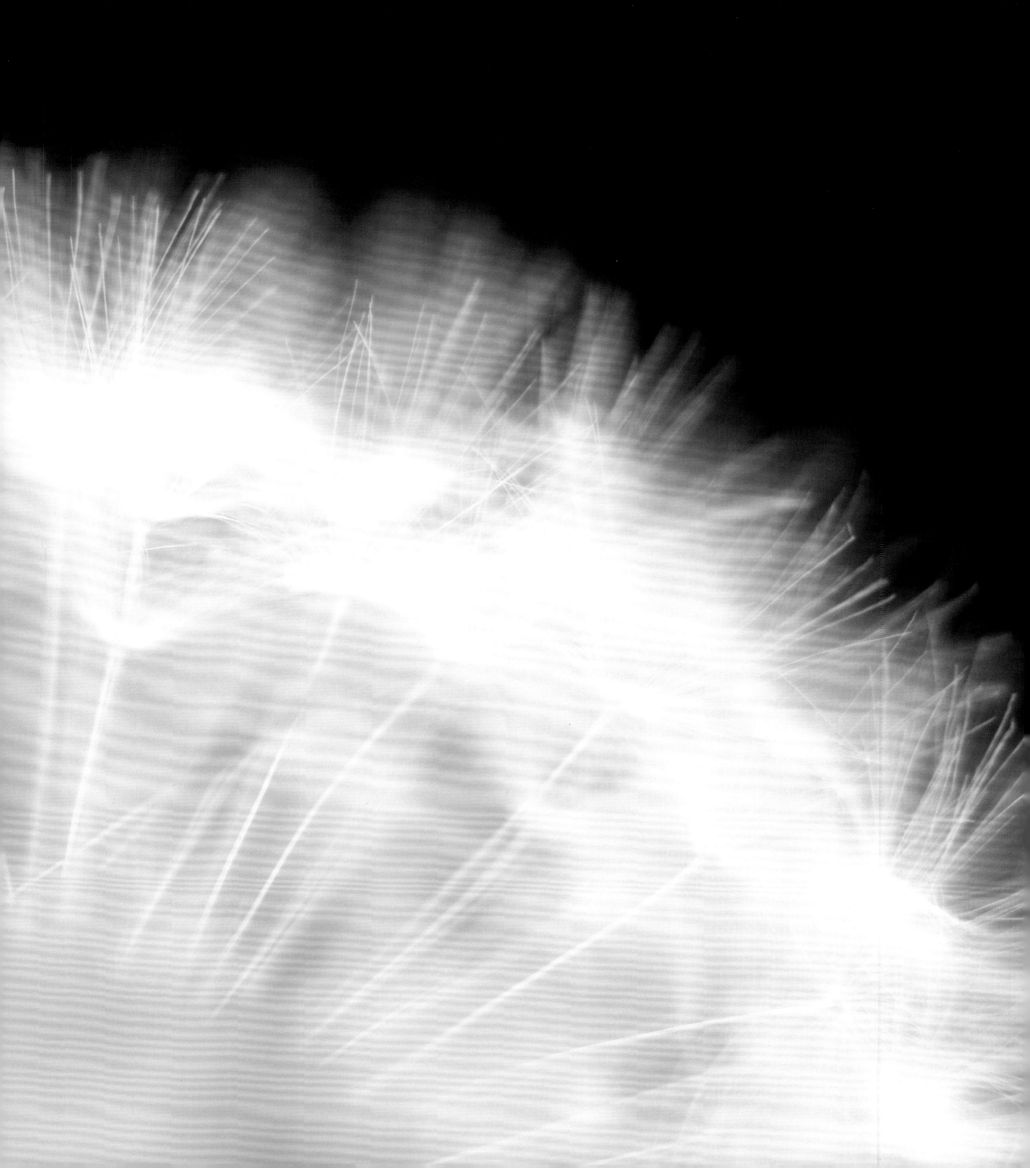

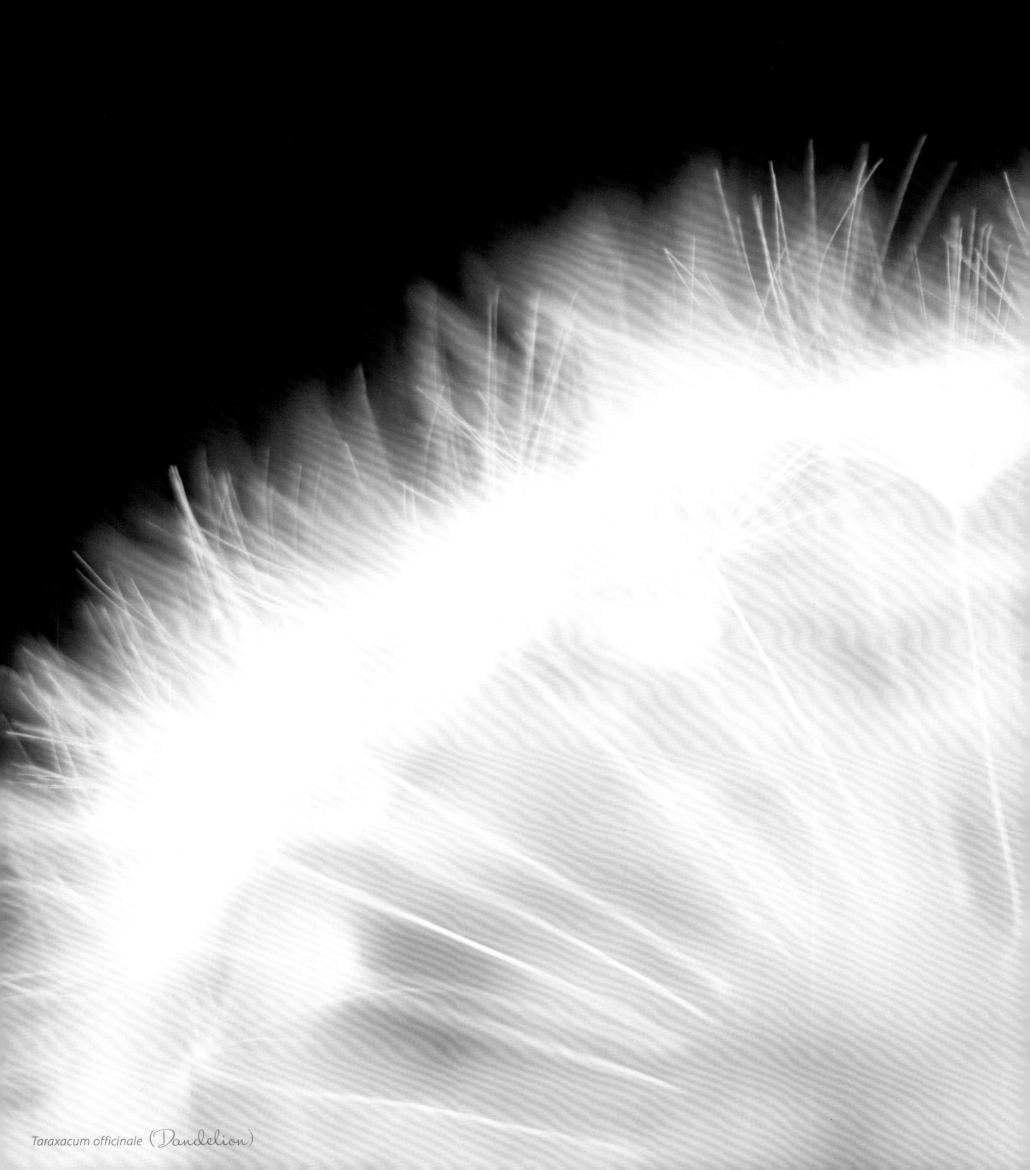

Taraxacum officinale (Dandelion)

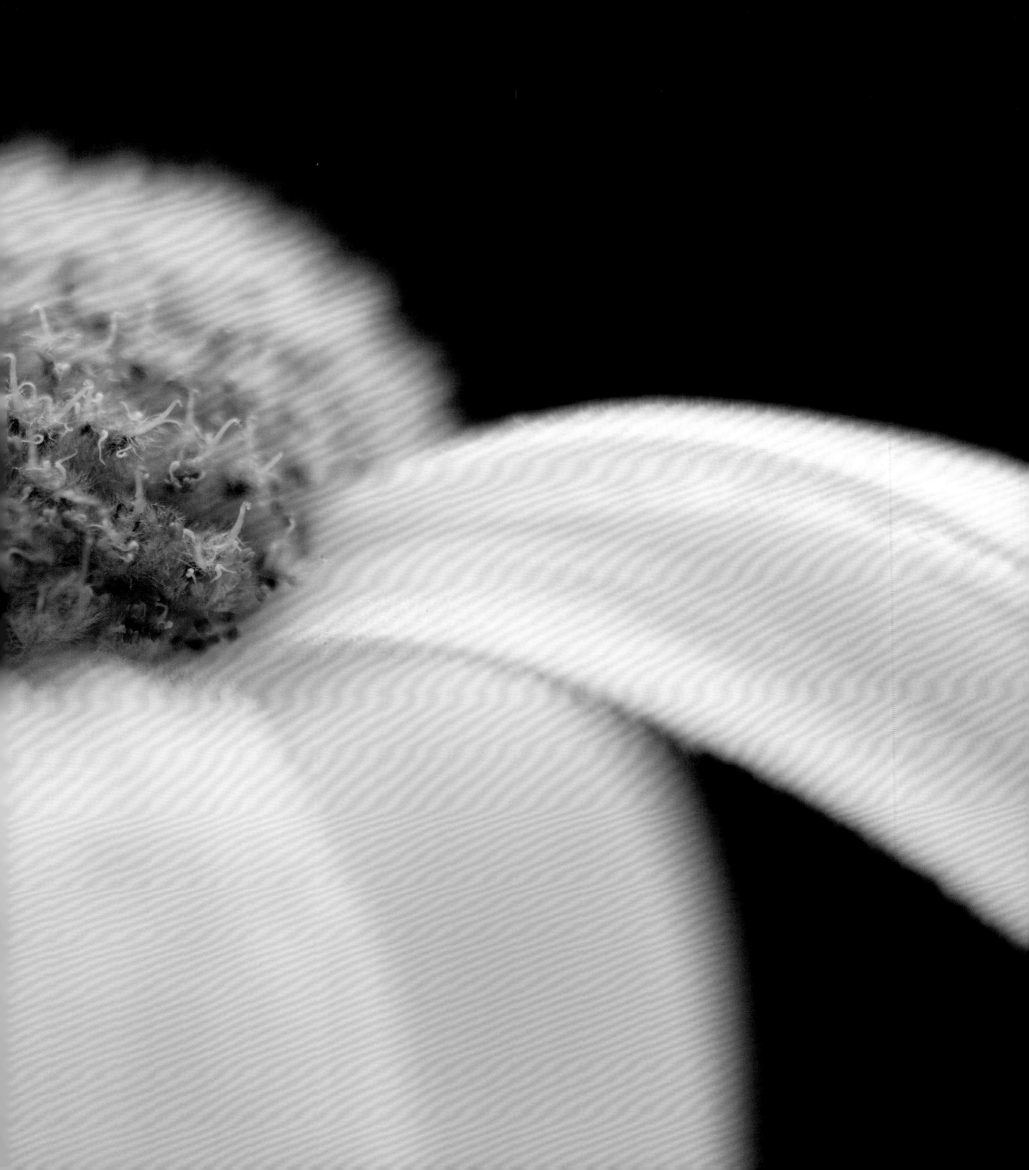

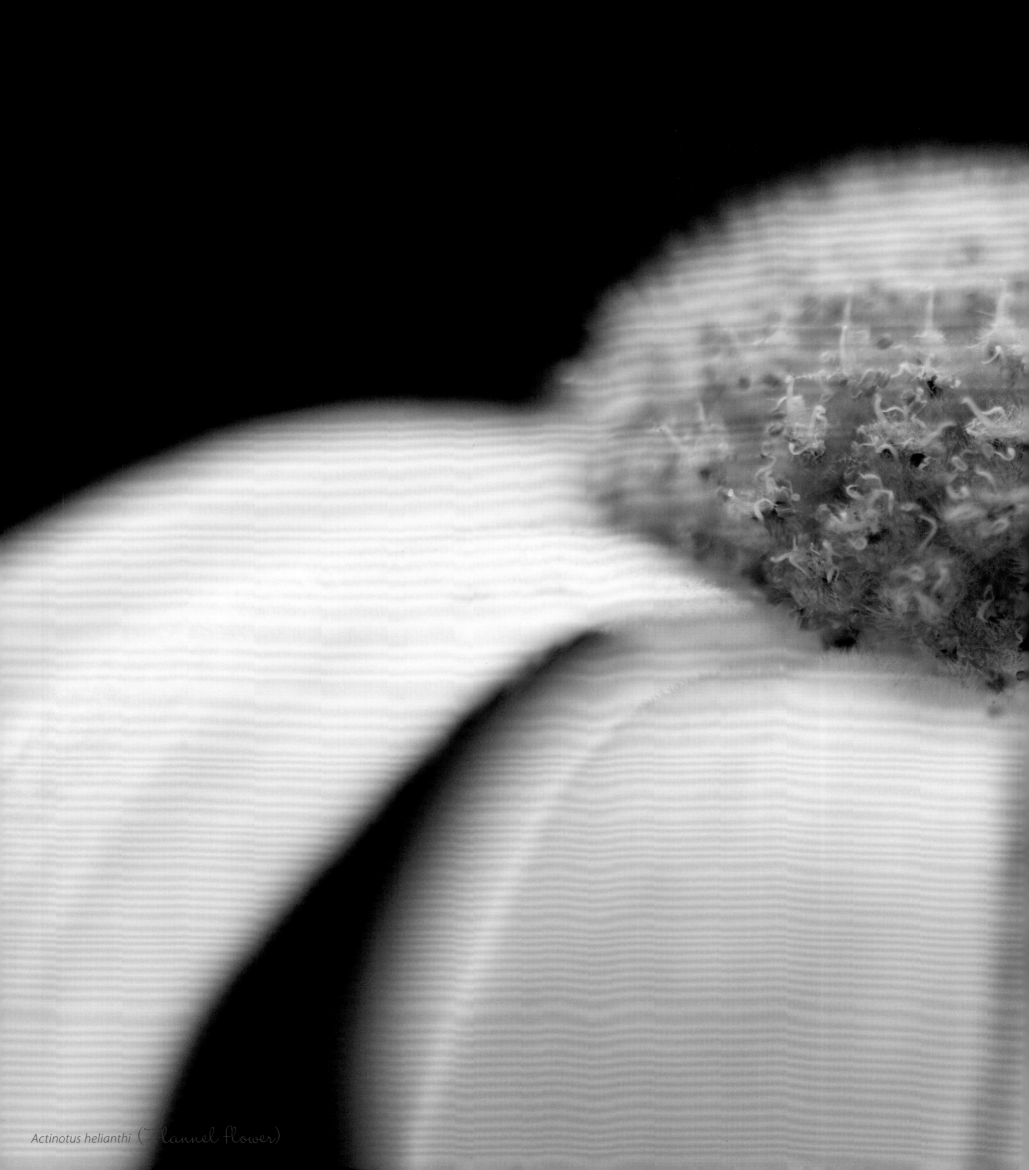

Actinotus helianthi (flannel flower)

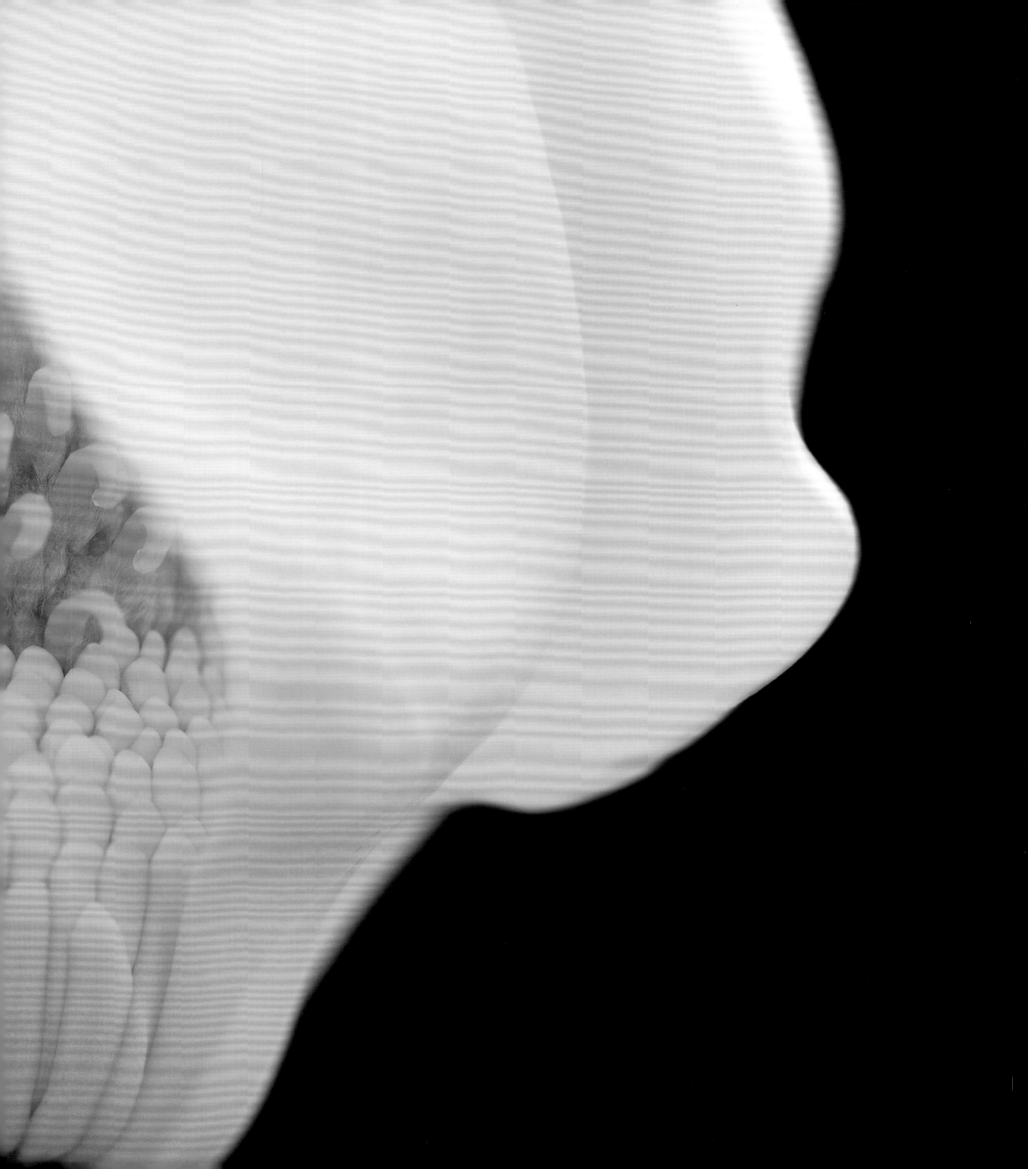

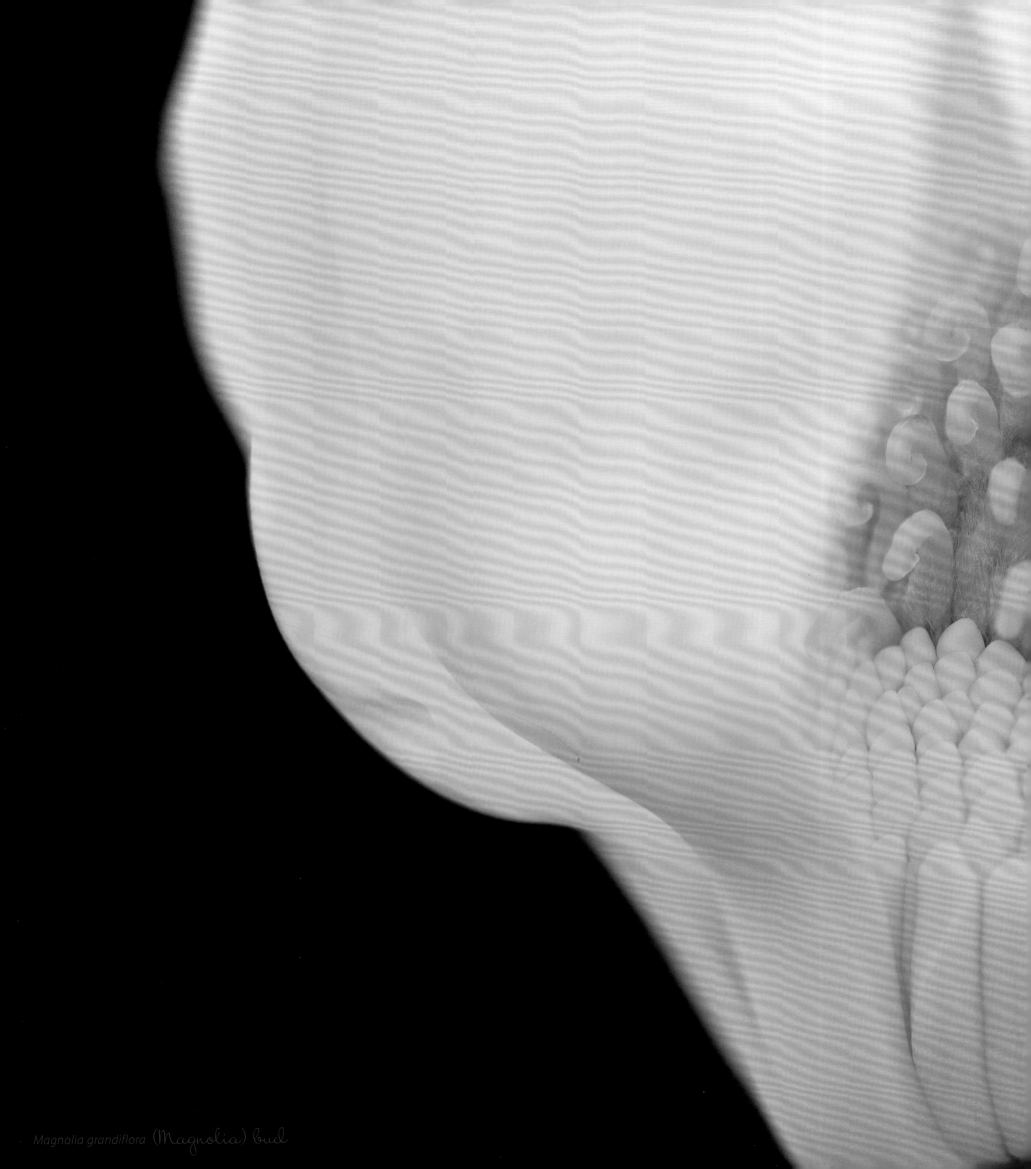

Magnolia grandiflora (Magnolia) bud

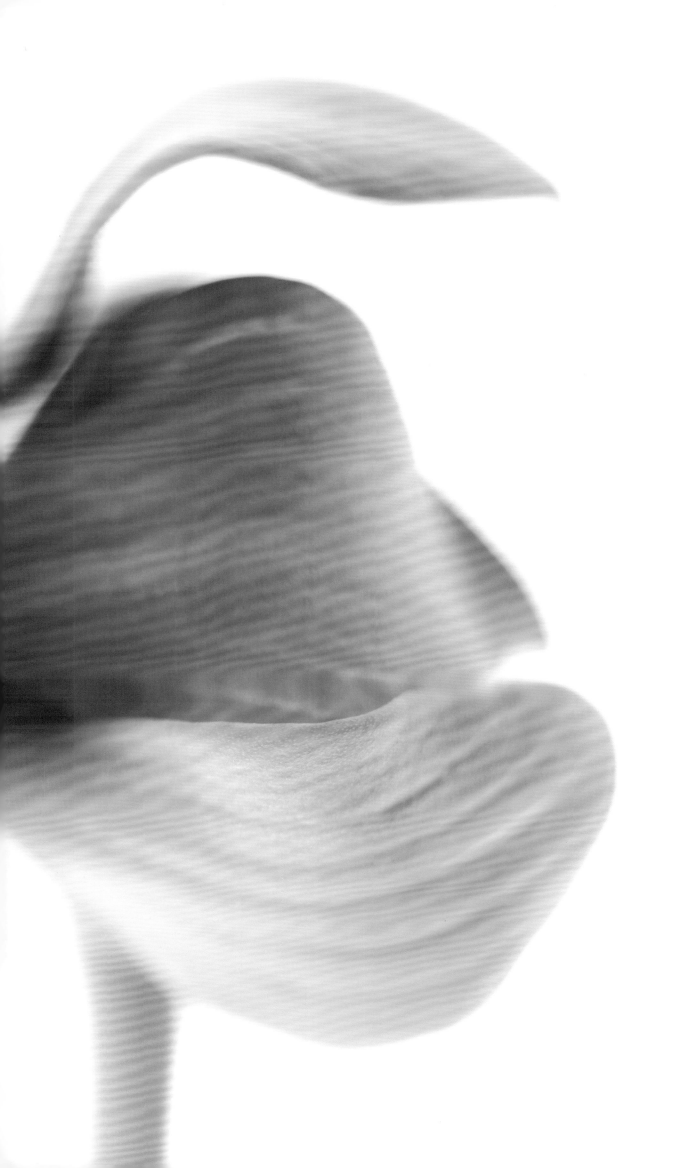

Dahlia cv. (Dahlia) bud

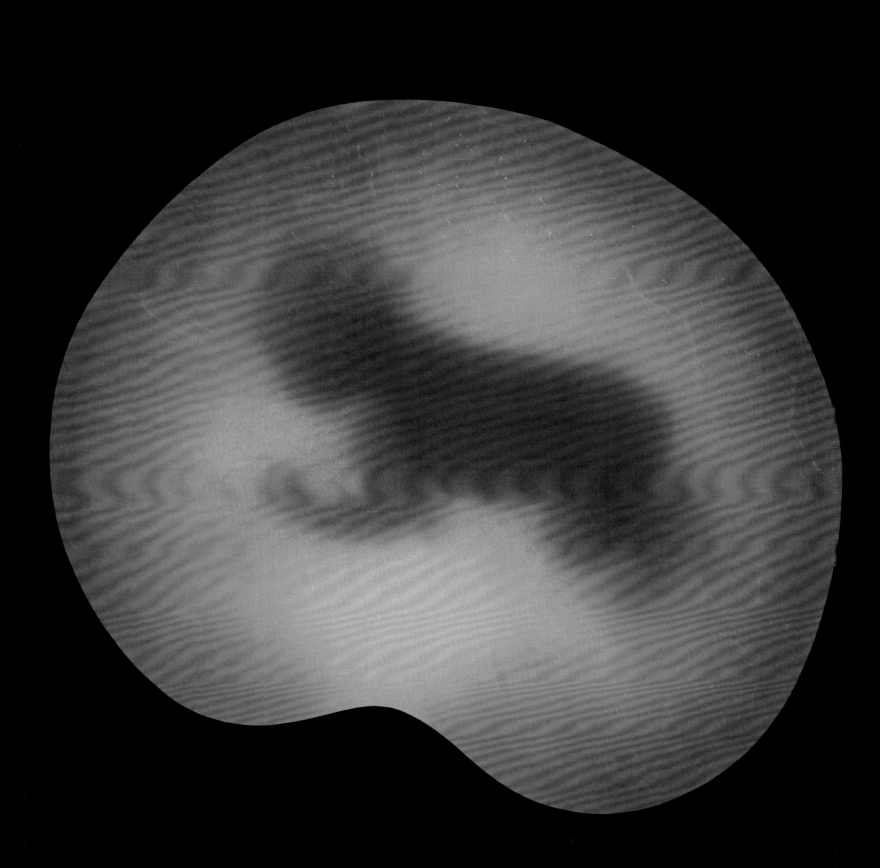

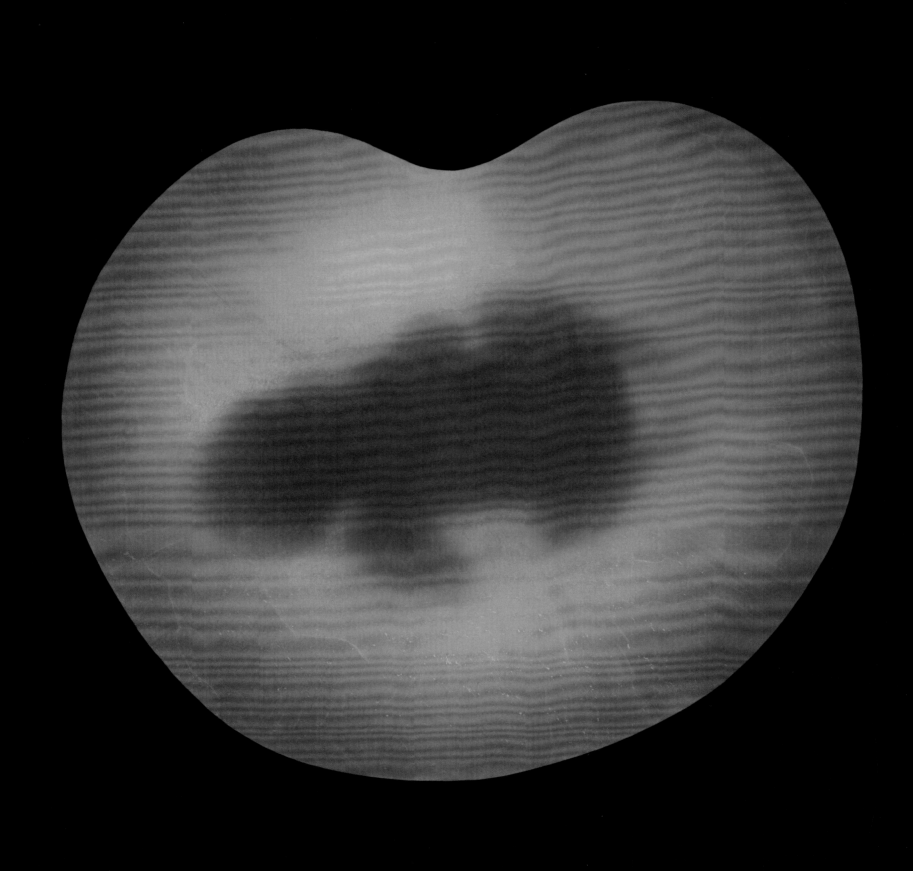

L–R: Alic (3 weeks), Maker (1 week)

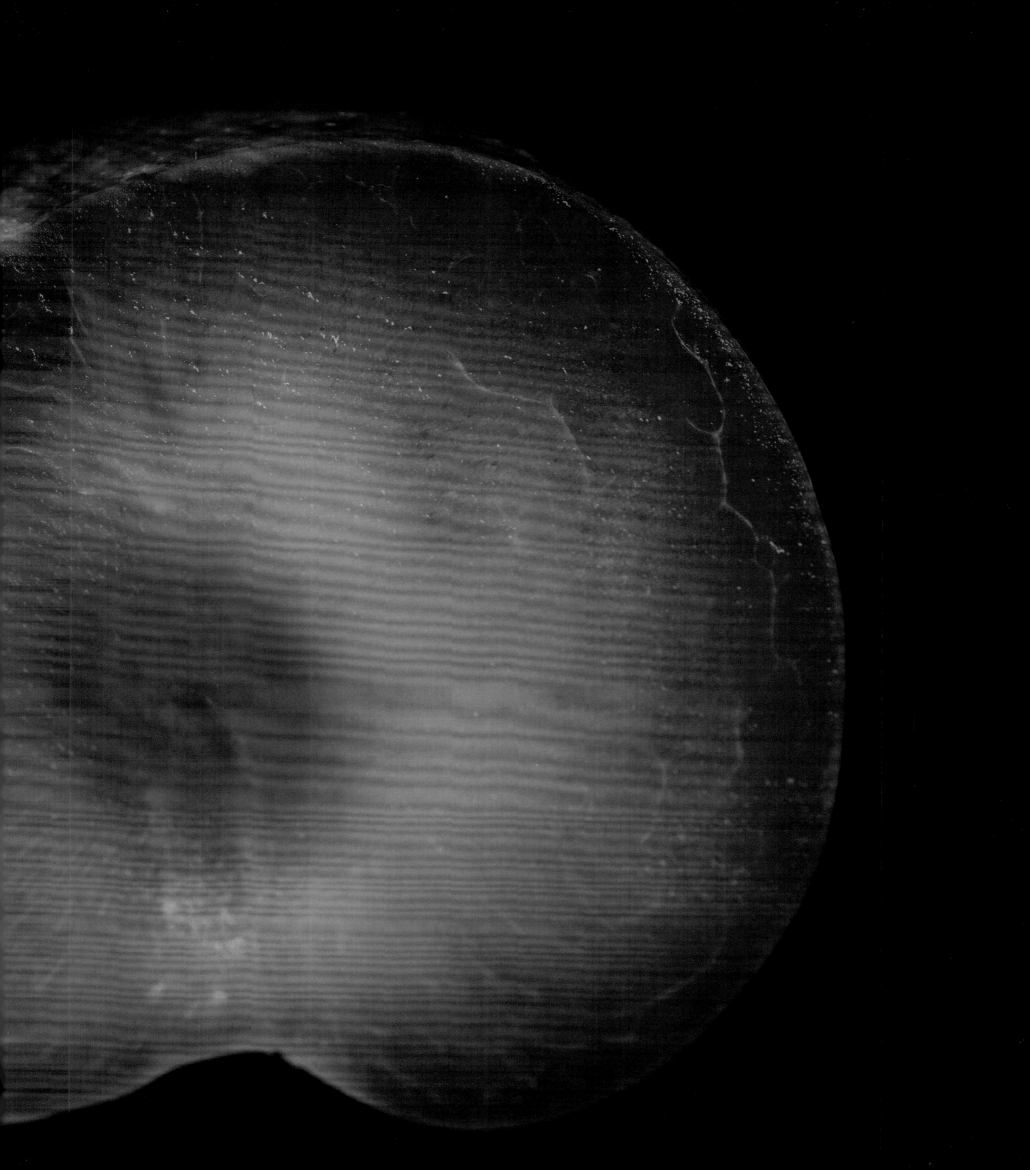

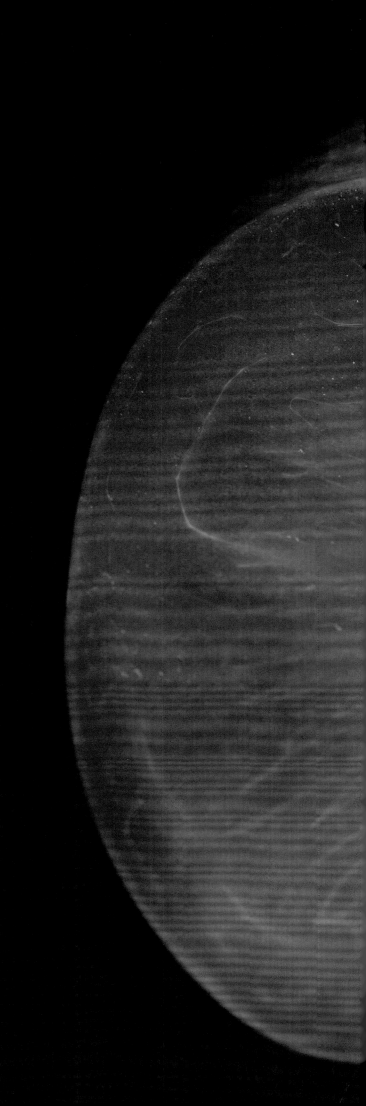

Prunus x domestica (Plum)

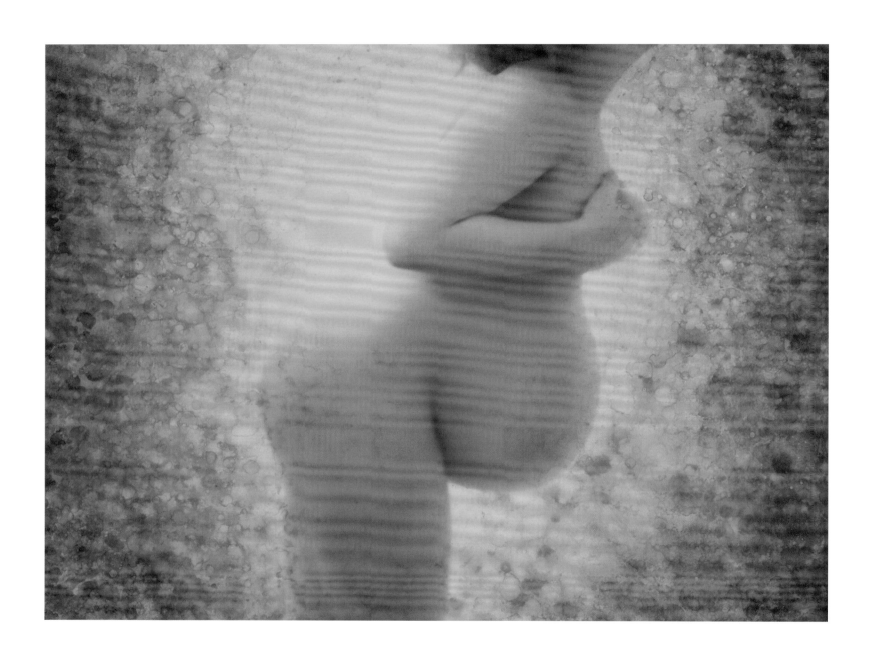

Katherine (39 weeks pregnant)

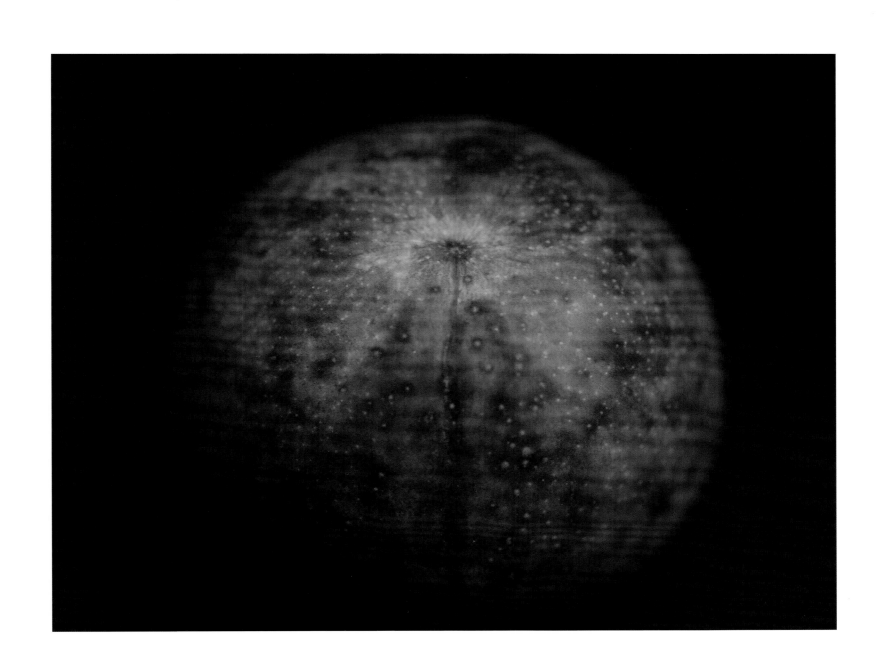

Prunus x domestica (Plum)

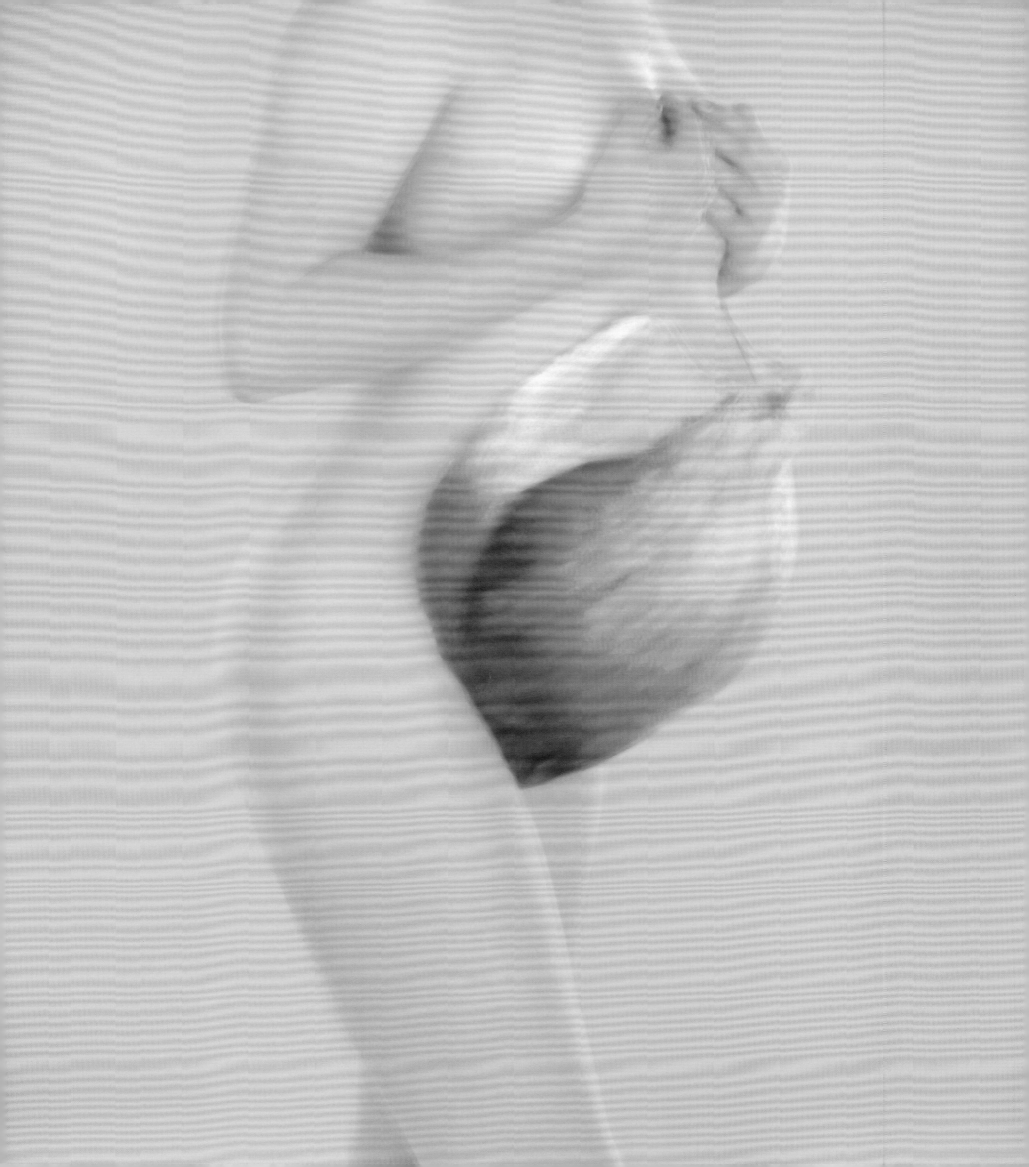

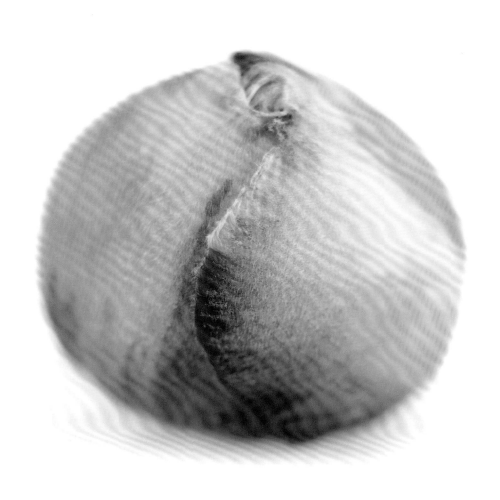

this page *Camellia cv.* (Camellia) bud opposite Natalie (38 weeks pregnant)

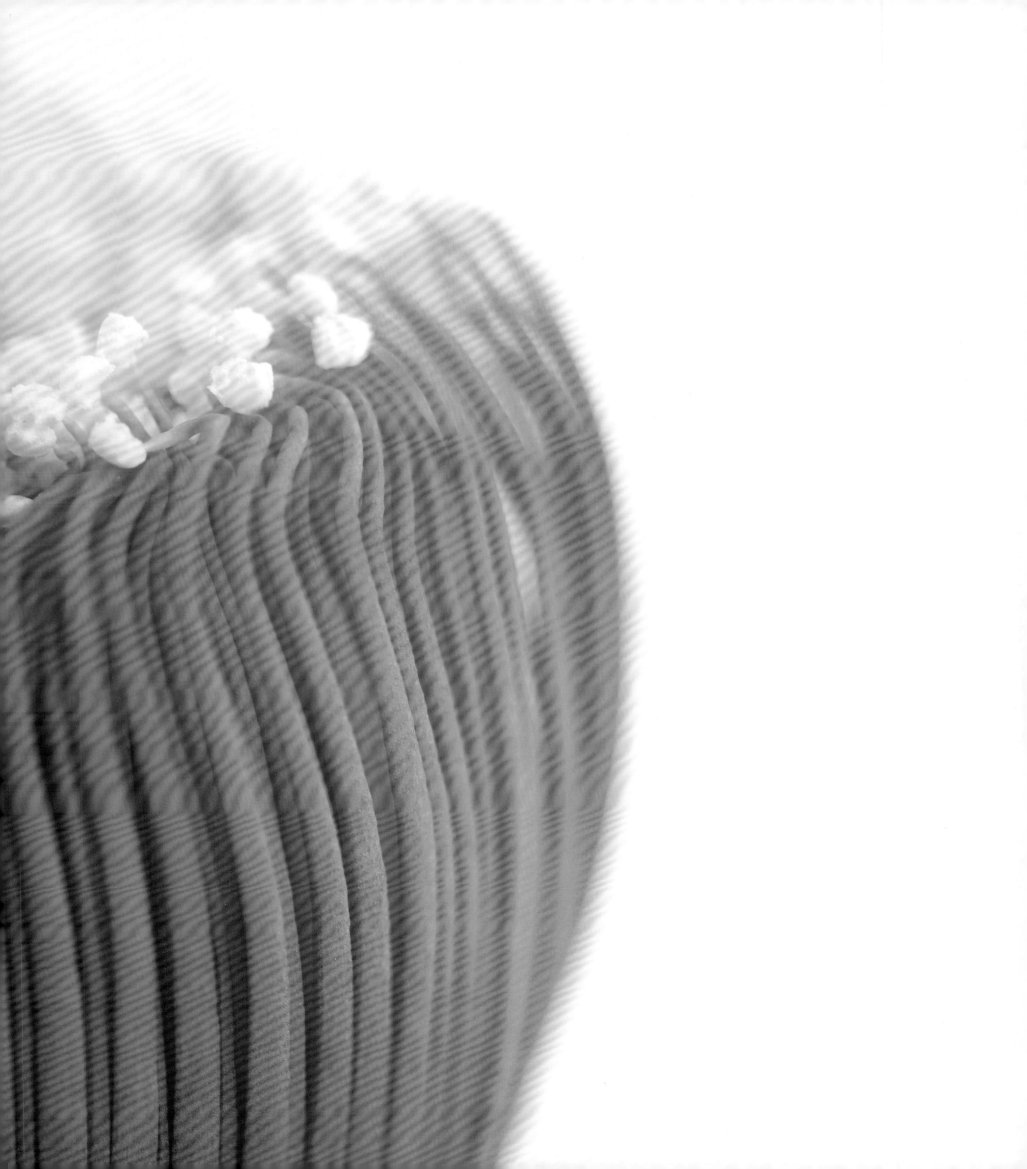

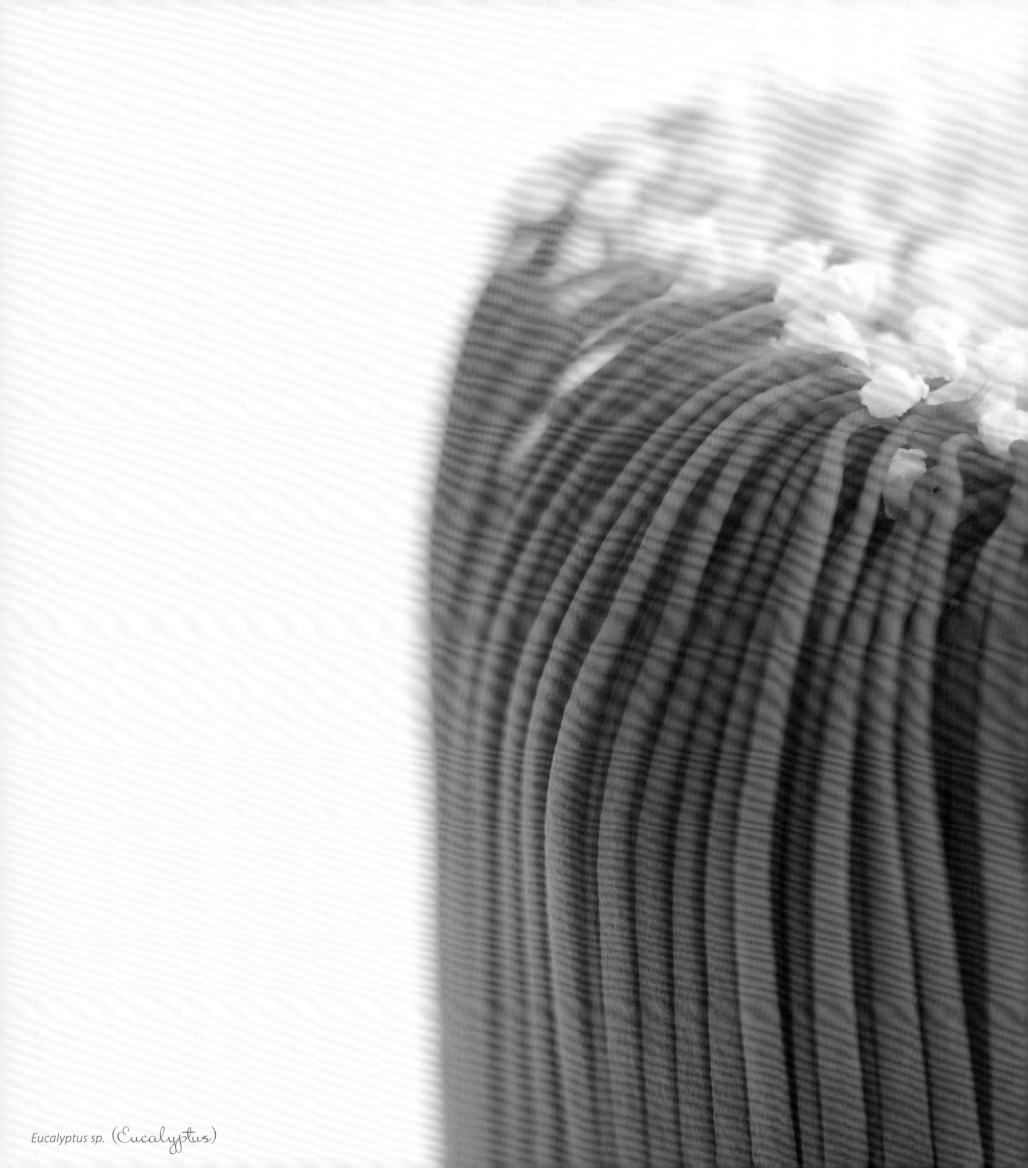

Eucalyptus sp. (Eucalyptus)

Tory (37 weeks pregnant)

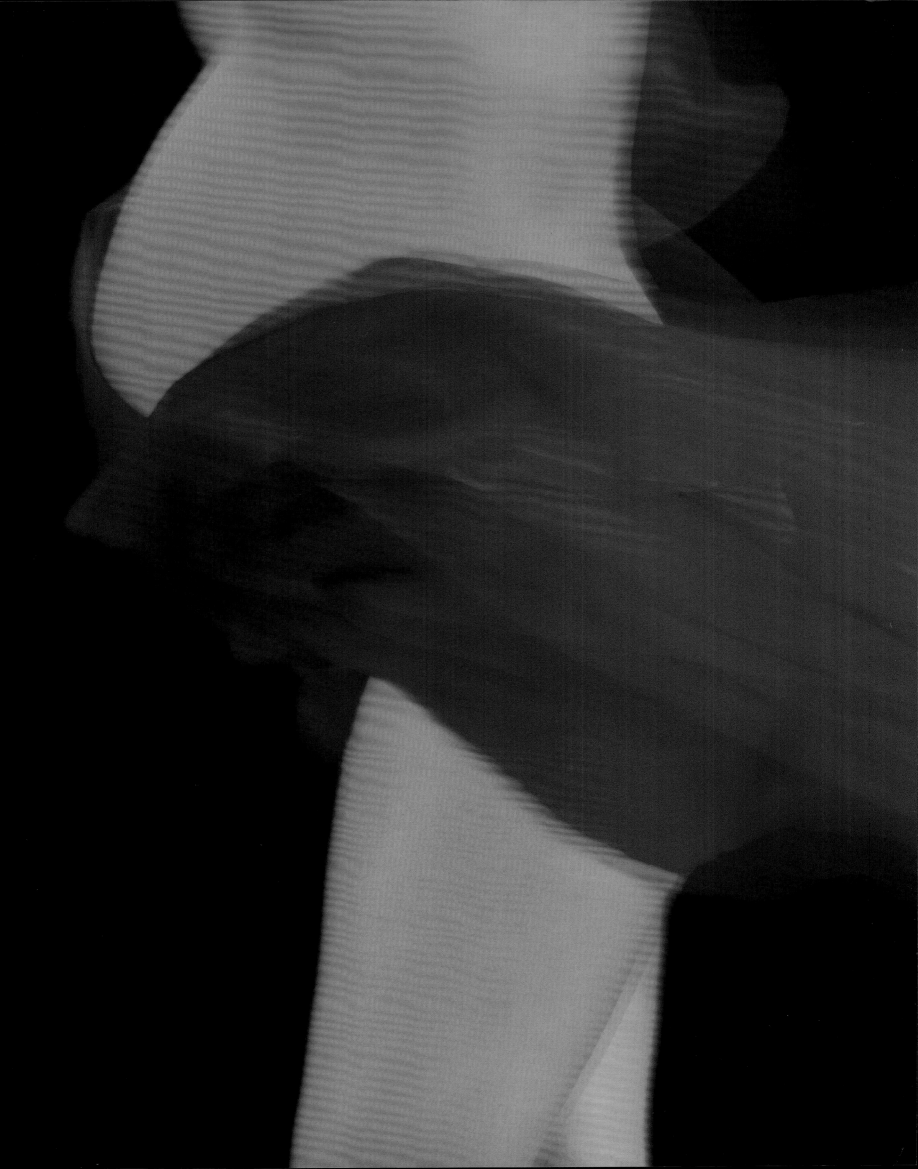

Cyclamen persicum cv. (Cyclamen)

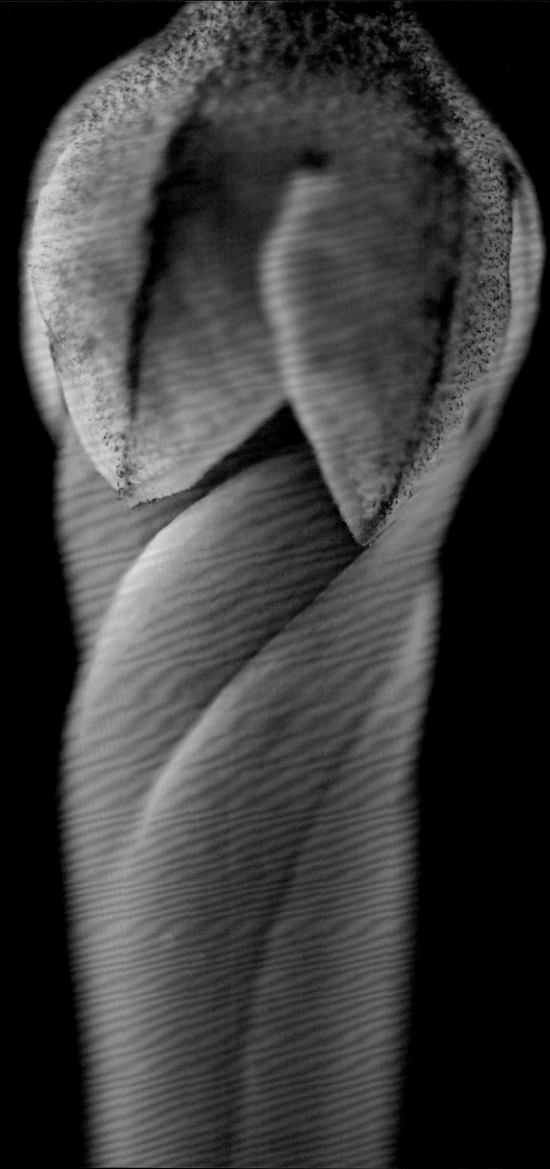

Cyclamen persicum cv. (Cyclamen) bud

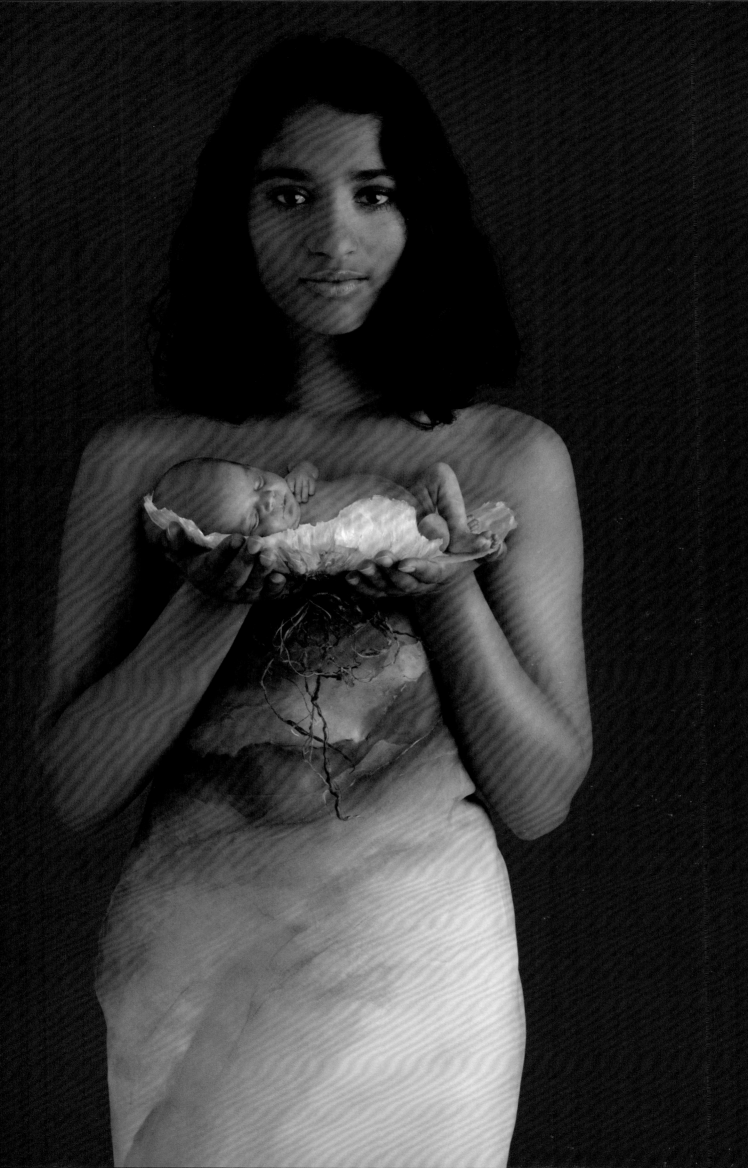

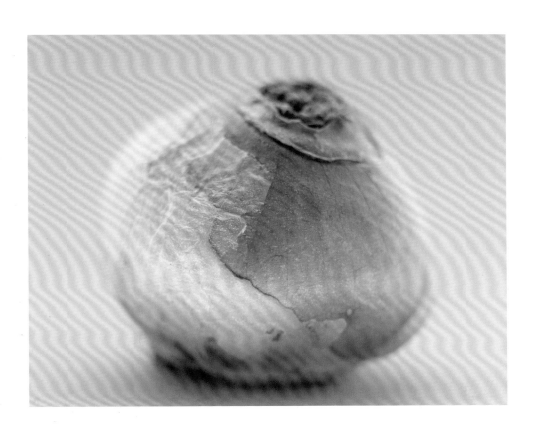

this page *Ornithogalum sp.* (Ornithogalum) *bulb* opposite Maneesha (16 years) holding Gabriella (10 weeks)

1993

Maneesha was born prematurely at 28 weeks on 3rd November.
At birth she weighed 680g (a little under 1.5lb).

16 years later

2009

Gabriella was born prematurely at 27 weeks on 23rd July.
At birth she weighed 550g (just over 1lb).

Following page Maneesha holding Gabriella (1kg/2.2lbs)
photographed in The Grace Unit at the children's hospital at Westmead, Sydney, Australia, 28th September, 2009

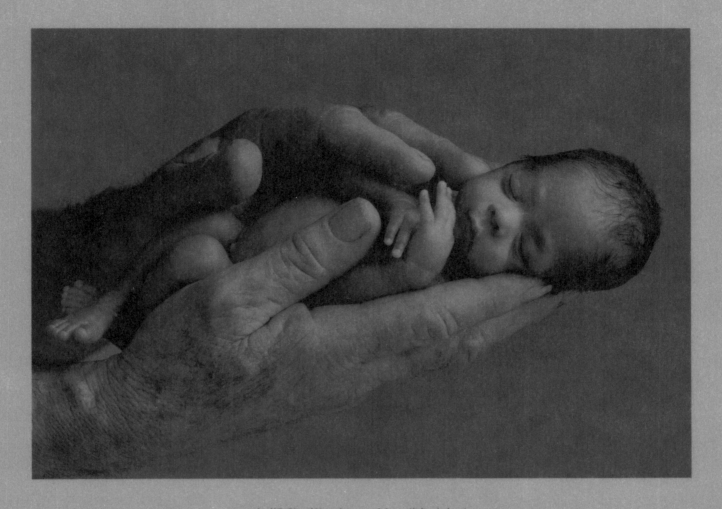

Jack holding Maneesha (1kg/2.2lbs)
photographed in the Special Care Baby Unit at National Women's Hospital,
Auckland, New Zealand, 9th December, 1993

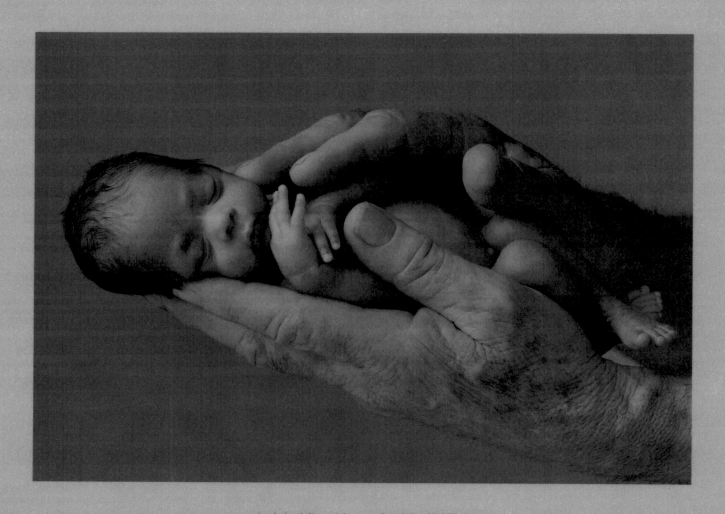

Jack holding Maneesha (1kg/2.2lbs)
photographed in the Special Care Baby Unit at National Women's Hospital,
Auckland, New Zealand, 9th December, 1993

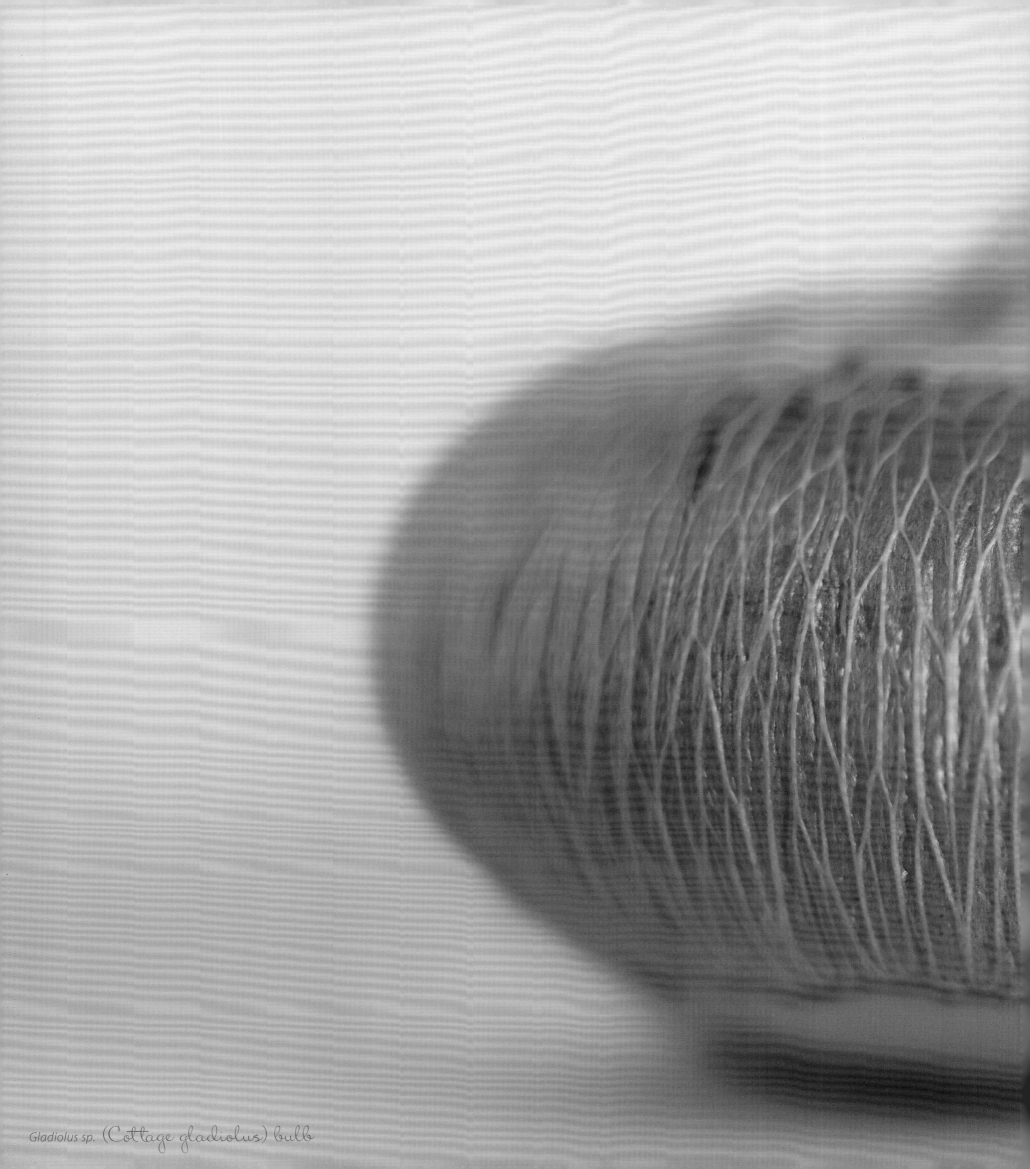

Gladiolus sp. (Cottage gladiolus) bulb

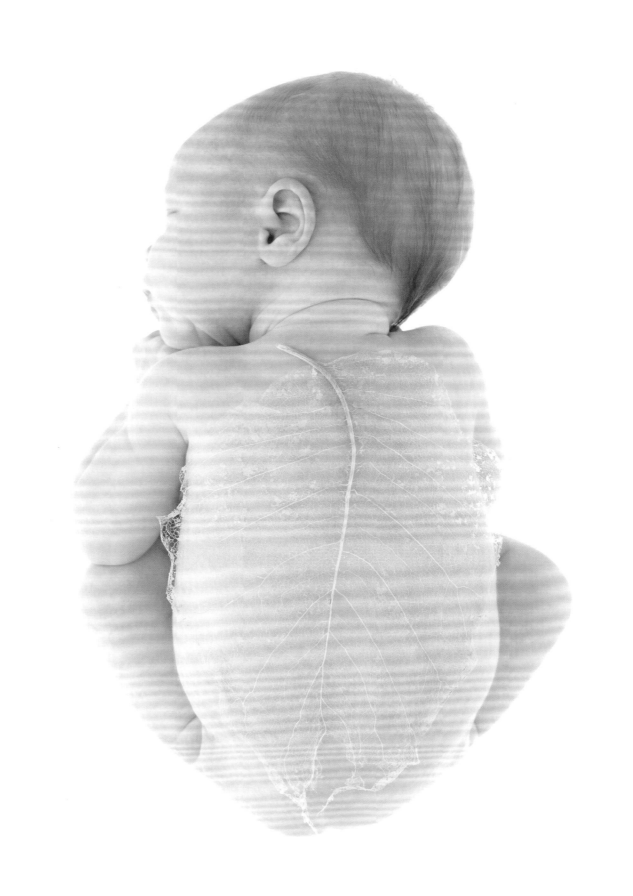

this page *Physalis peruviana* (Cape gooseberry) opposite Molly (2 weeks)

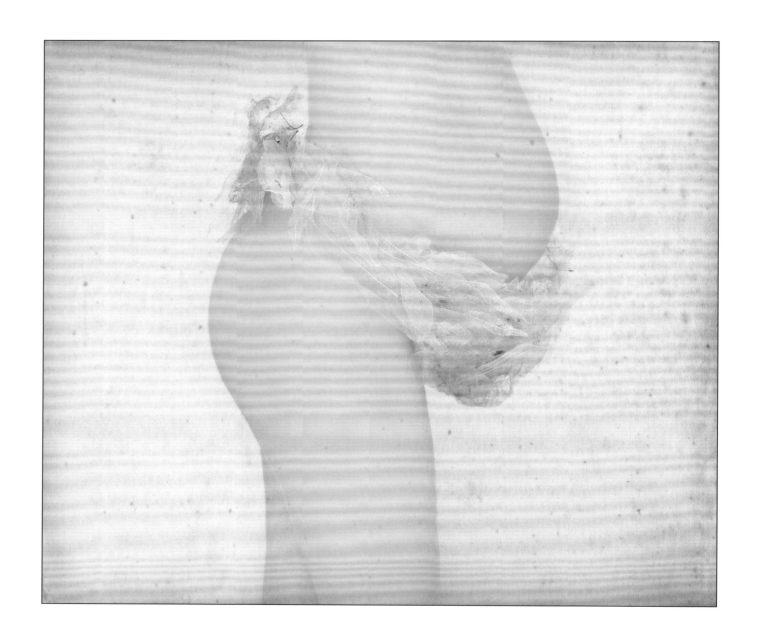

Renée (36 weeks pregnant)

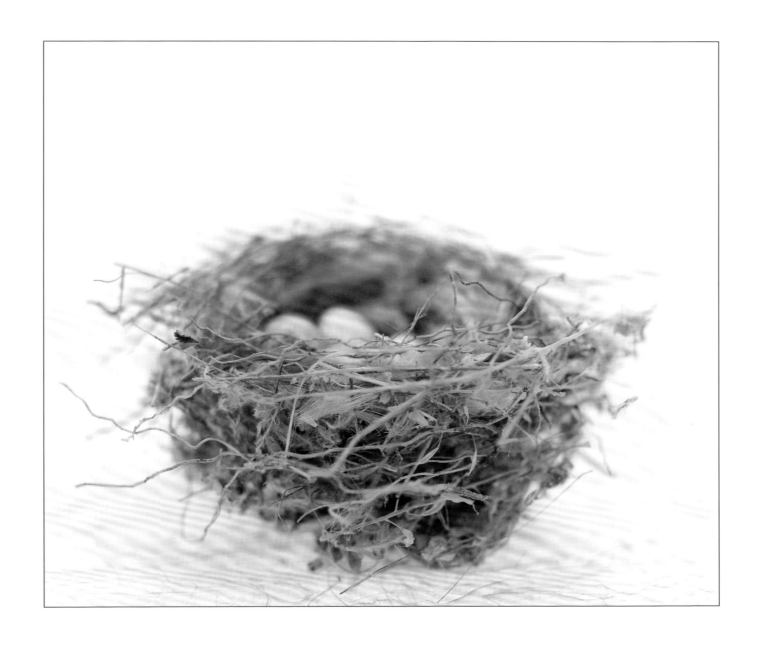

Carduelis carduelis (European Goldfinch) nest, found Cooma, NSW, Australia, 1981

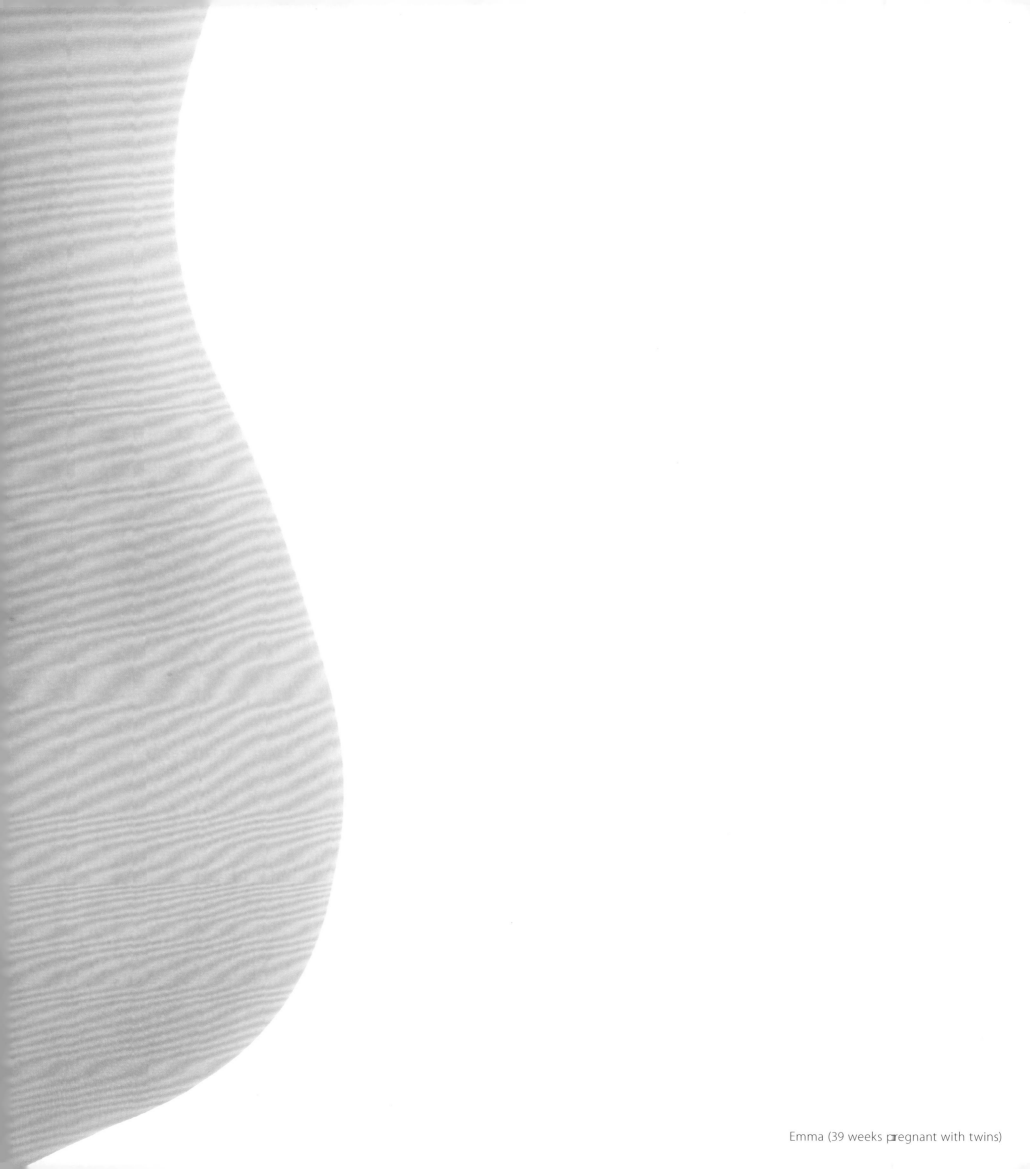

Emma (39 weeks pregnant with twins)

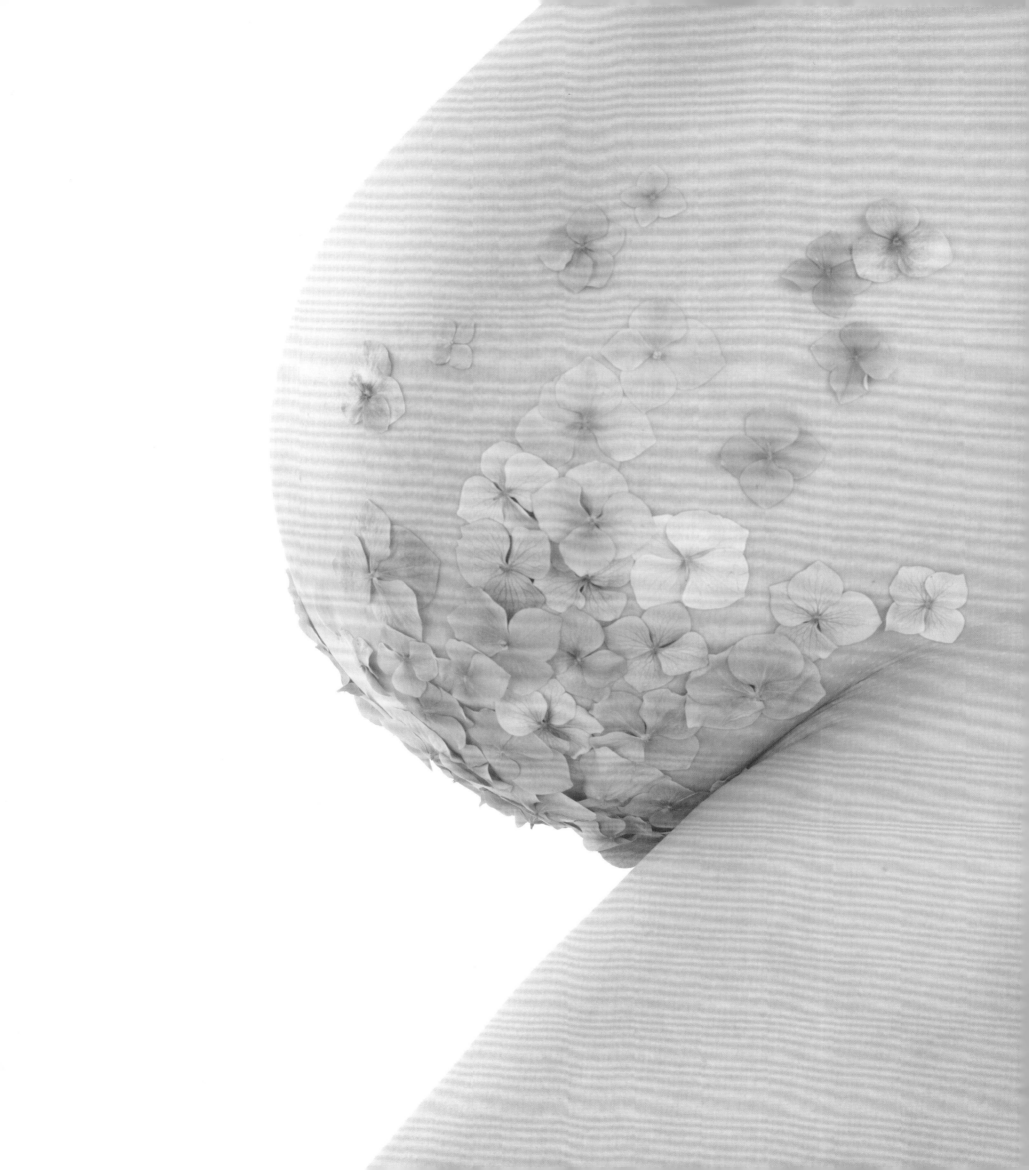

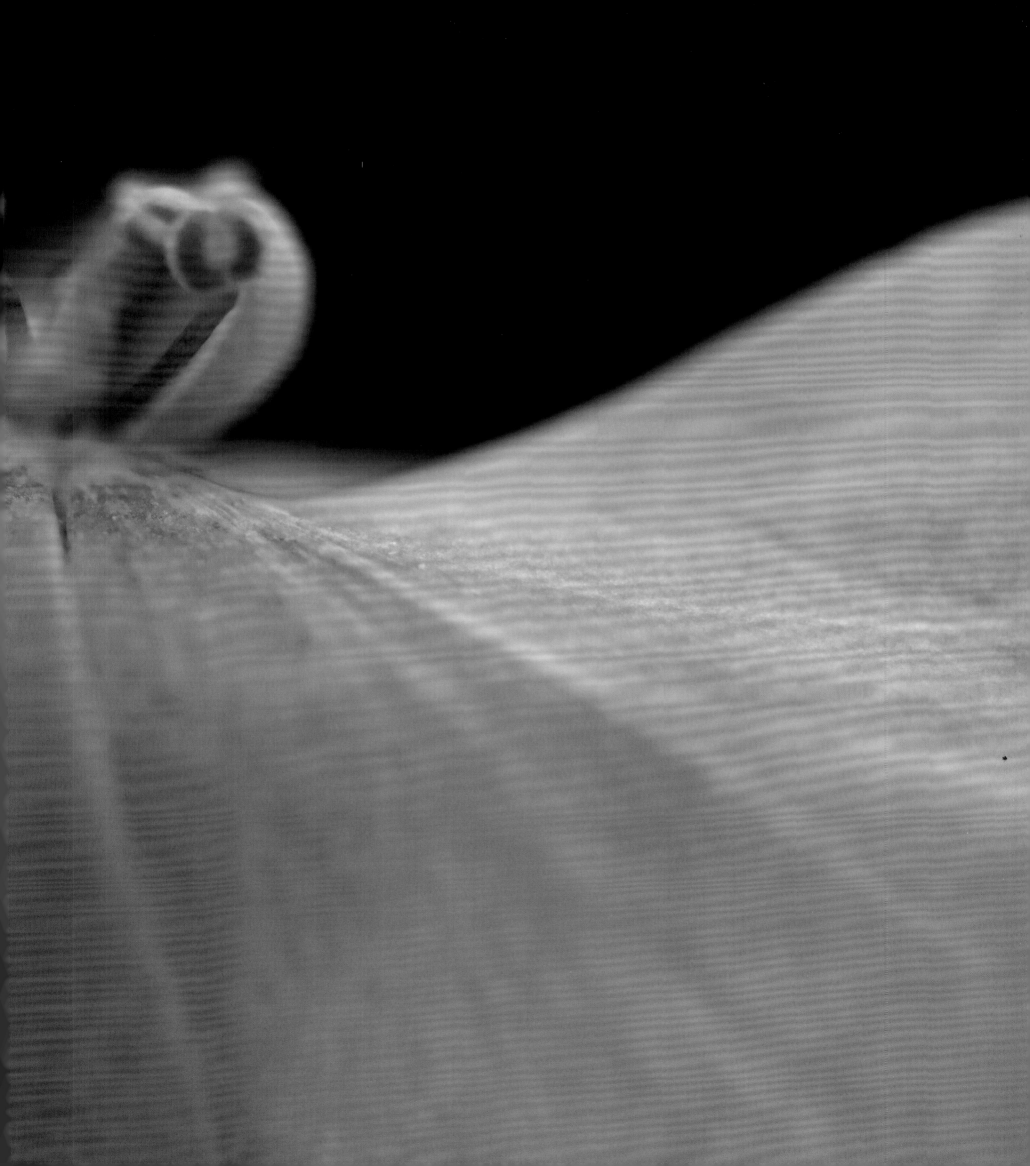

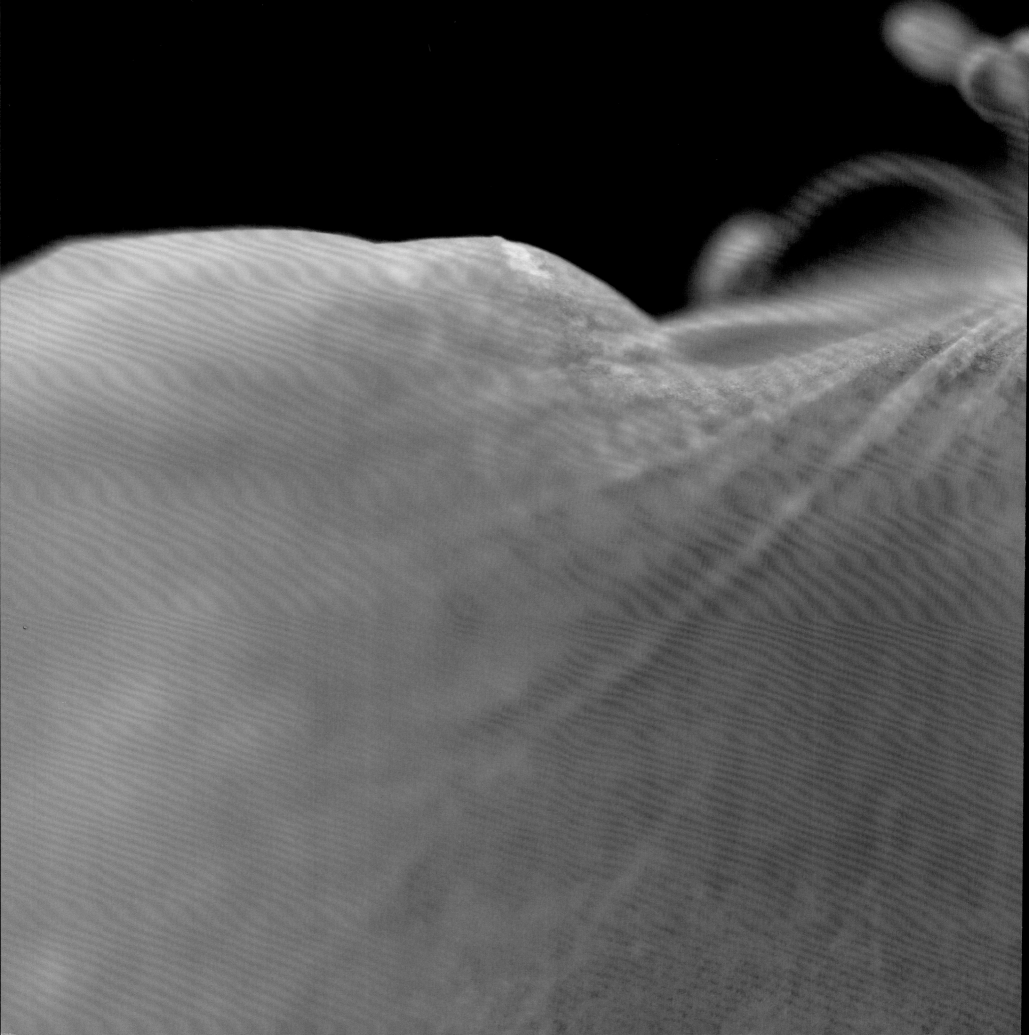

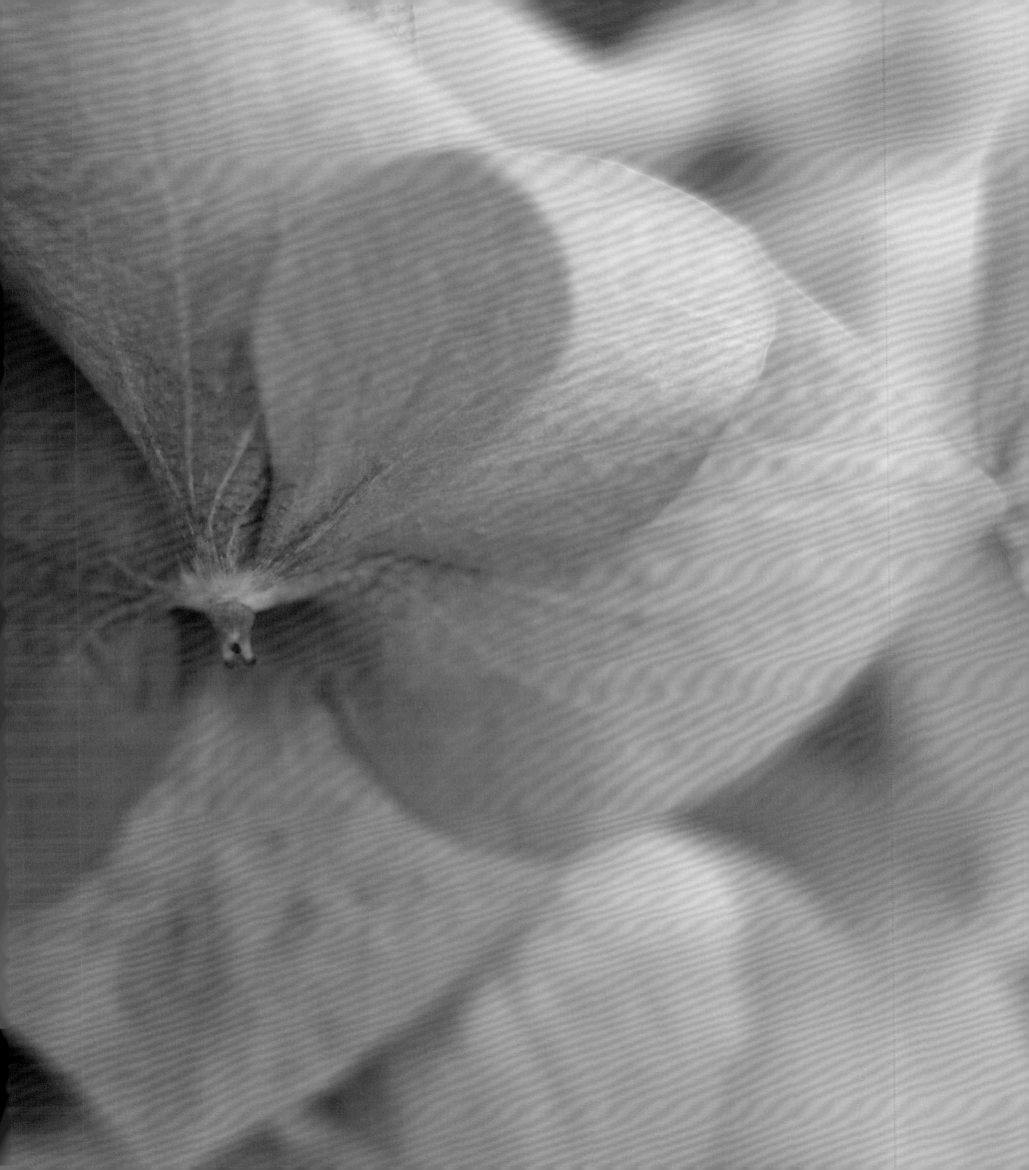

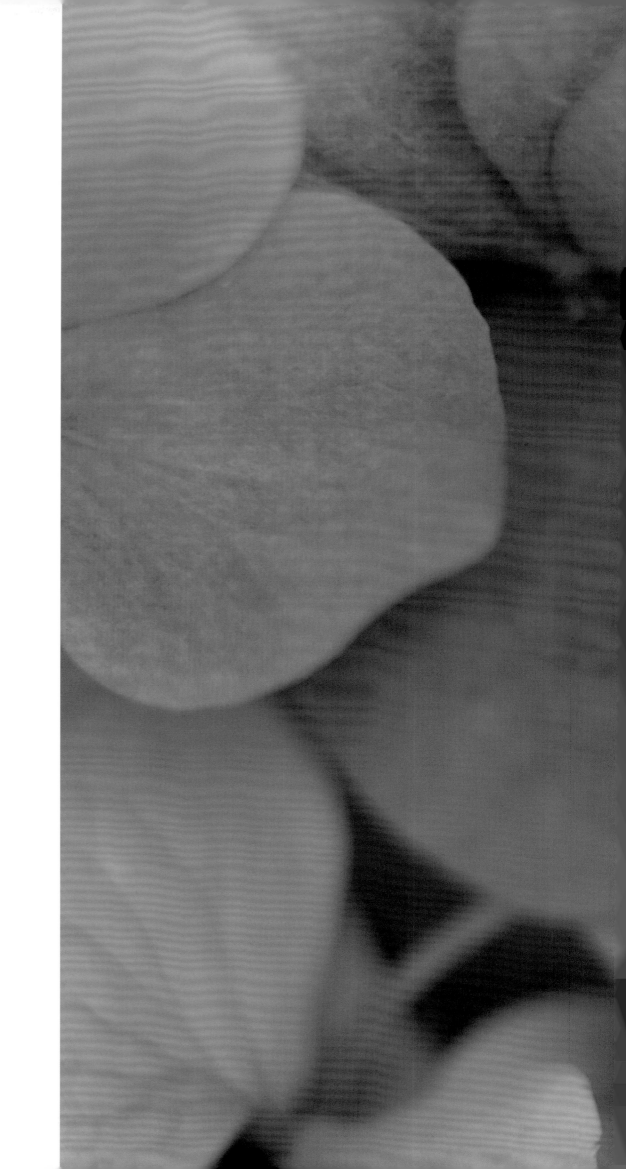

Following pages *Hydrangea macrophylla* (Hydrangea)

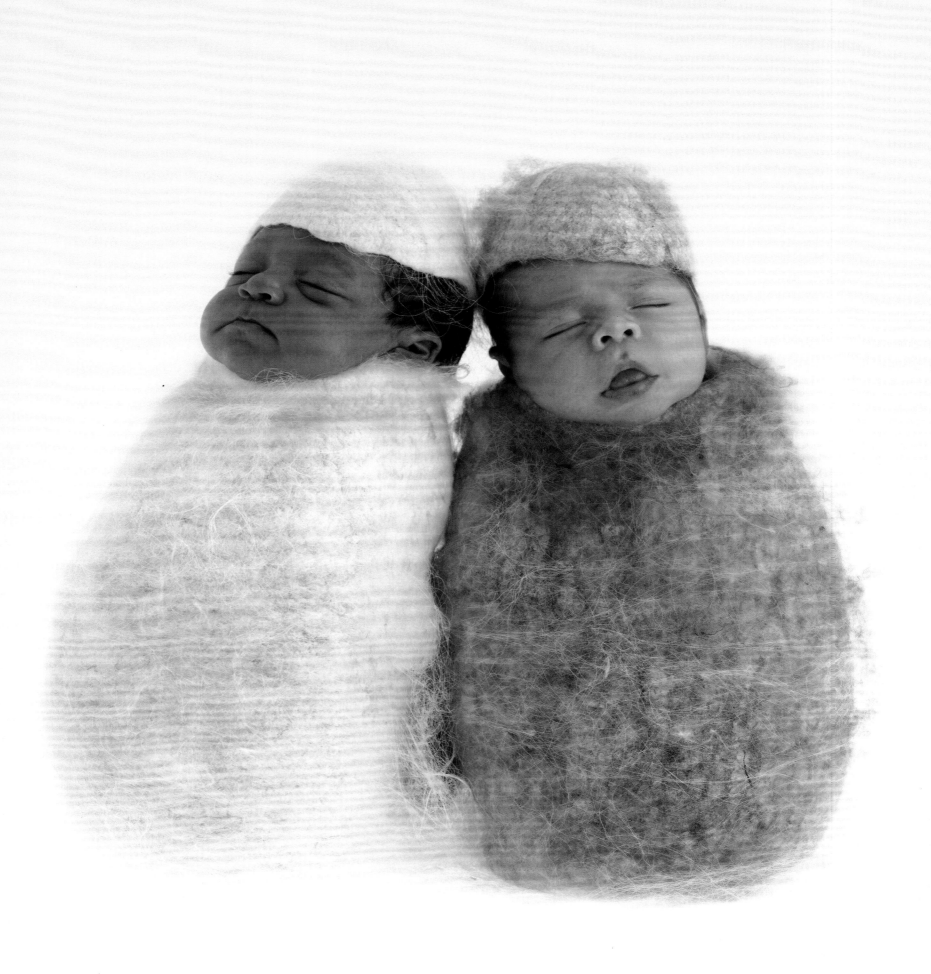

L–R: Brodie (3 weeks), Miles (3 weeks)

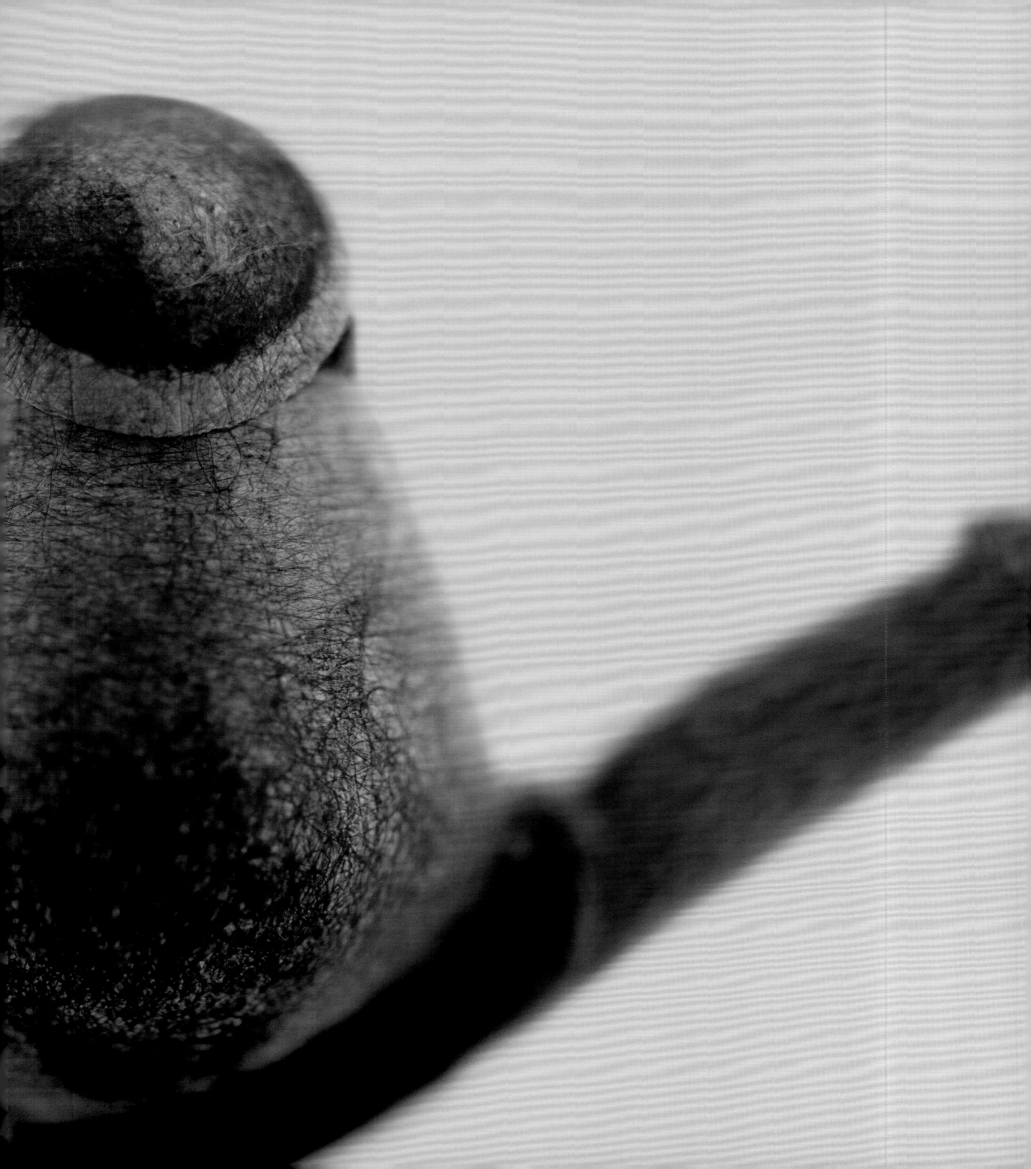

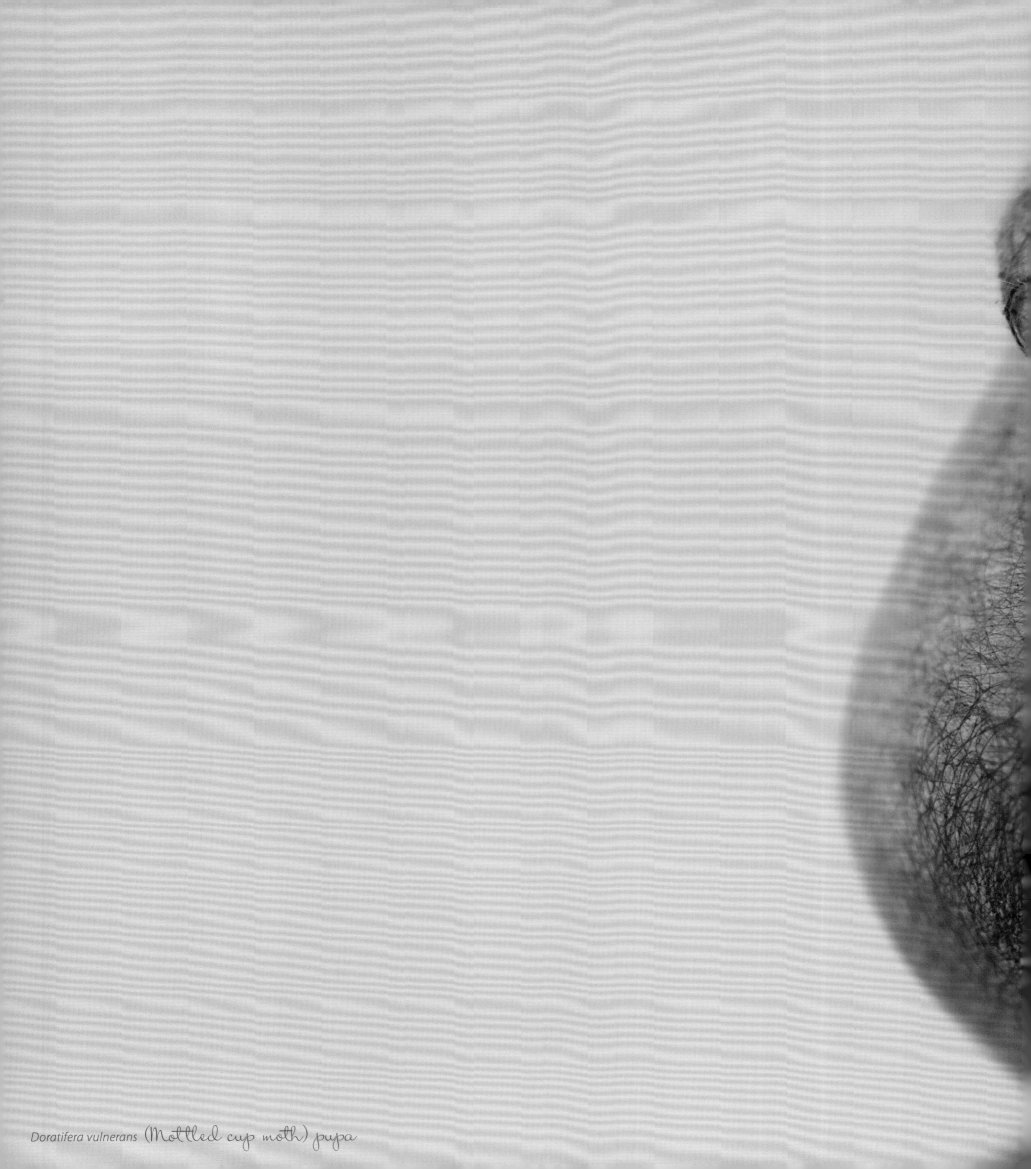

Doratifera vulnerans (Mottled cup moth) pupa

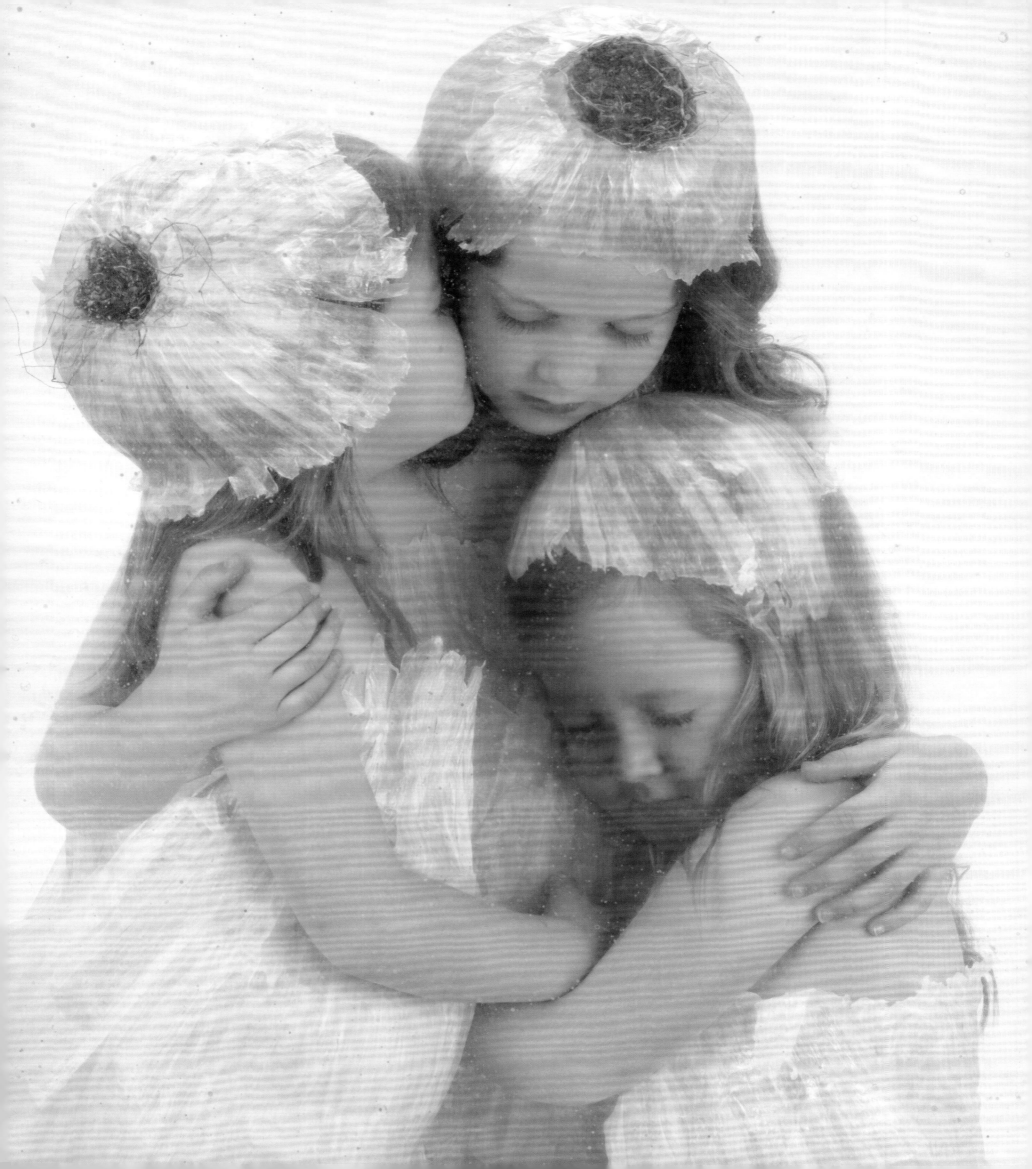

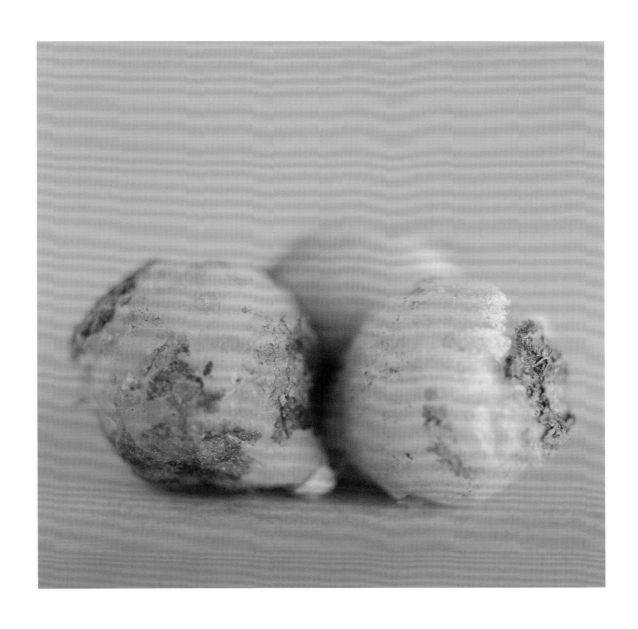

this page *Lachenalia aloides* (Soldier boy) bulbs opposite, sisters, L–R: Inès (7 years), Edith (9 years), Bunny (5 years)

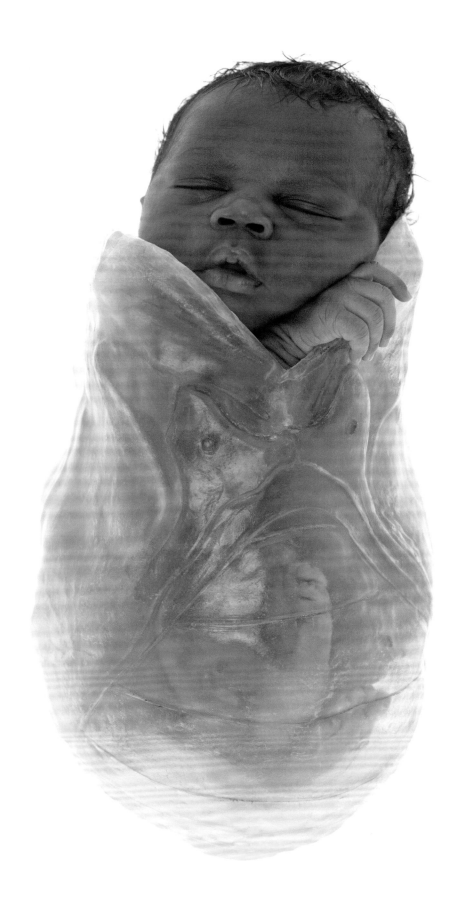

Anade (10 days)

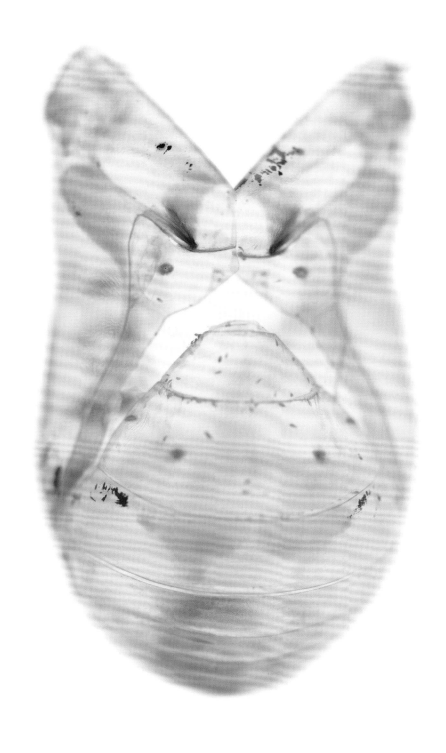

Euploea core (Common crow butterfly) exuvia

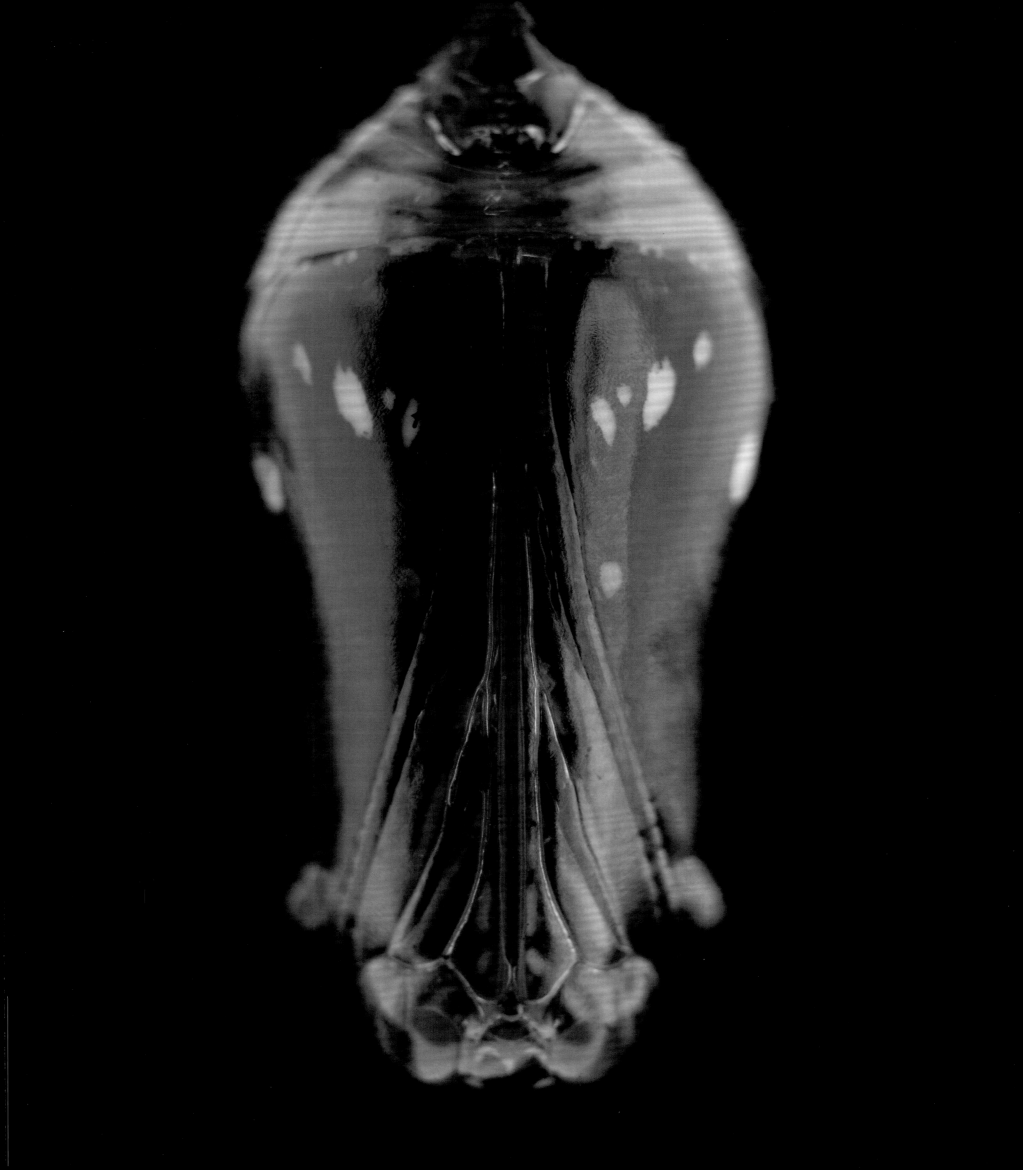

Euploea core (Common crow butterfly) pupa

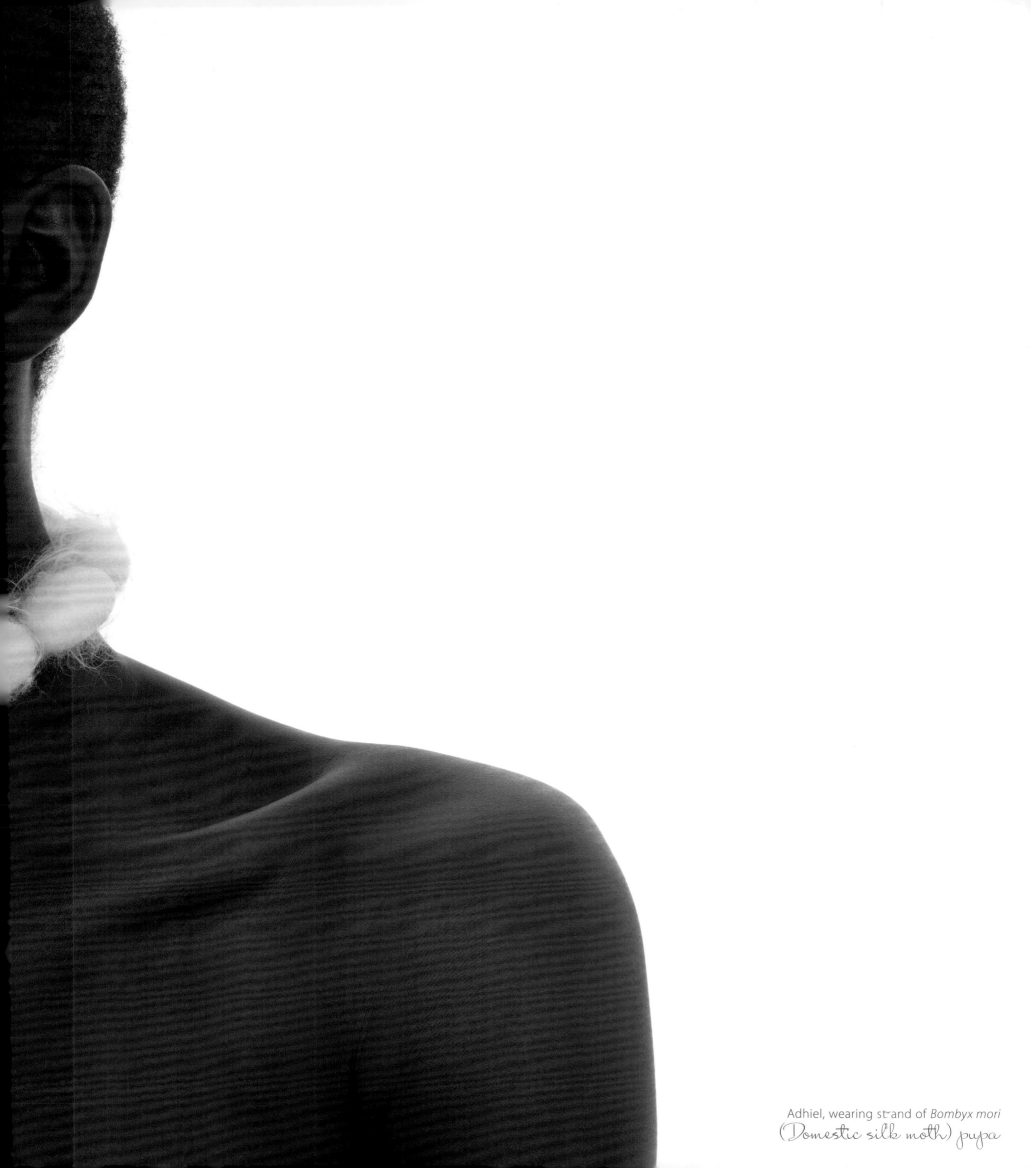

Adhiel, wearing strand of *Bombyx mori*
(Domestic silk moth) pupa

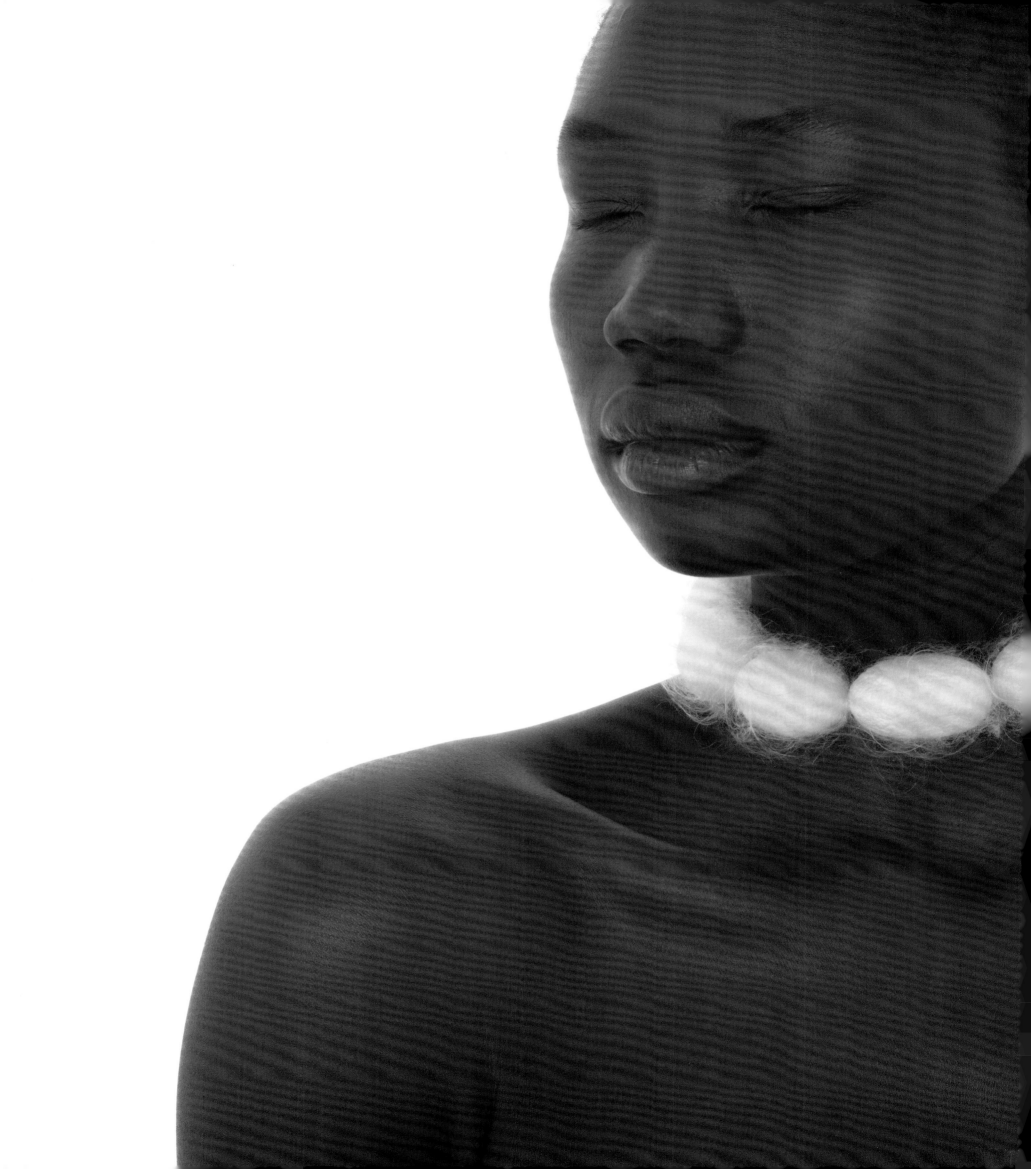

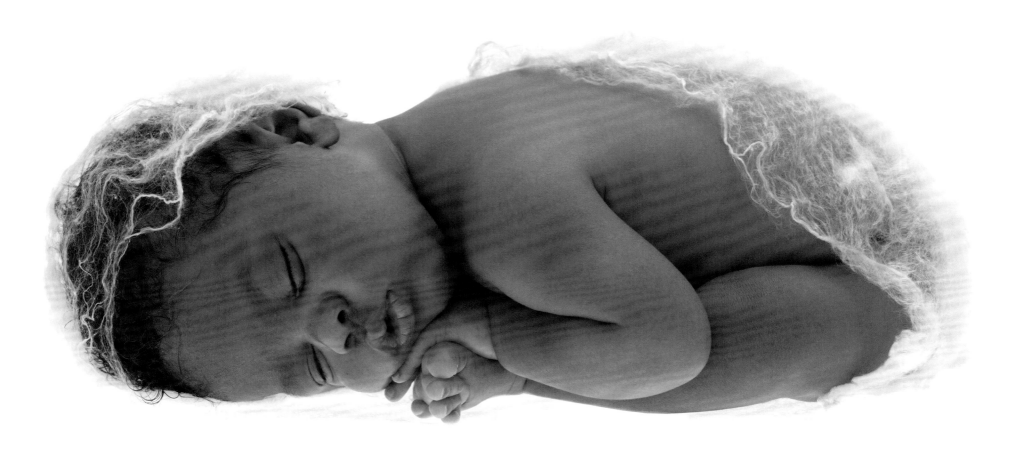

Ethan (4 weeks)

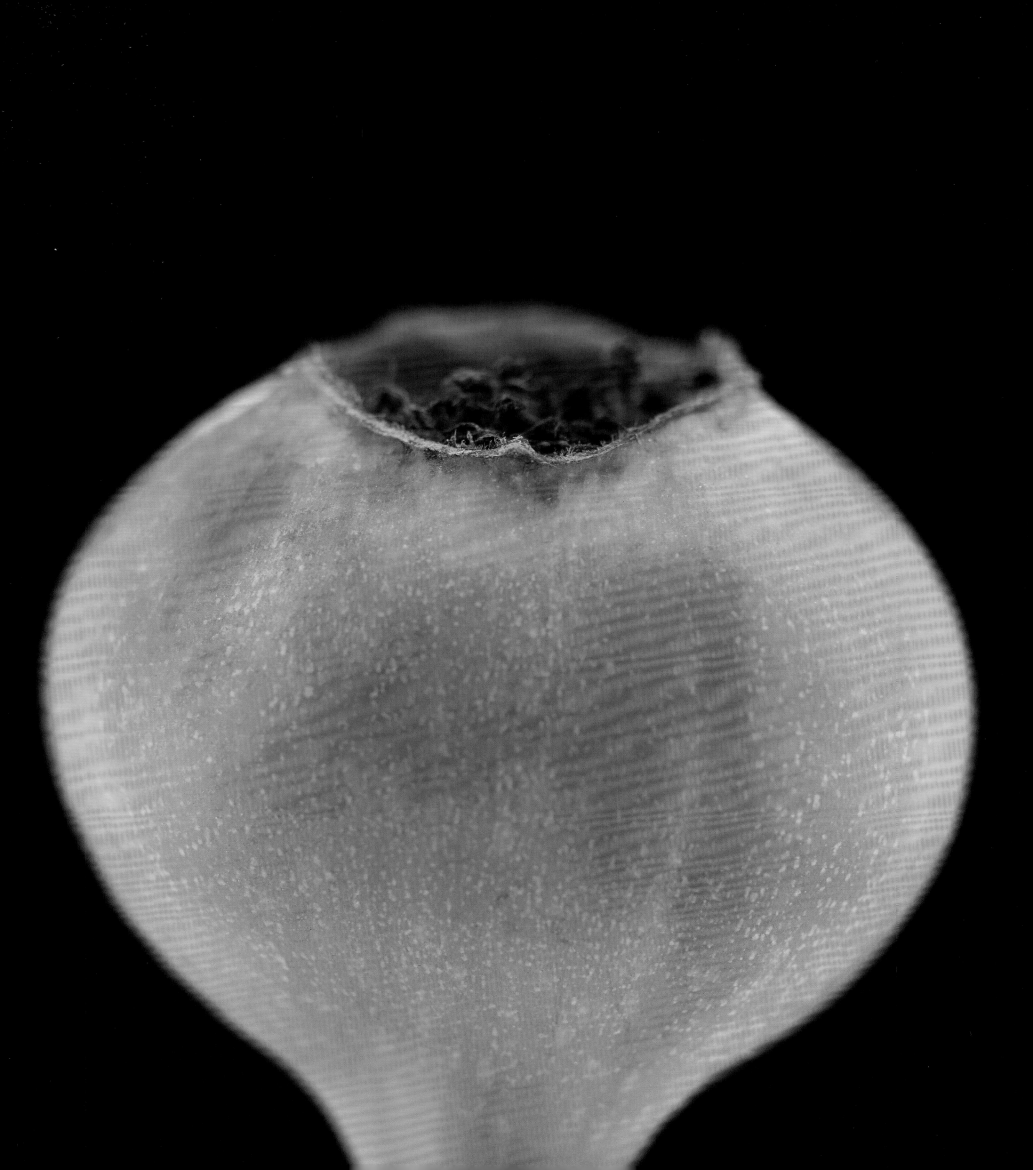

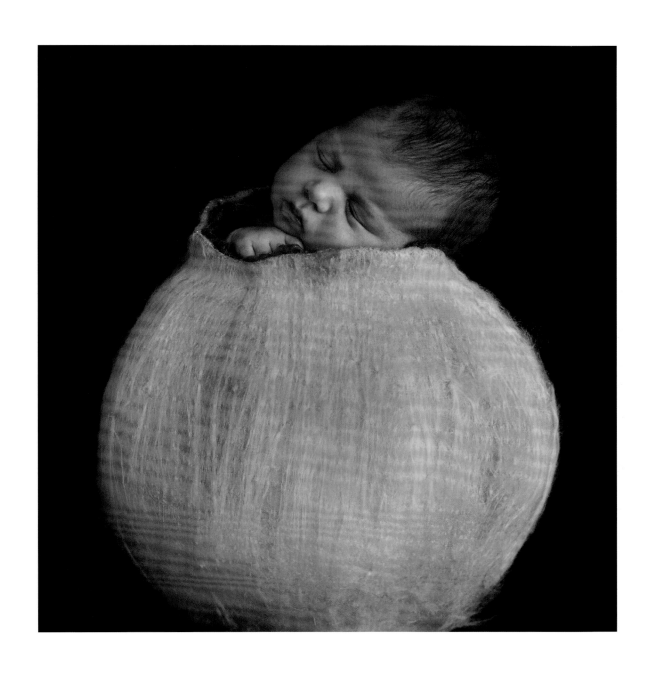

this page Pesalili-Star (8 days) opposite *Rosa canina* (Rosehip)

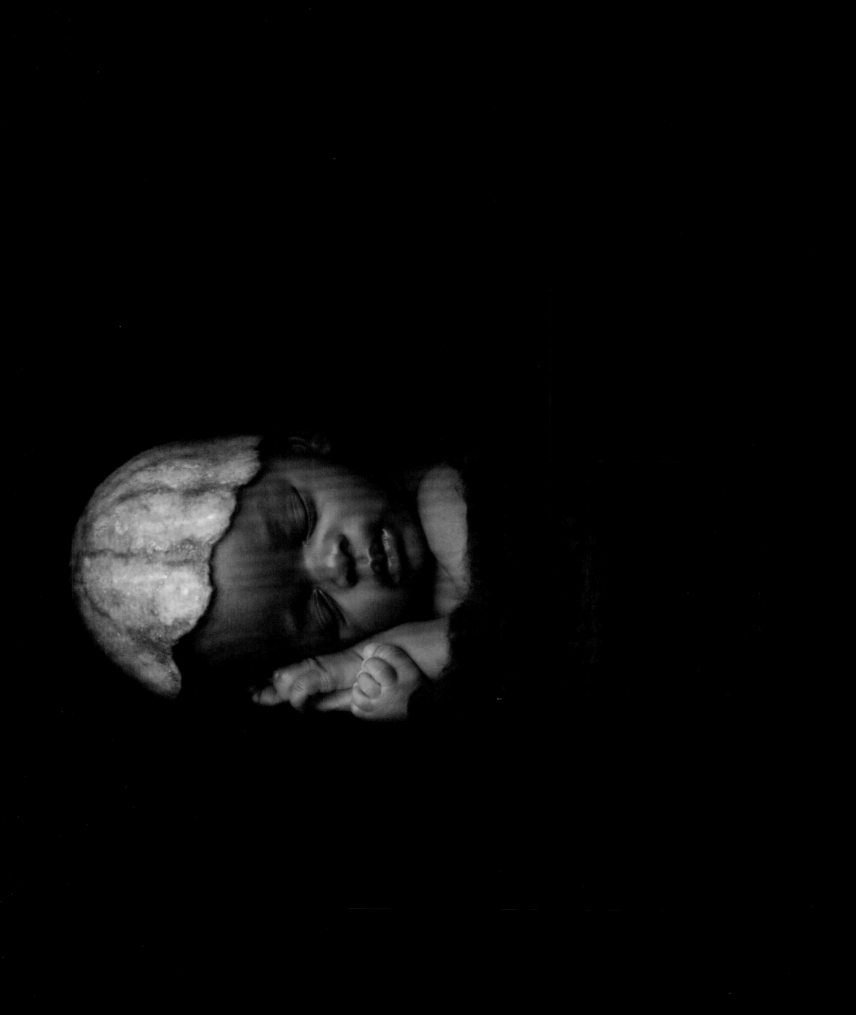

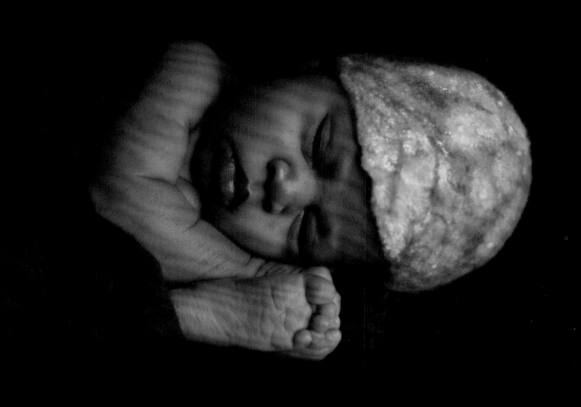

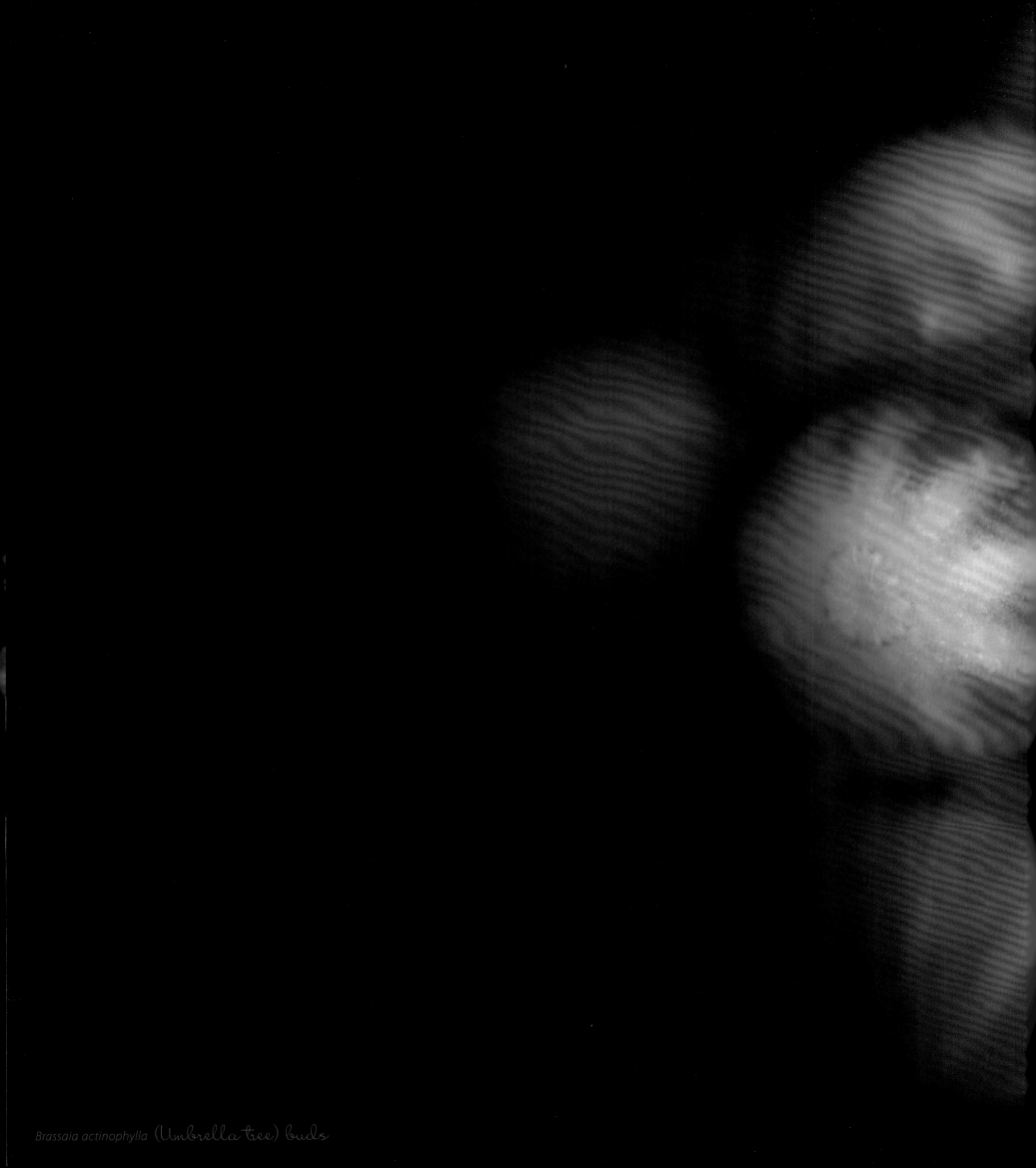

Brassaia actinophylla (Umbrella tree) buds

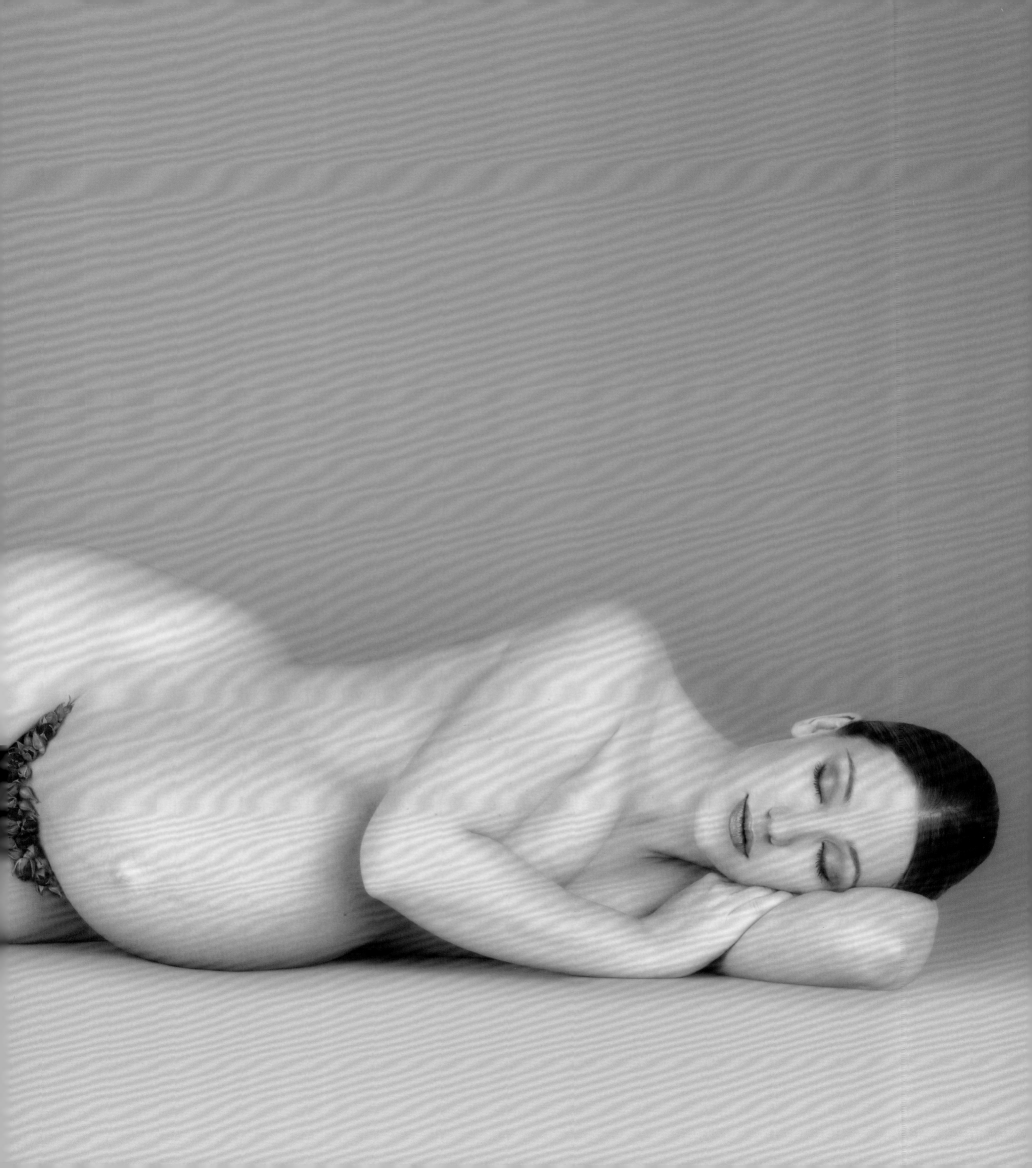

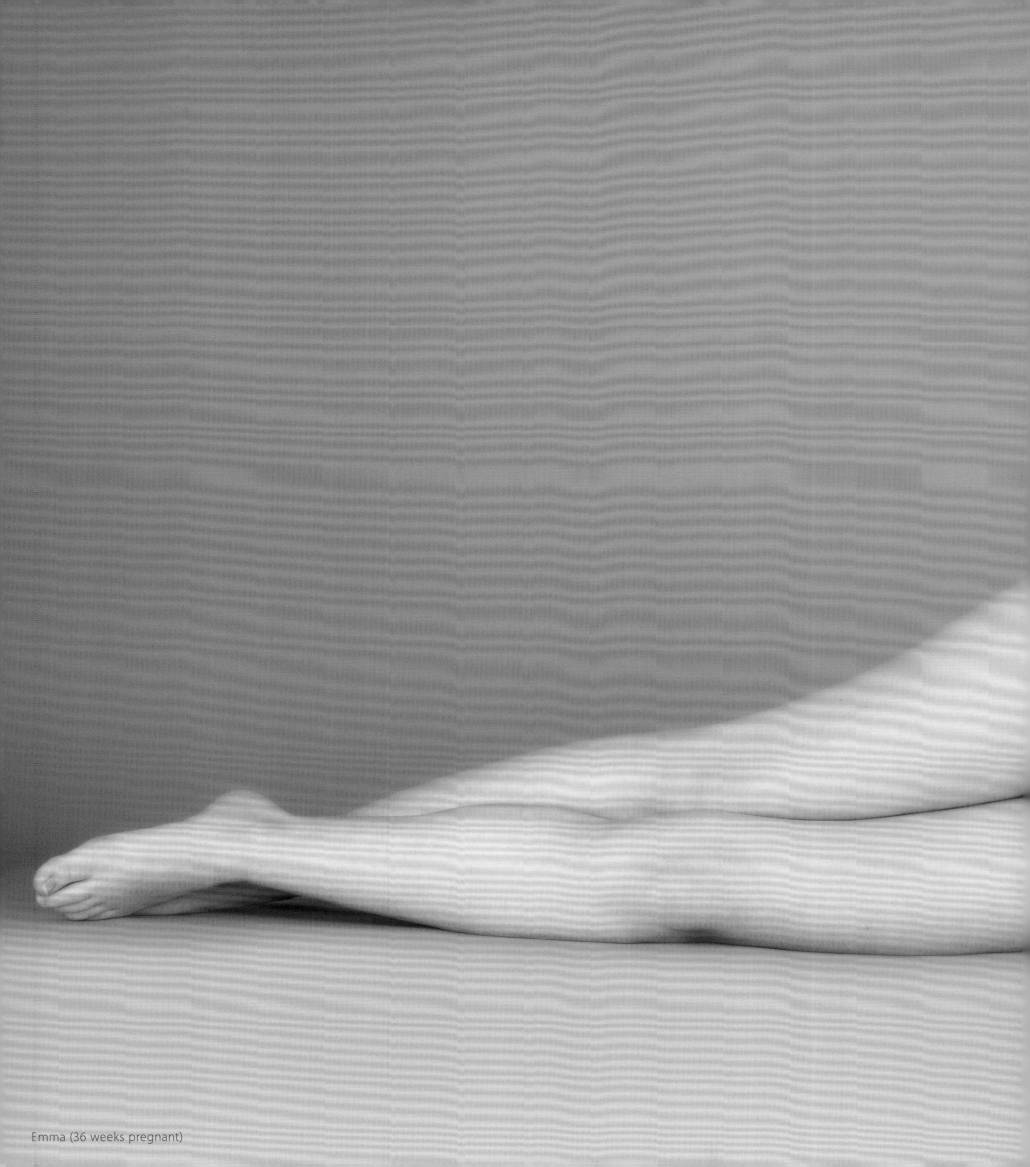

Emma (36 weeks pregnant)

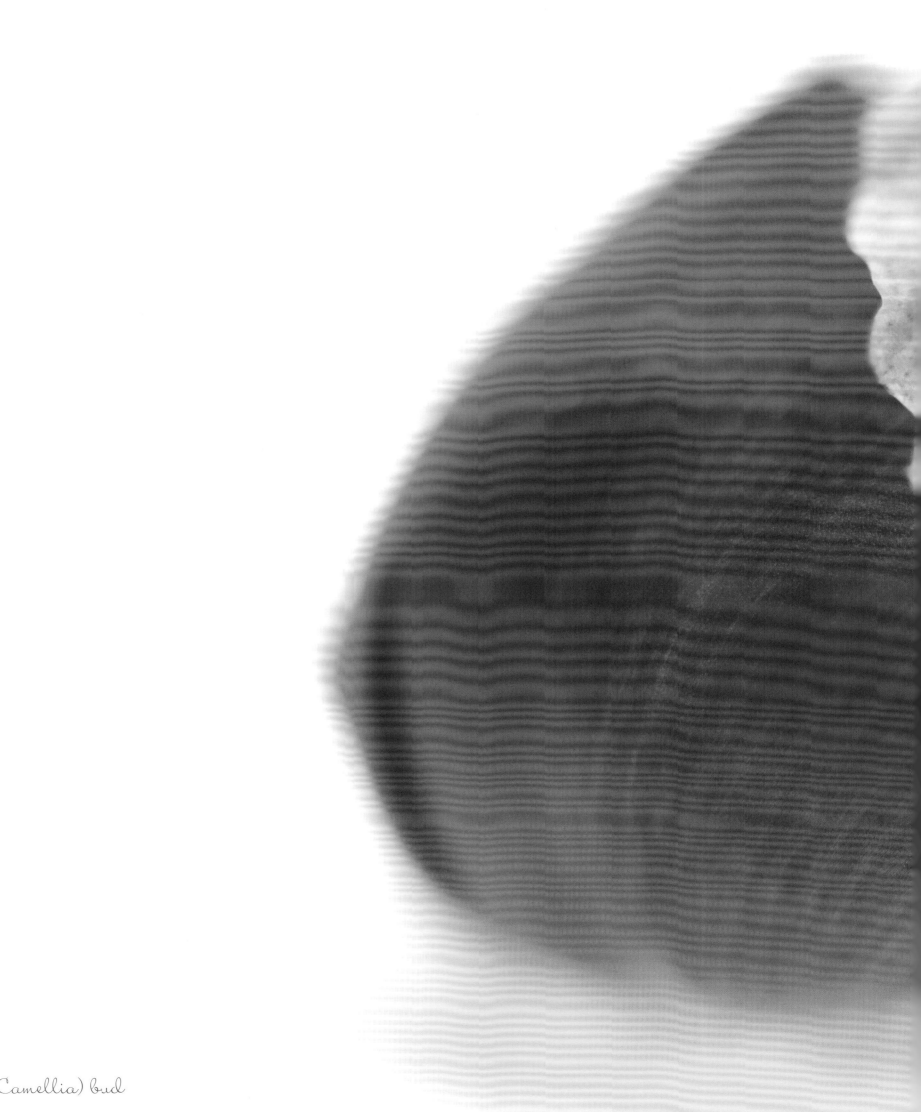

Camellia cv. (Camellia) bud

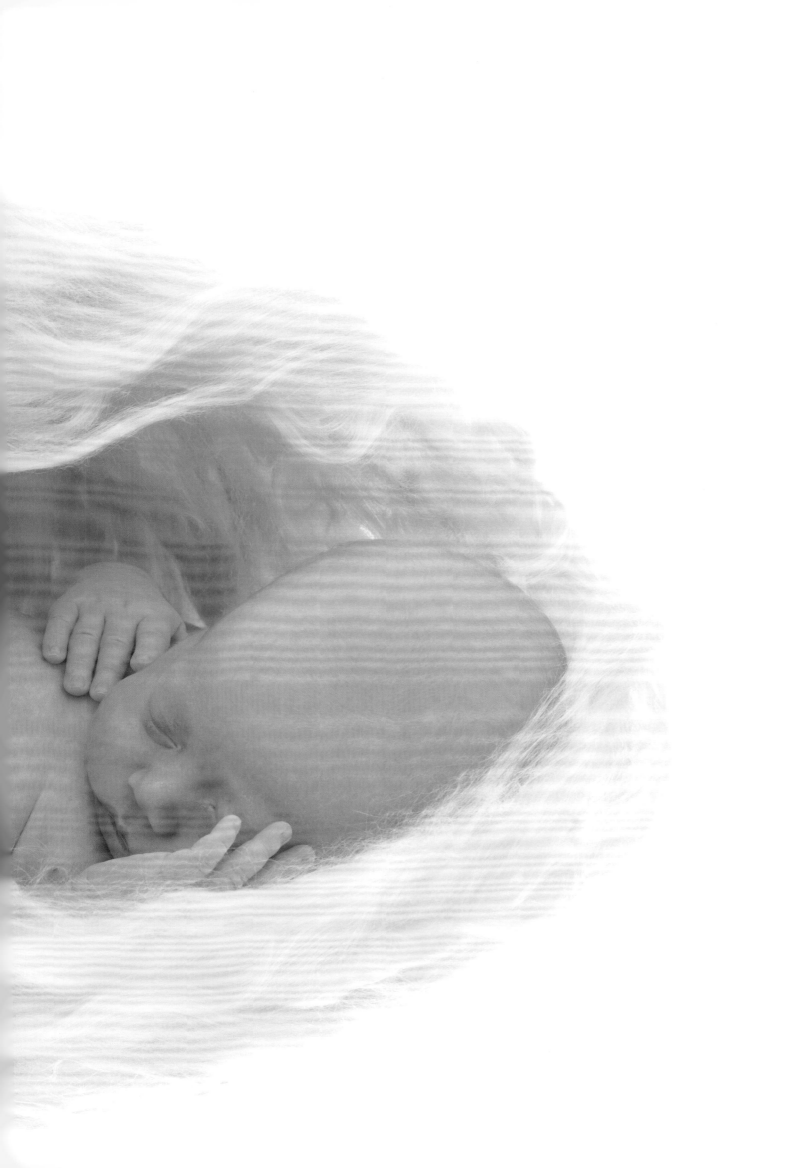

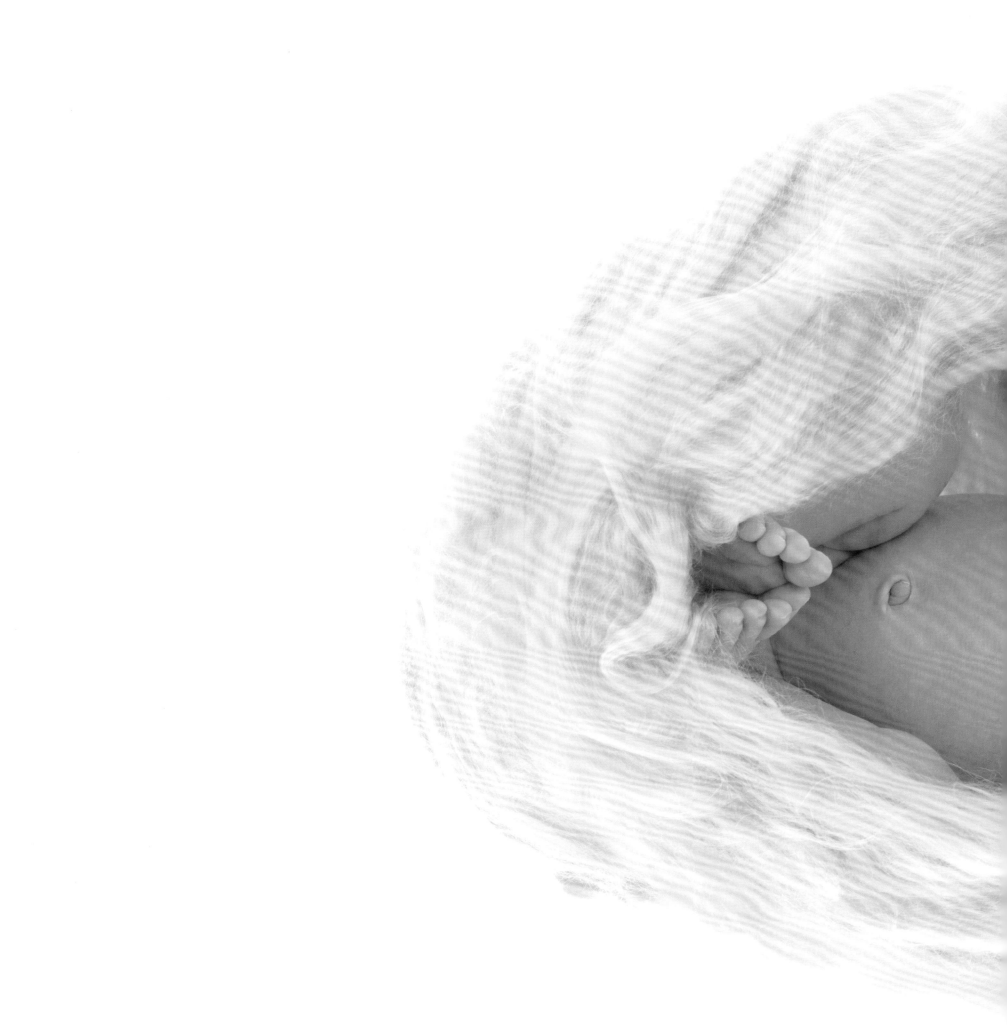

Poppy (2 weeks)

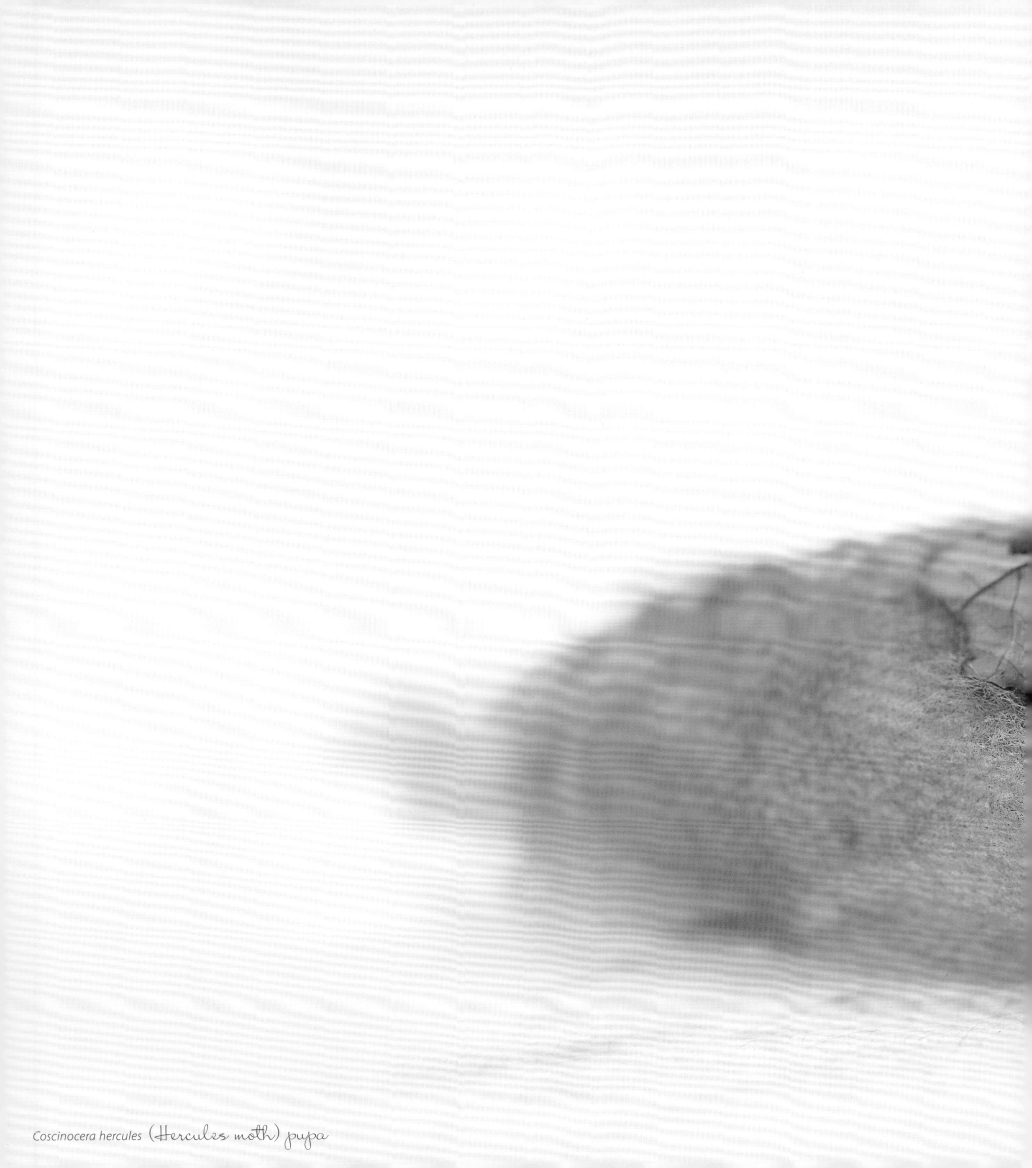

Coscinocera hercules (Hercules moth) pupa

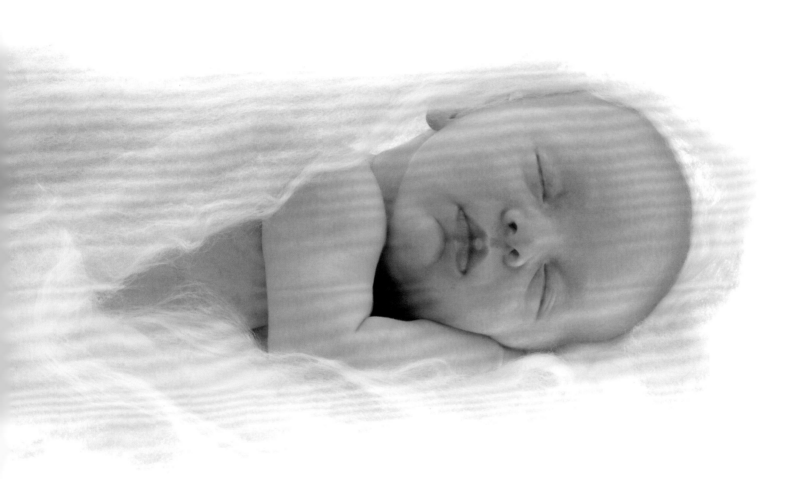

Nelson (3 weeks)

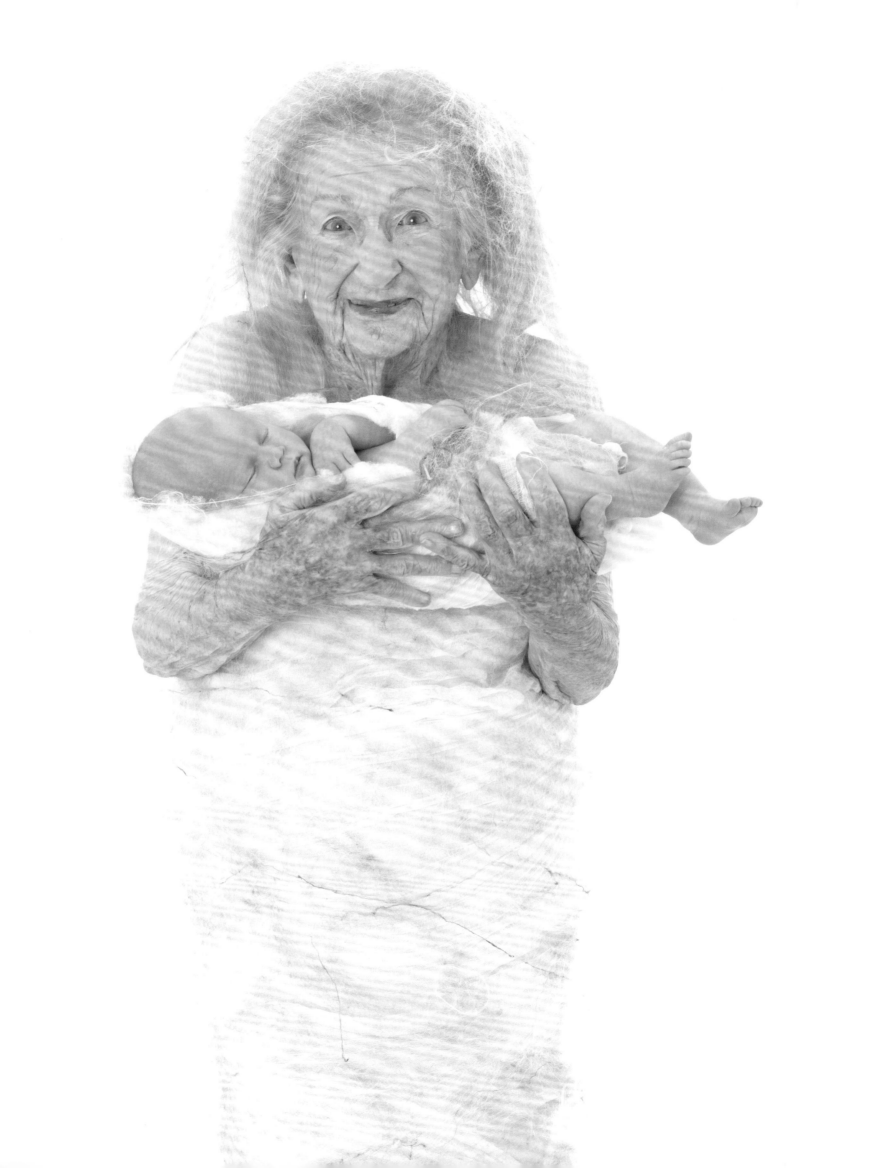

Violet (107 years) holding Ciara (3 weeks)

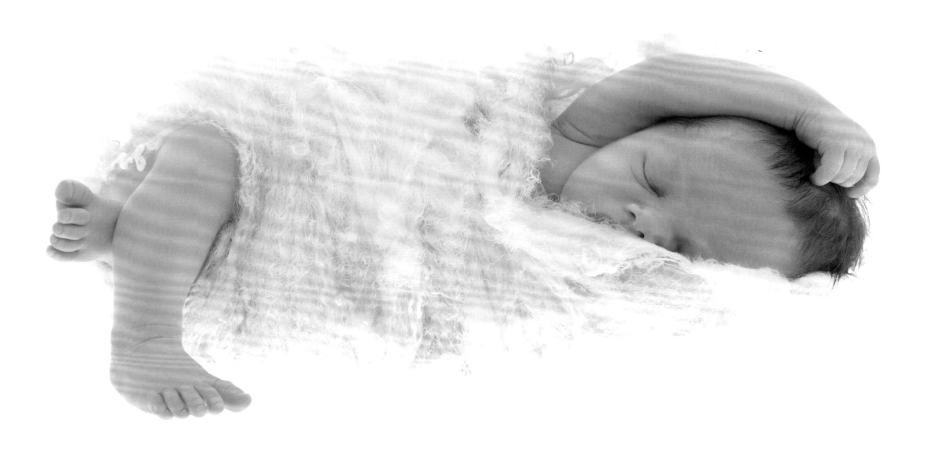

this page *Coscinocera hercules* (Hercules moth) *pupa* opposite Lael (1 week)

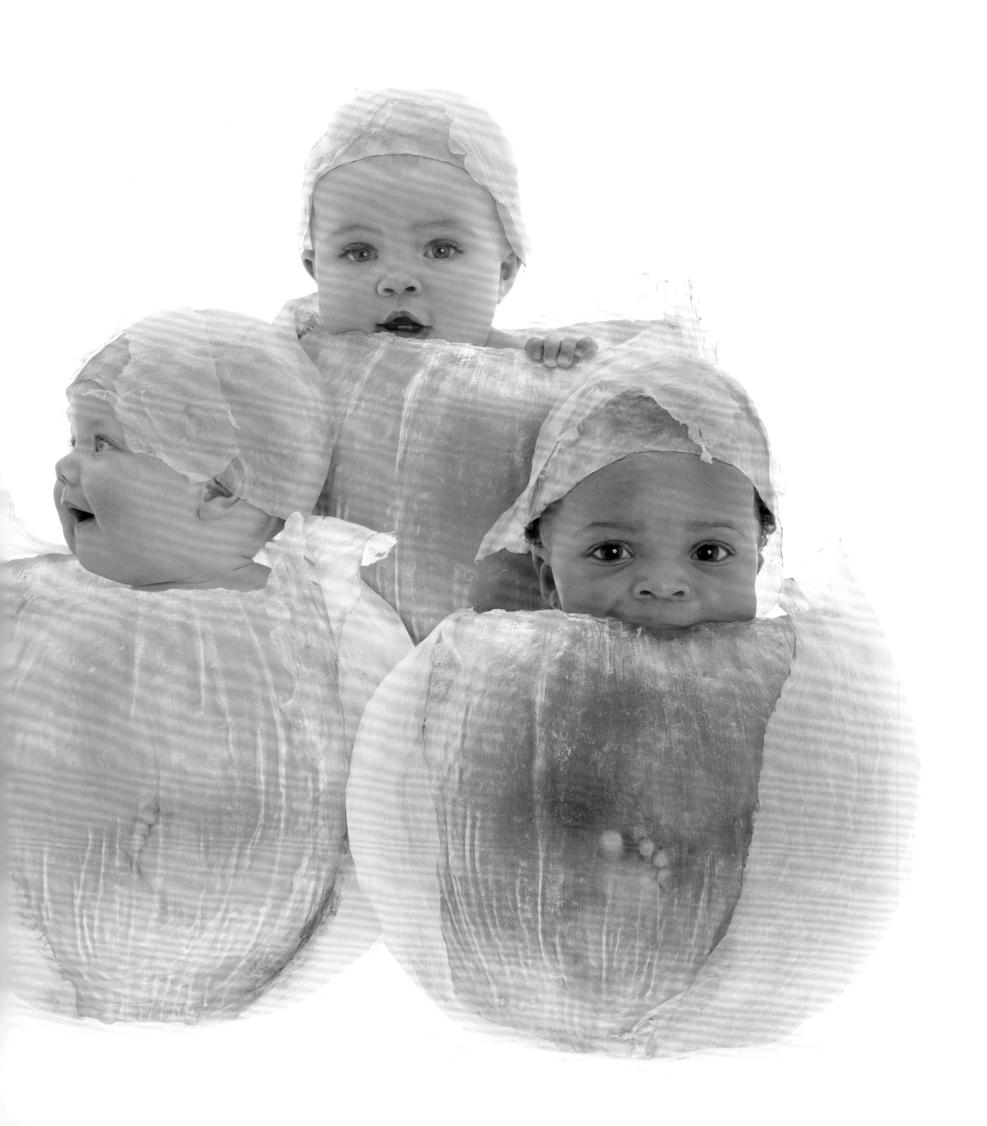

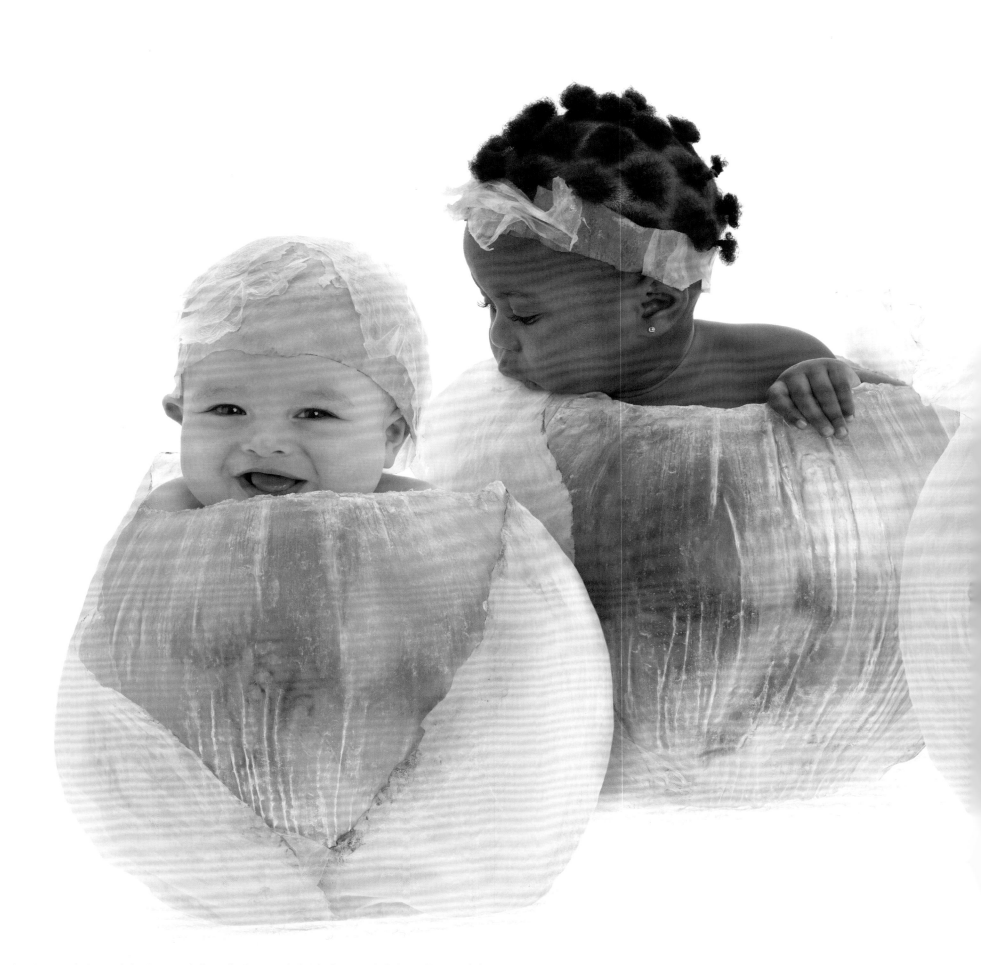

L–R: Kahu (6 months), Cordelia (8 months), Holly (7 months), Isla (7 months), Jane (6 months)

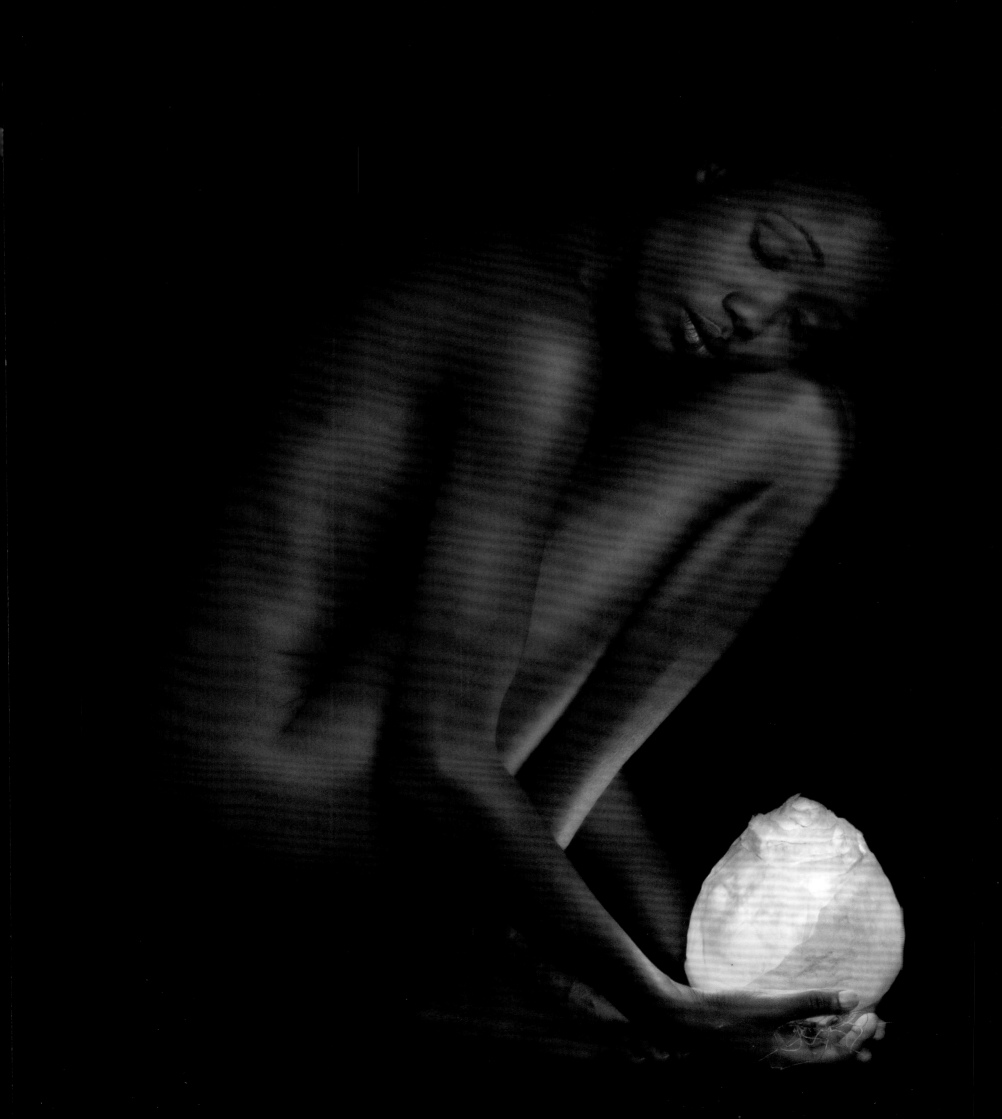

Tina

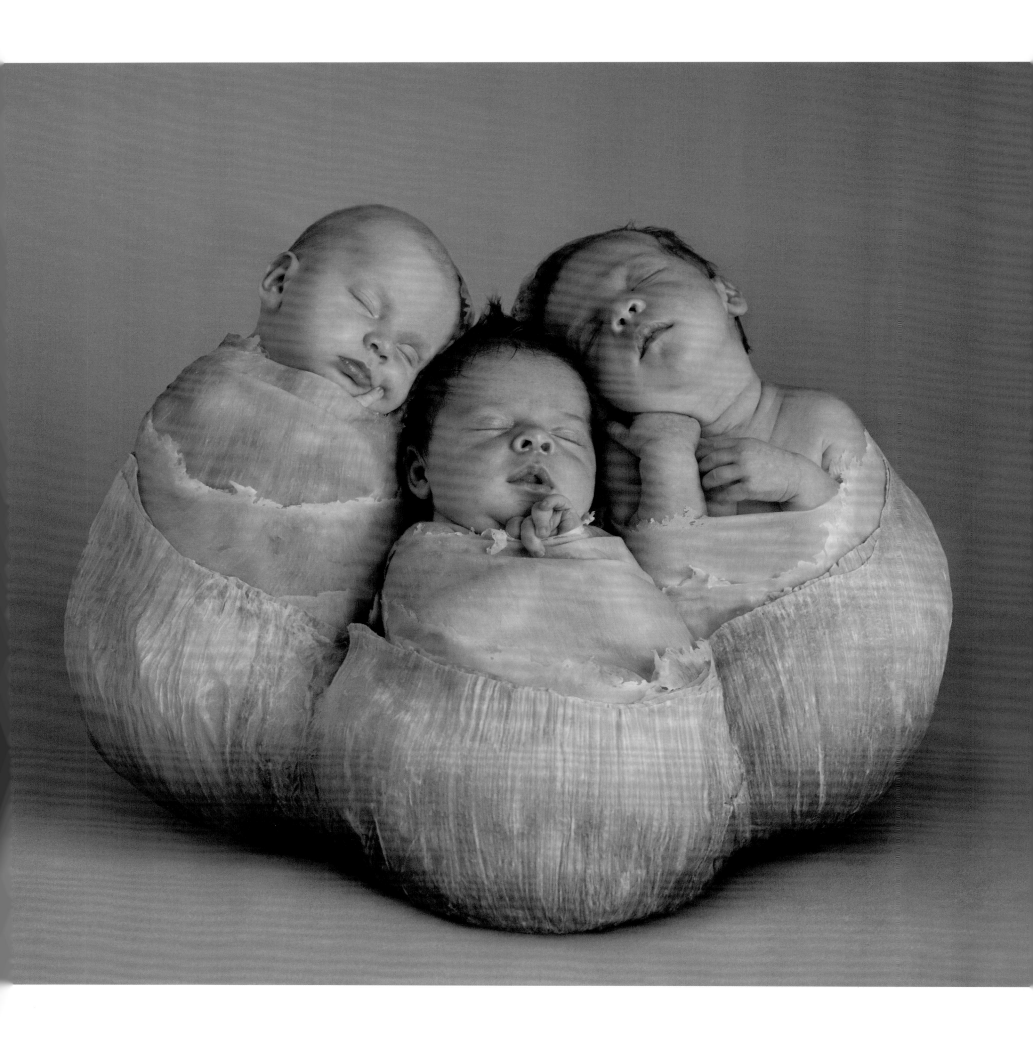

L–R: Taylor (4 weeks), Evy (2 weeks), Willow (3 weeks)

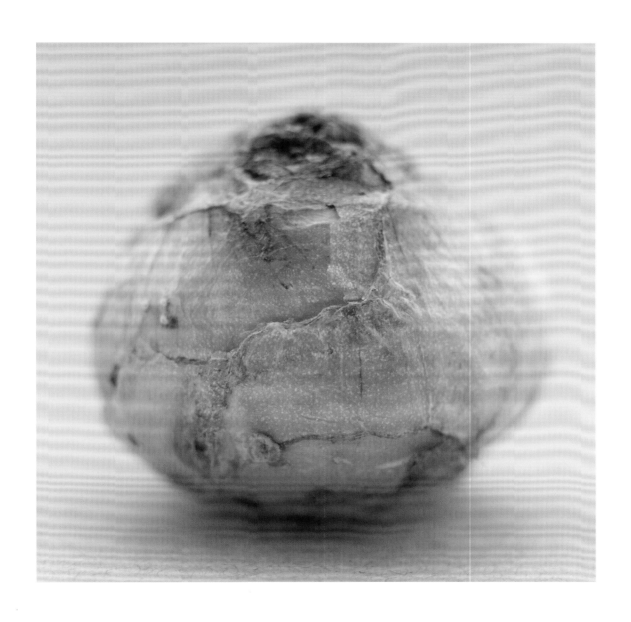

Ornithogalum sp. (Ornithogalum) *bulb*

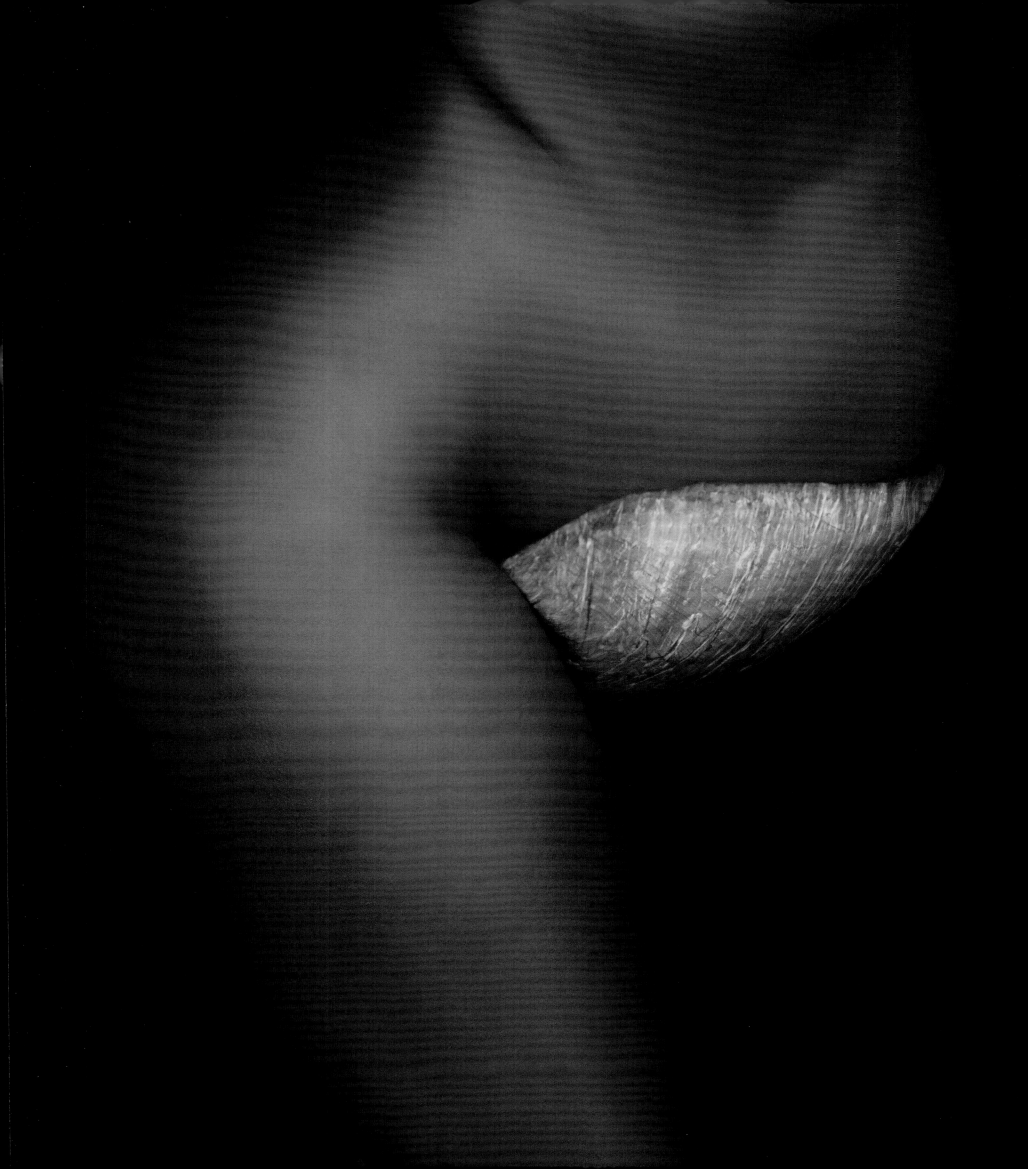

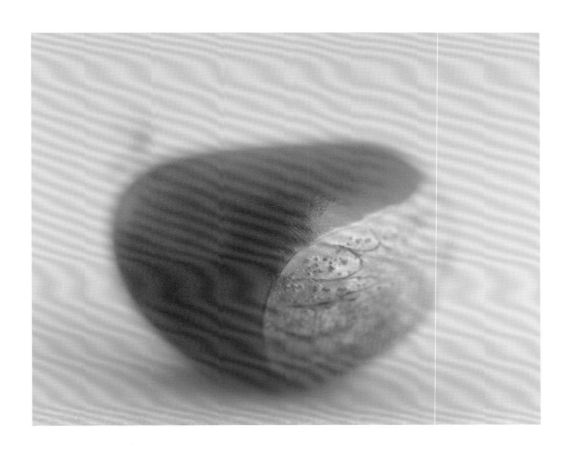

this page *Castanea sativa* (Chestnut) opposite Imme (36 weeks pregnant)

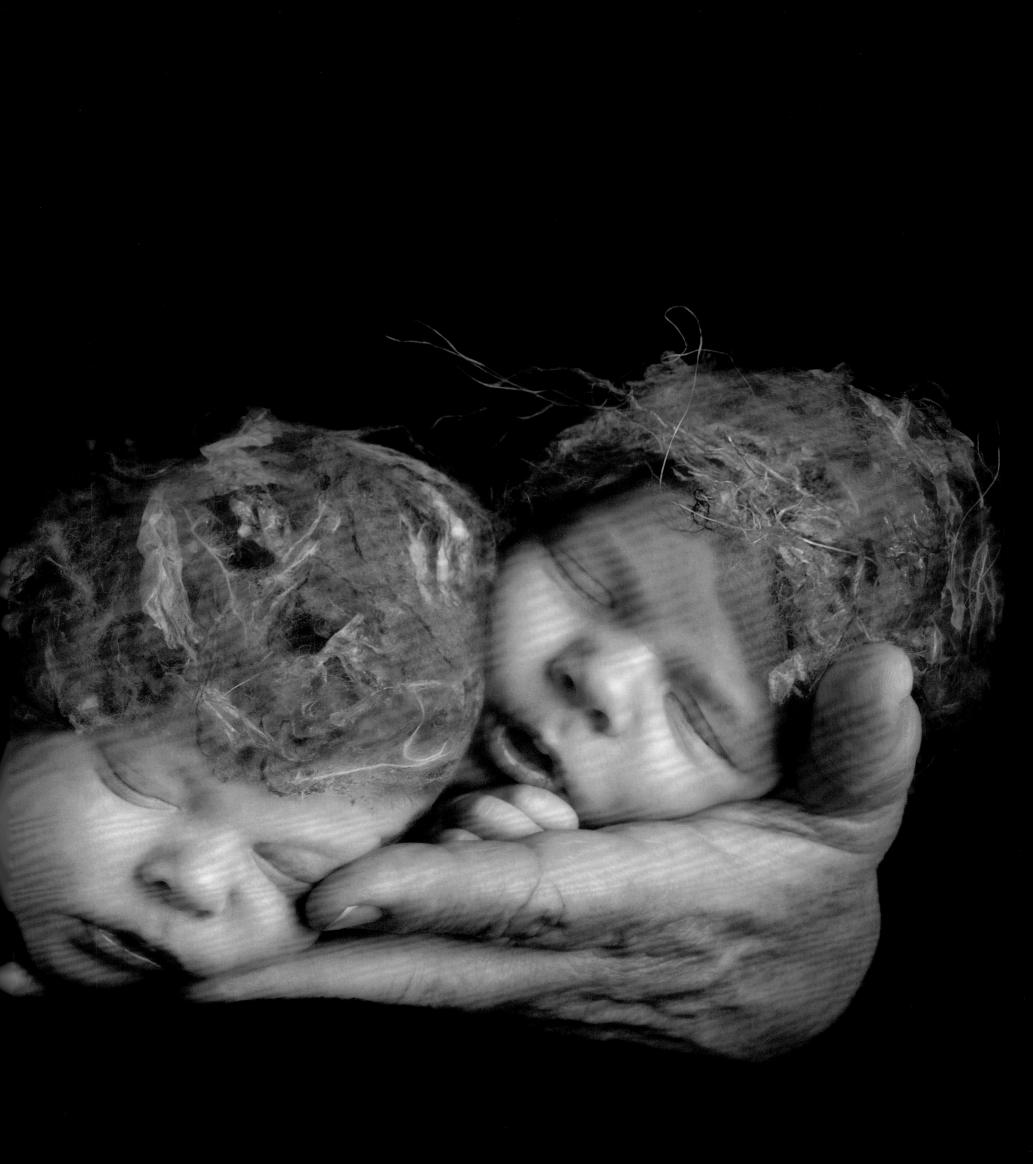

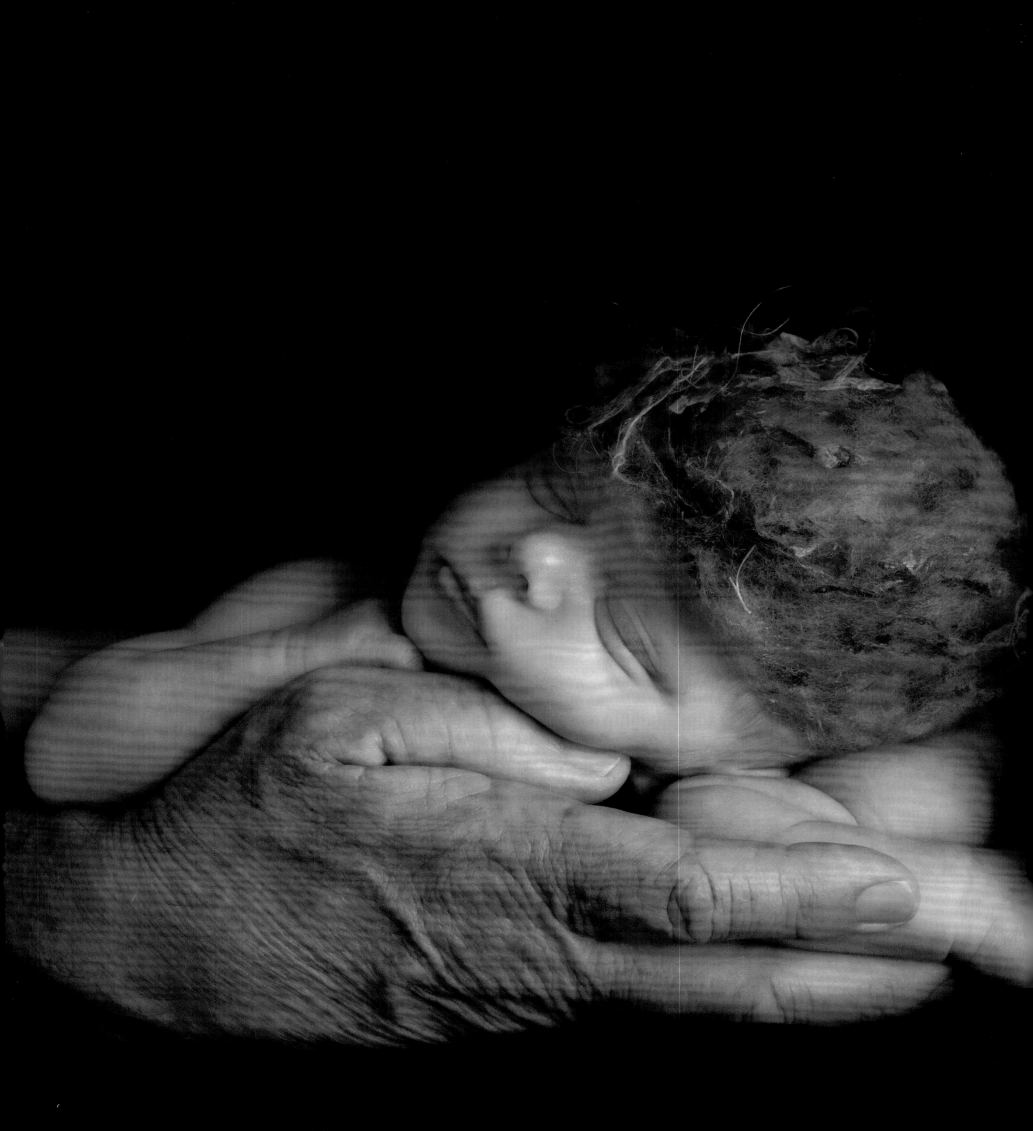

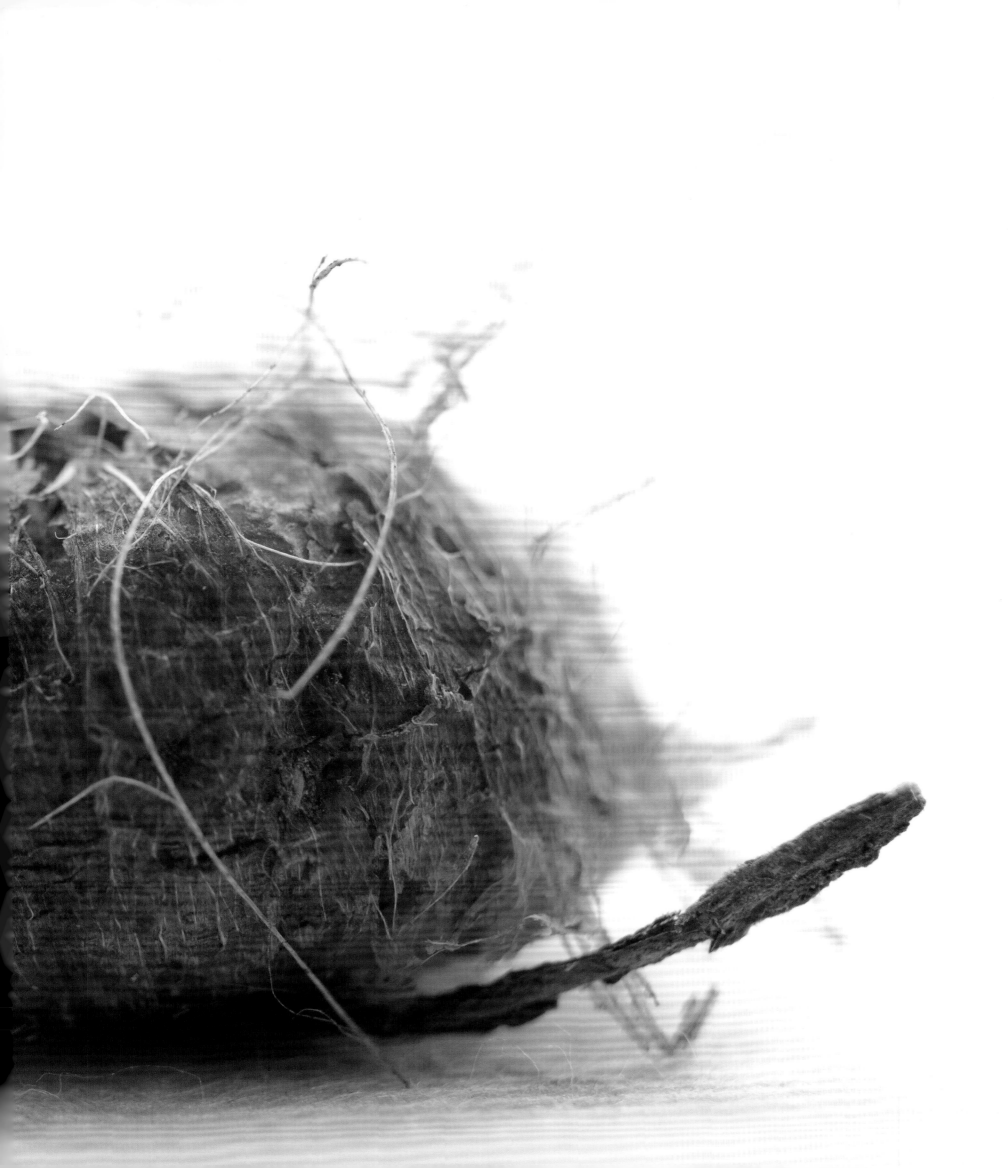

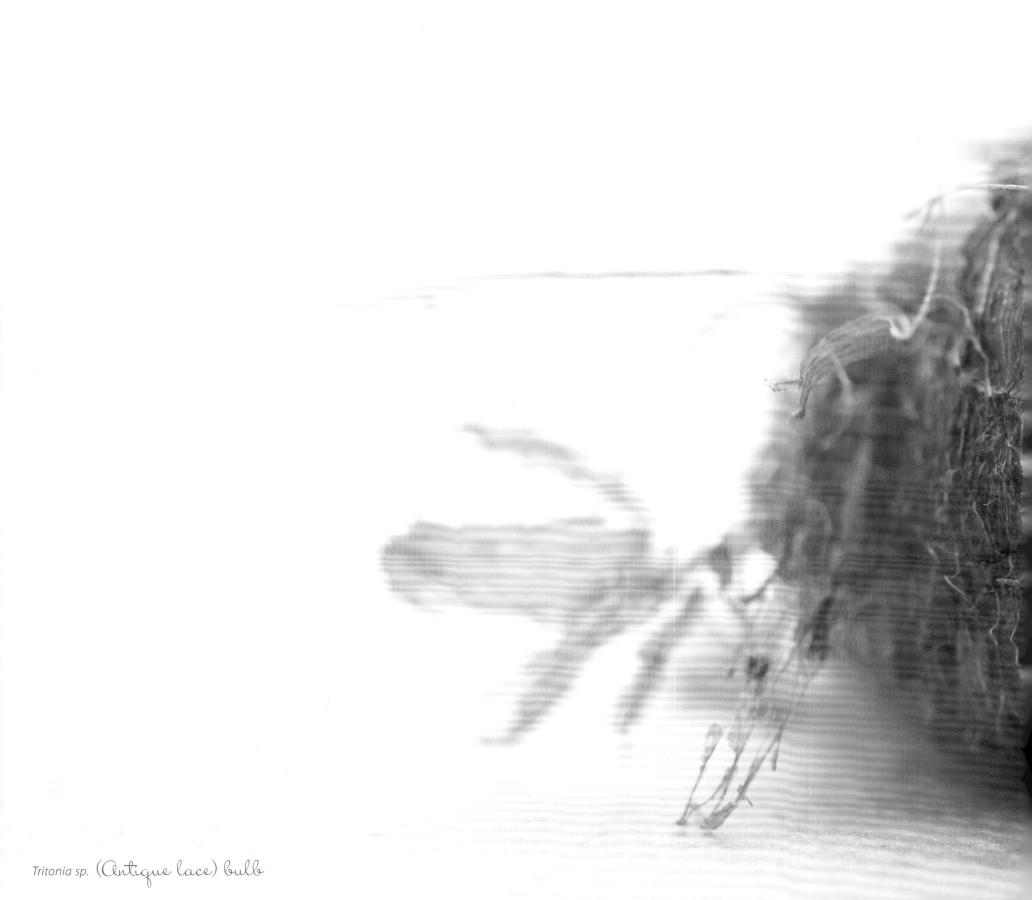

Tritonia sp. (Antique lace) bulb

Plumeria rubra (Frangipani)

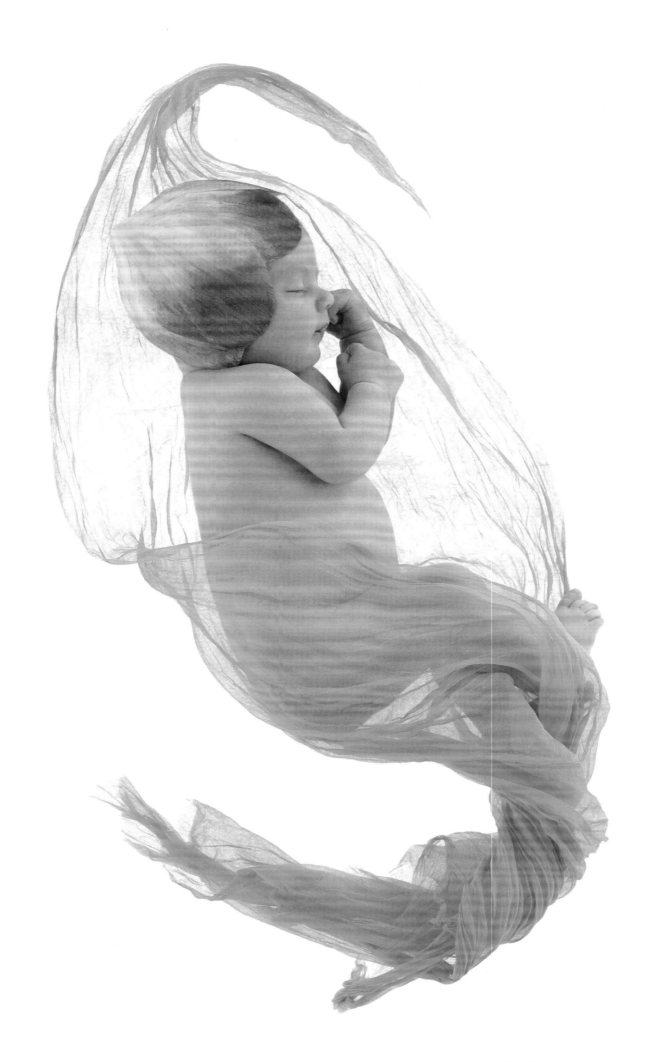

this page Harper (4 weeks) opposite *Freesia refracta* (Freesia) bud

Iris x xiphium (Dutch iris) bud

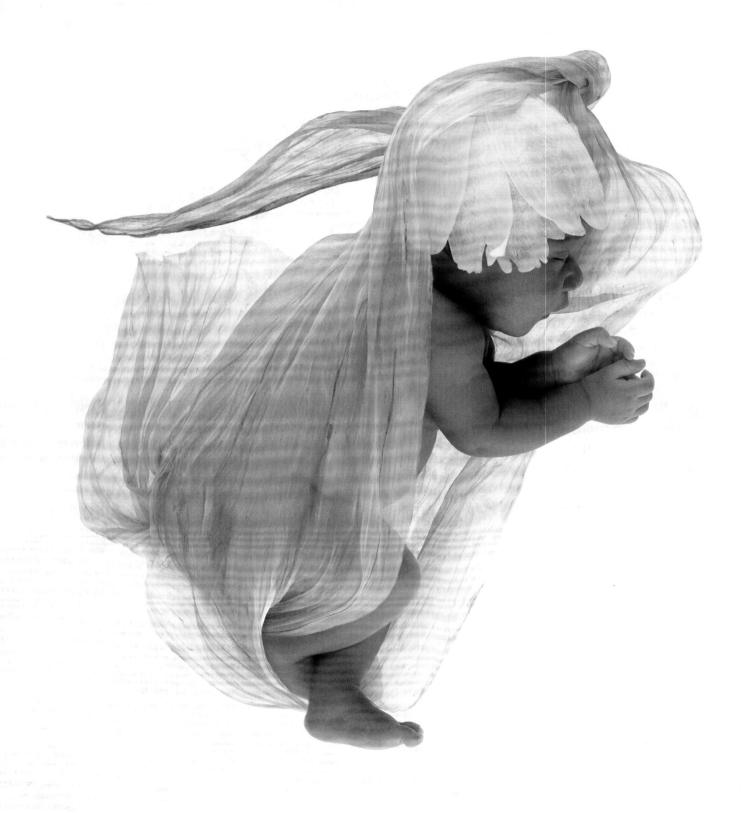

this page Esther (3 weeks) opposite *Narcissus cv.* (Daffodil) bud

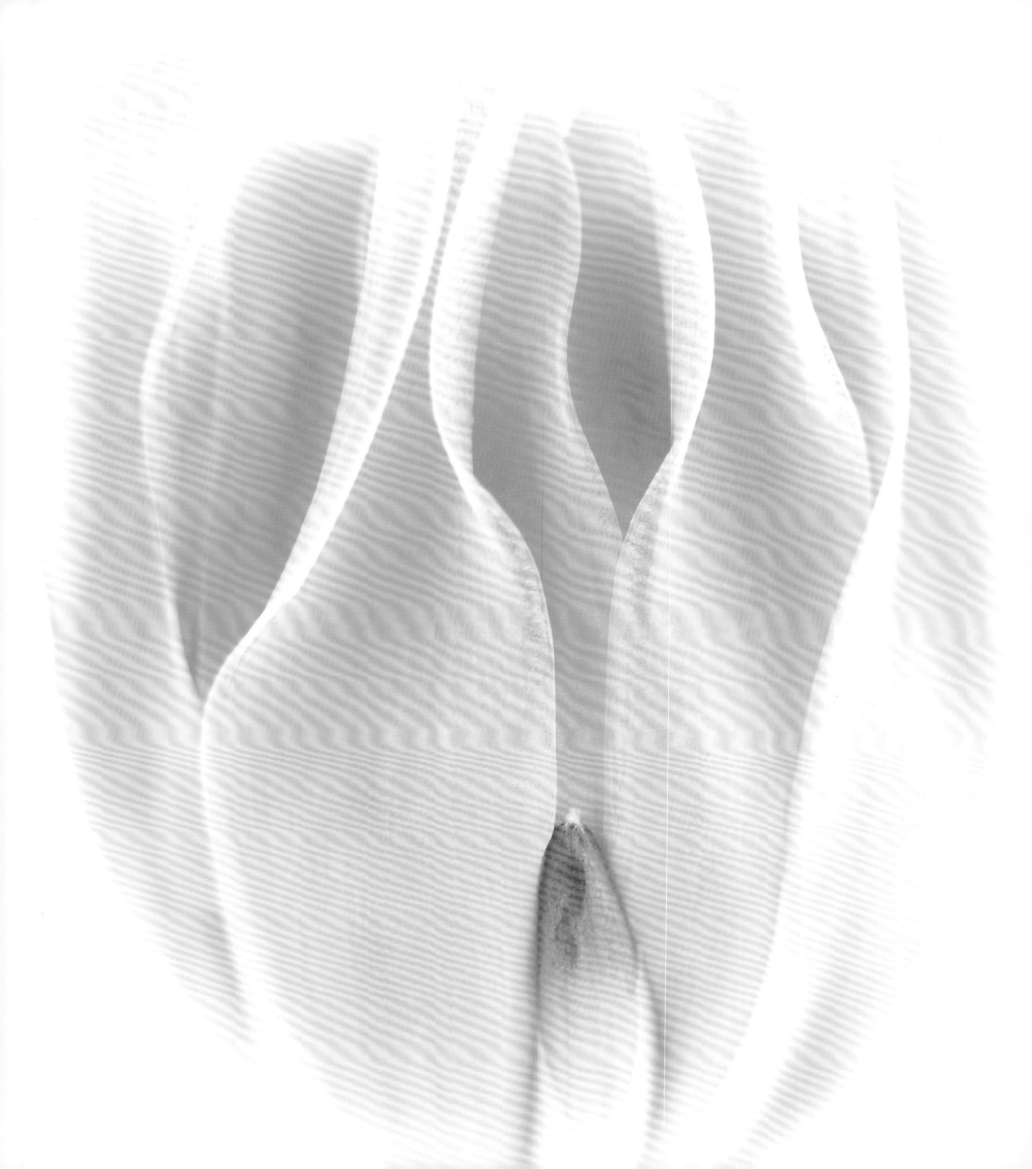

Rosa cv. (David Austin rose) bud

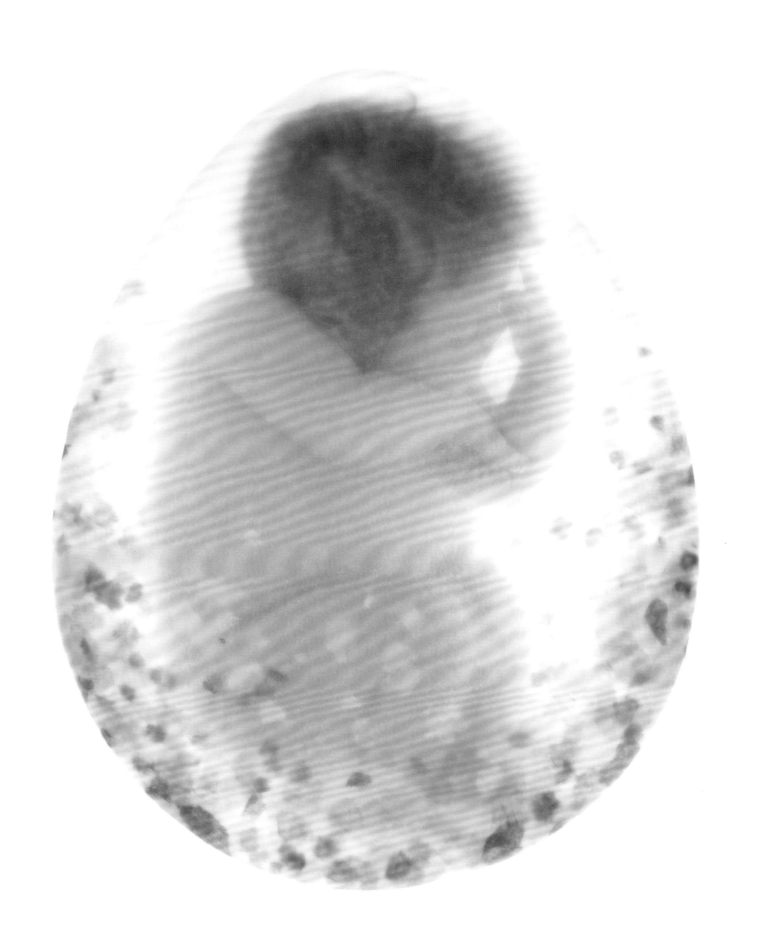

Daniel (4 weeks)

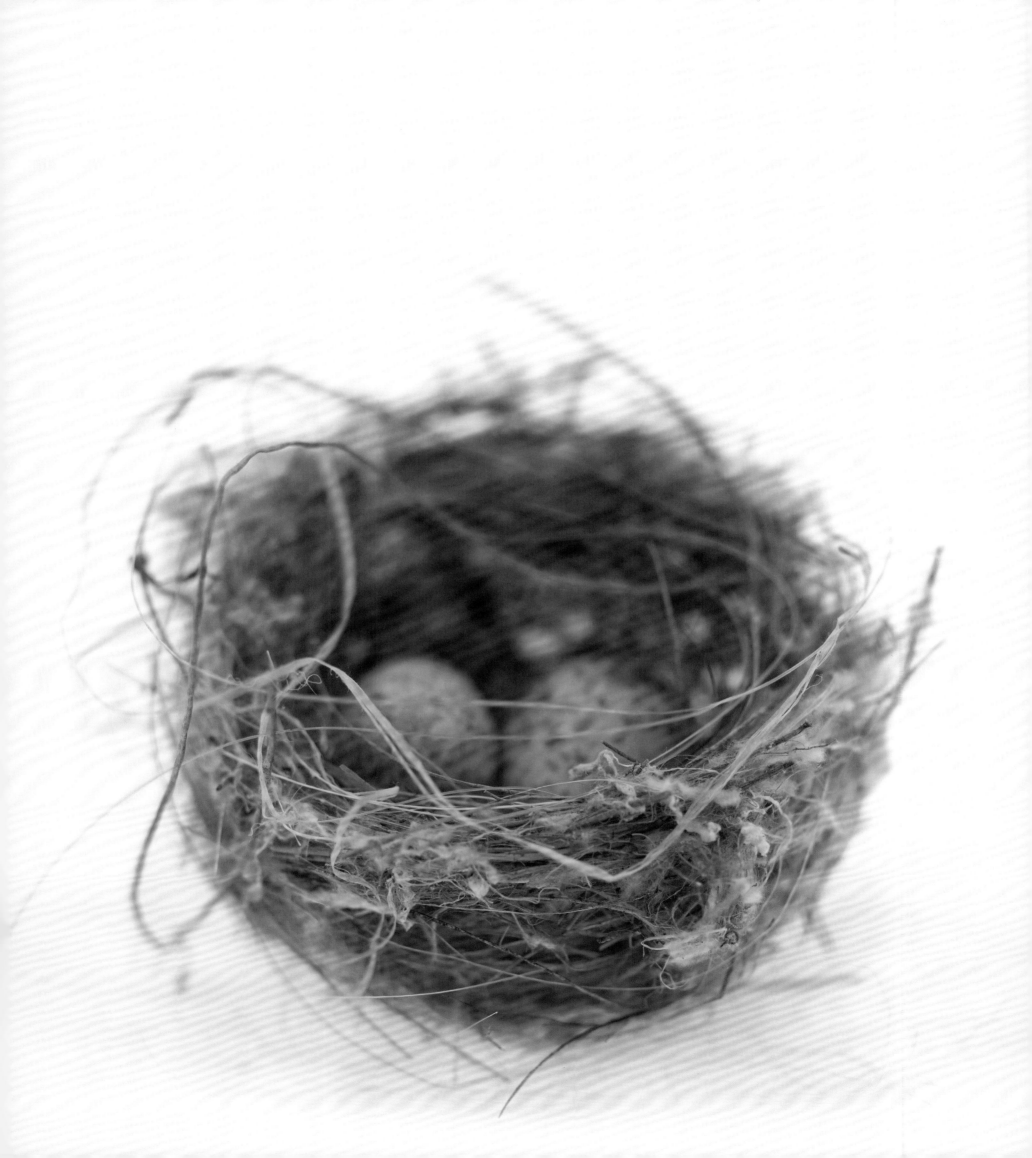

Meliphagidae (Honeyeater) nest

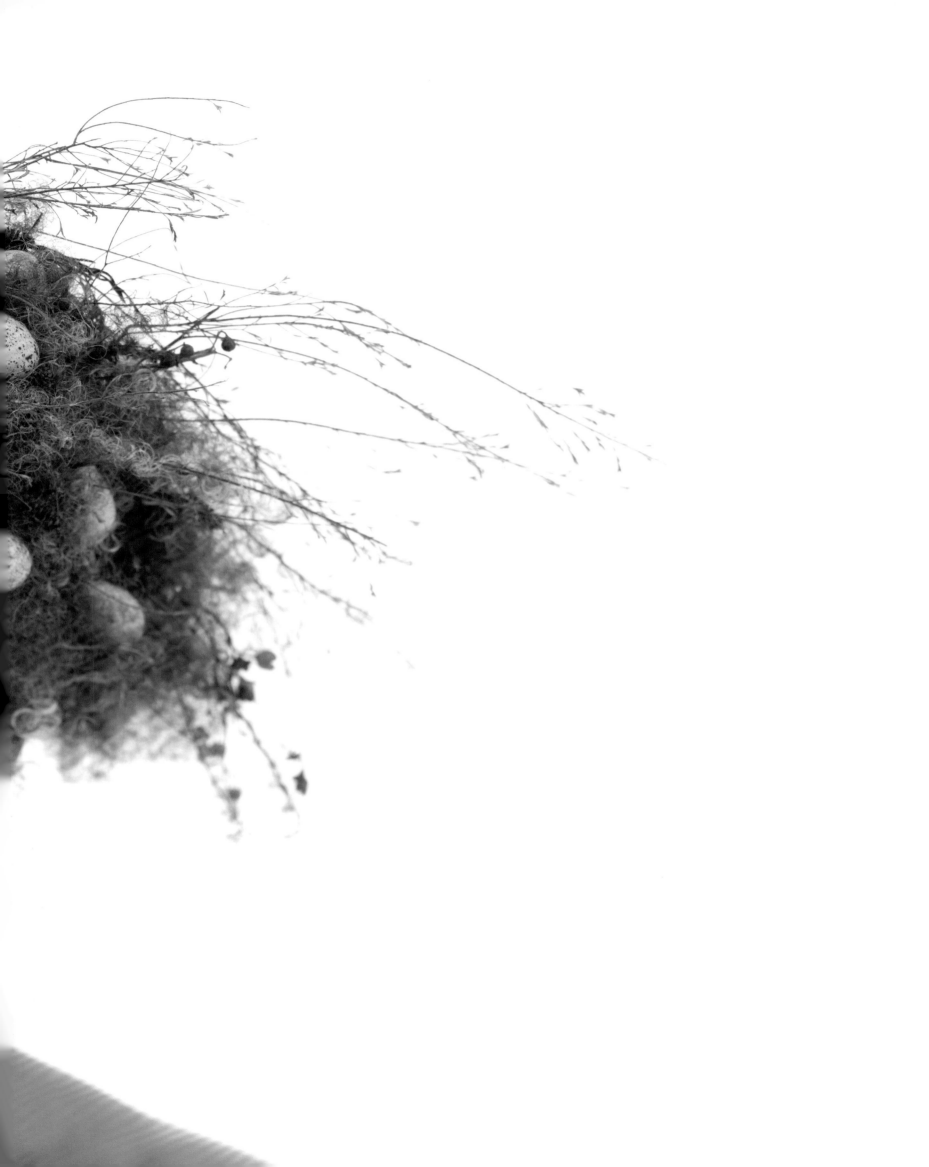

Valerie

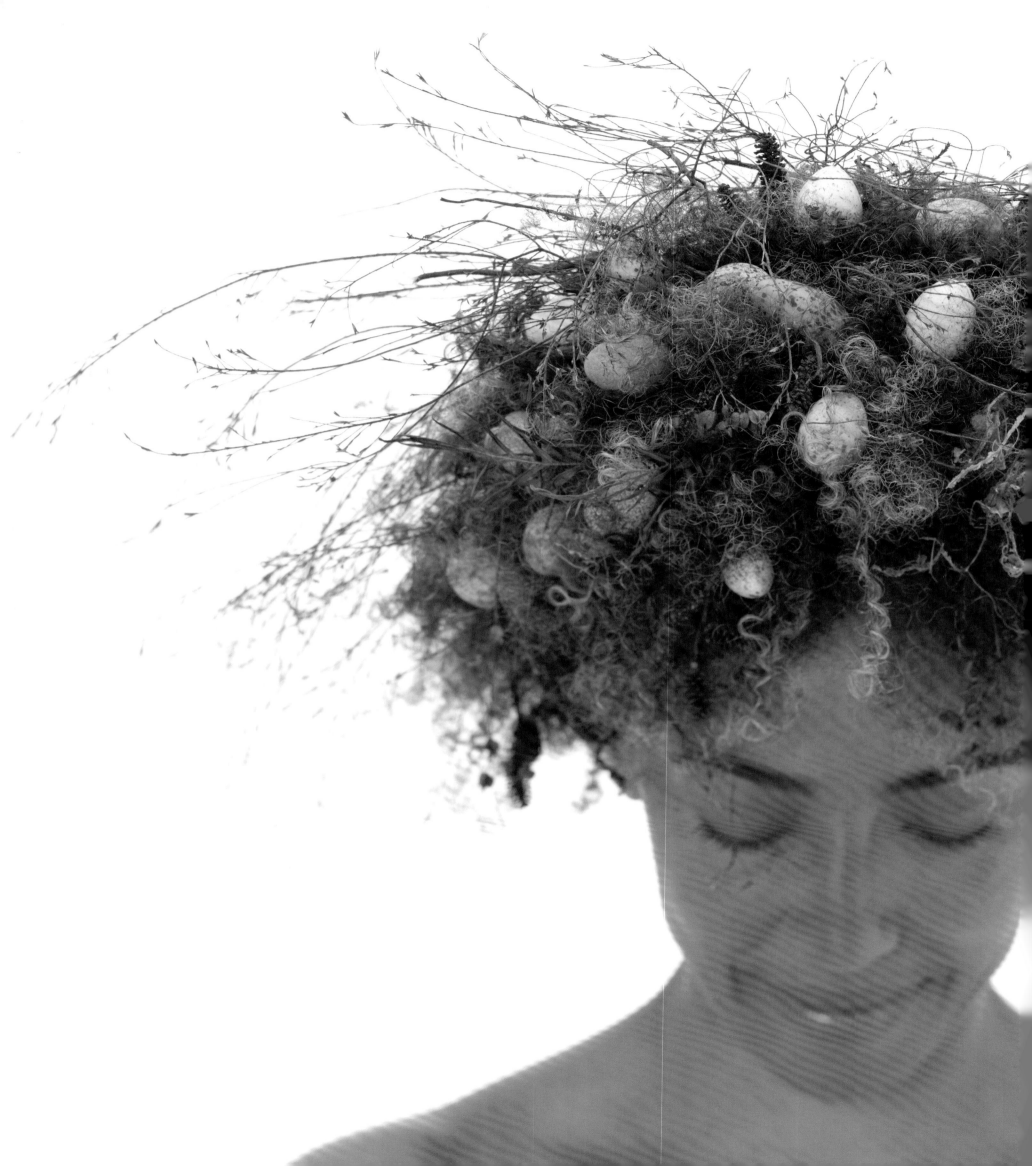

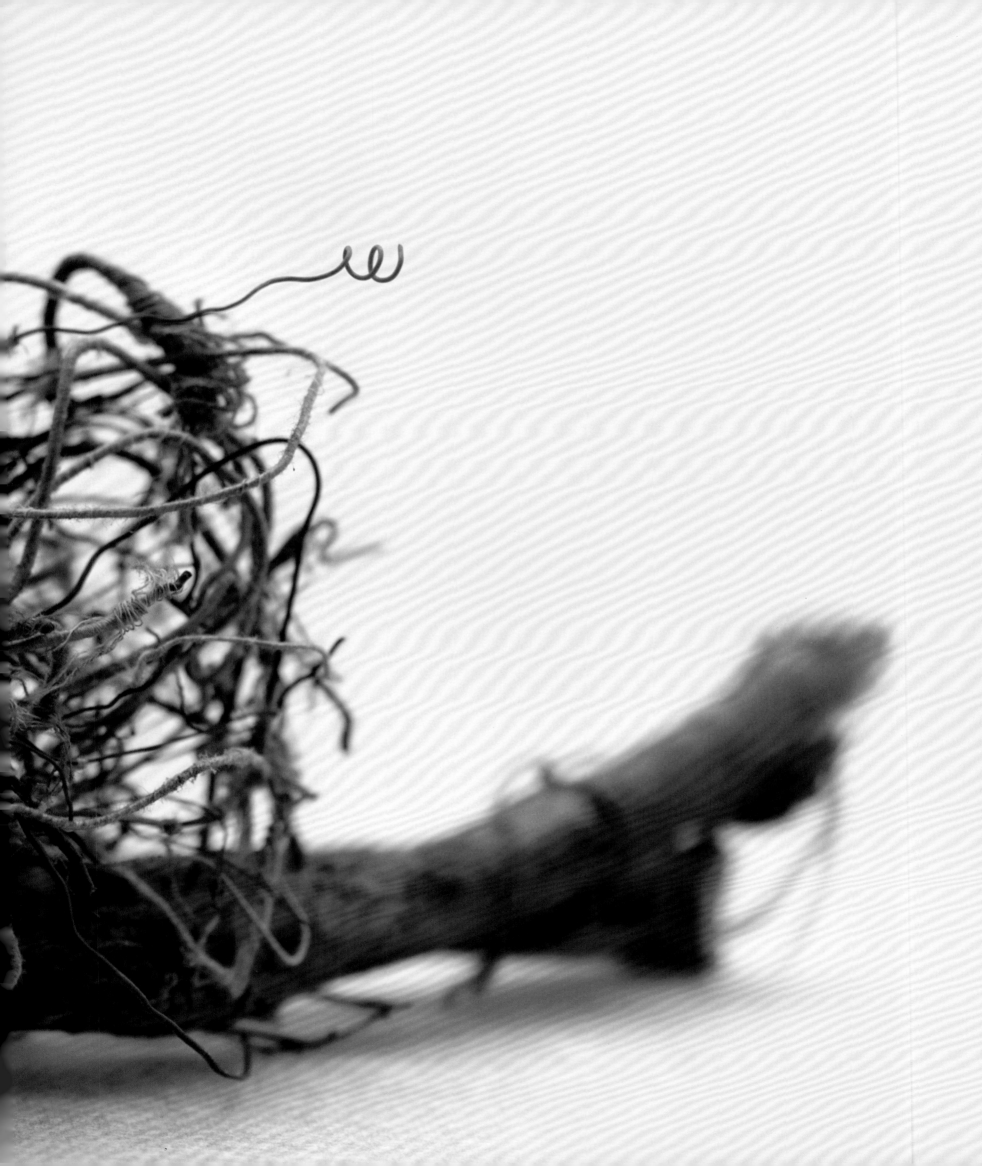

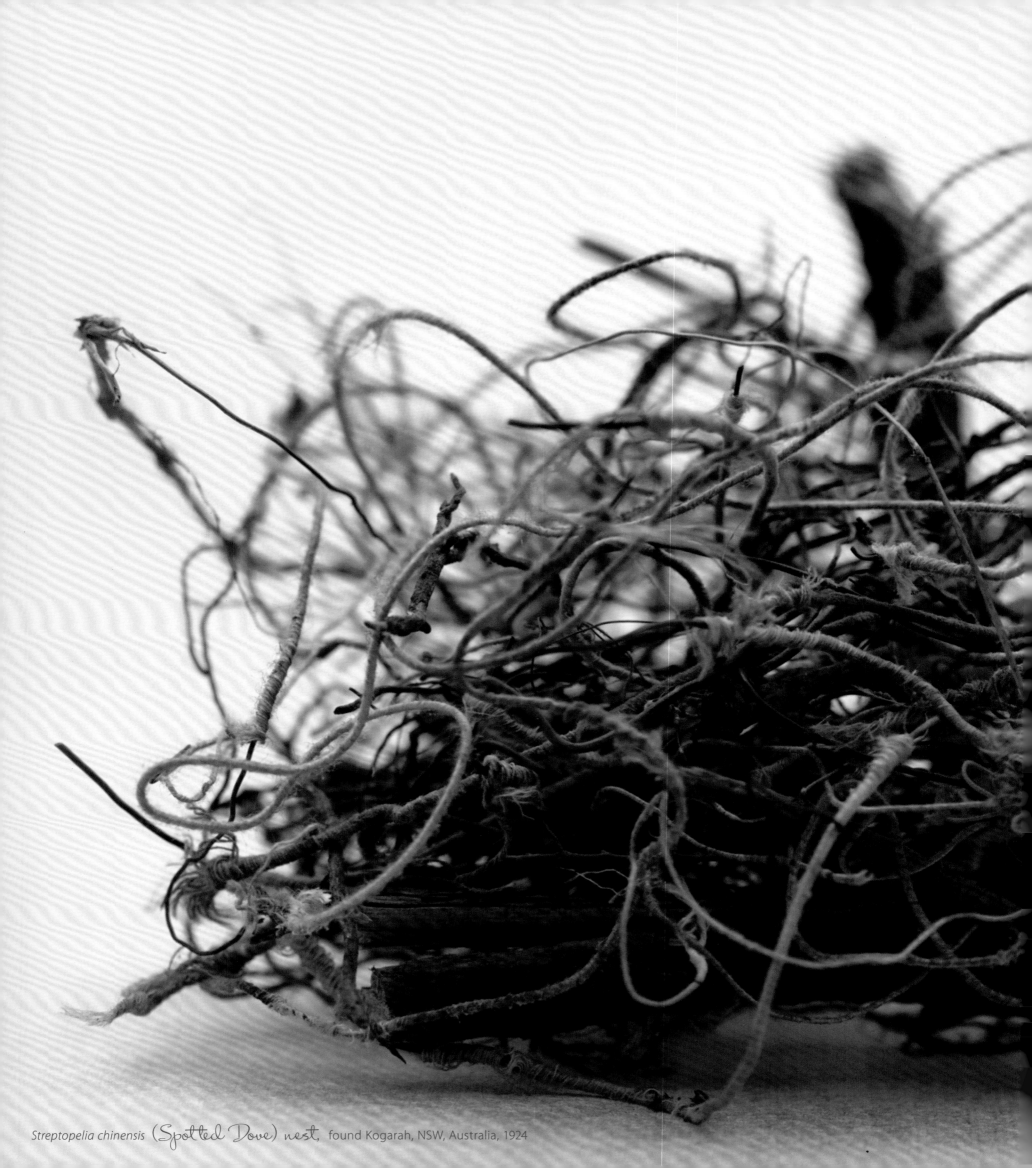

Streptopelia chinensis (Spotted Dove) nest, found Kogarah, NSW, Australia, 1924

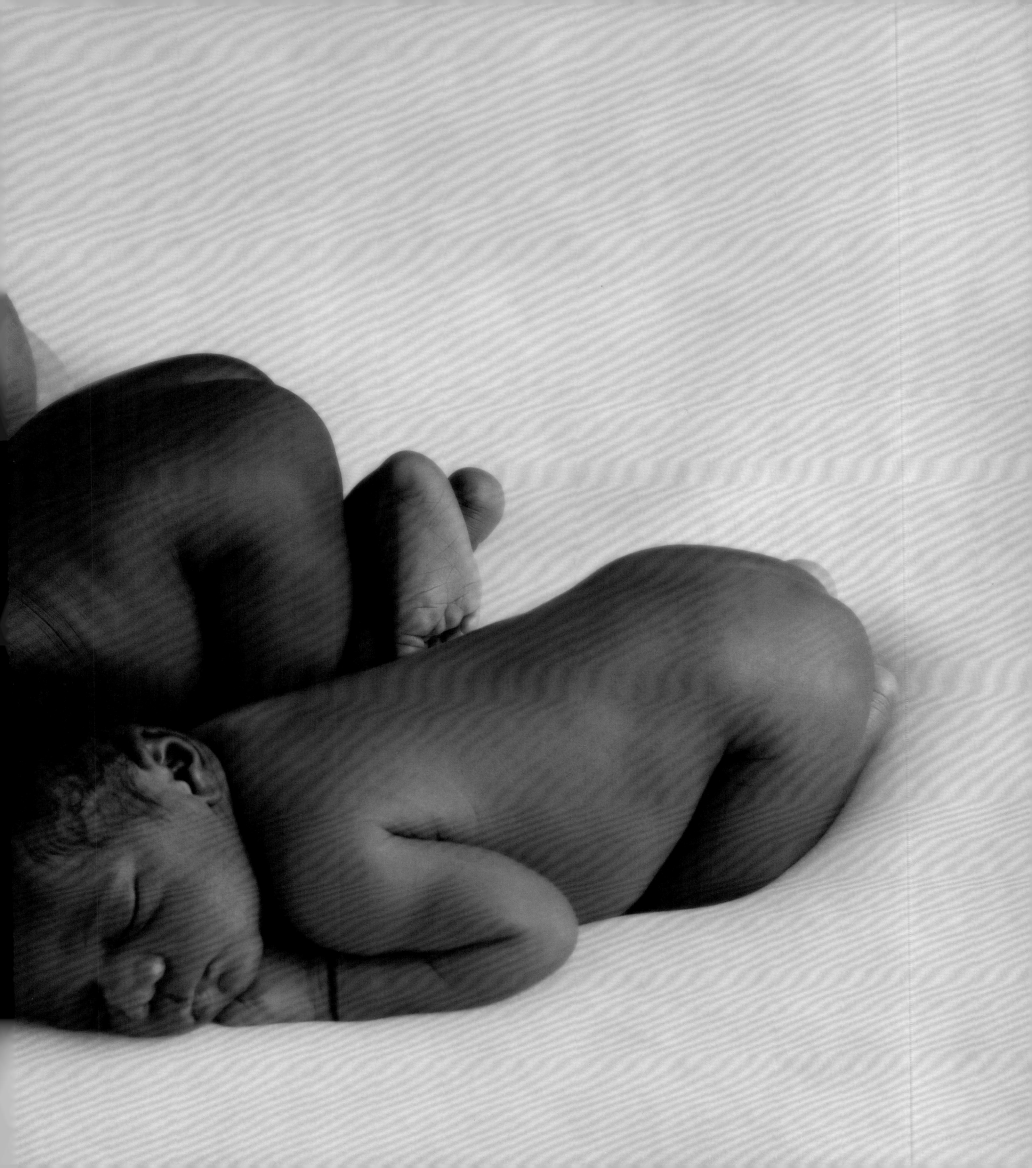

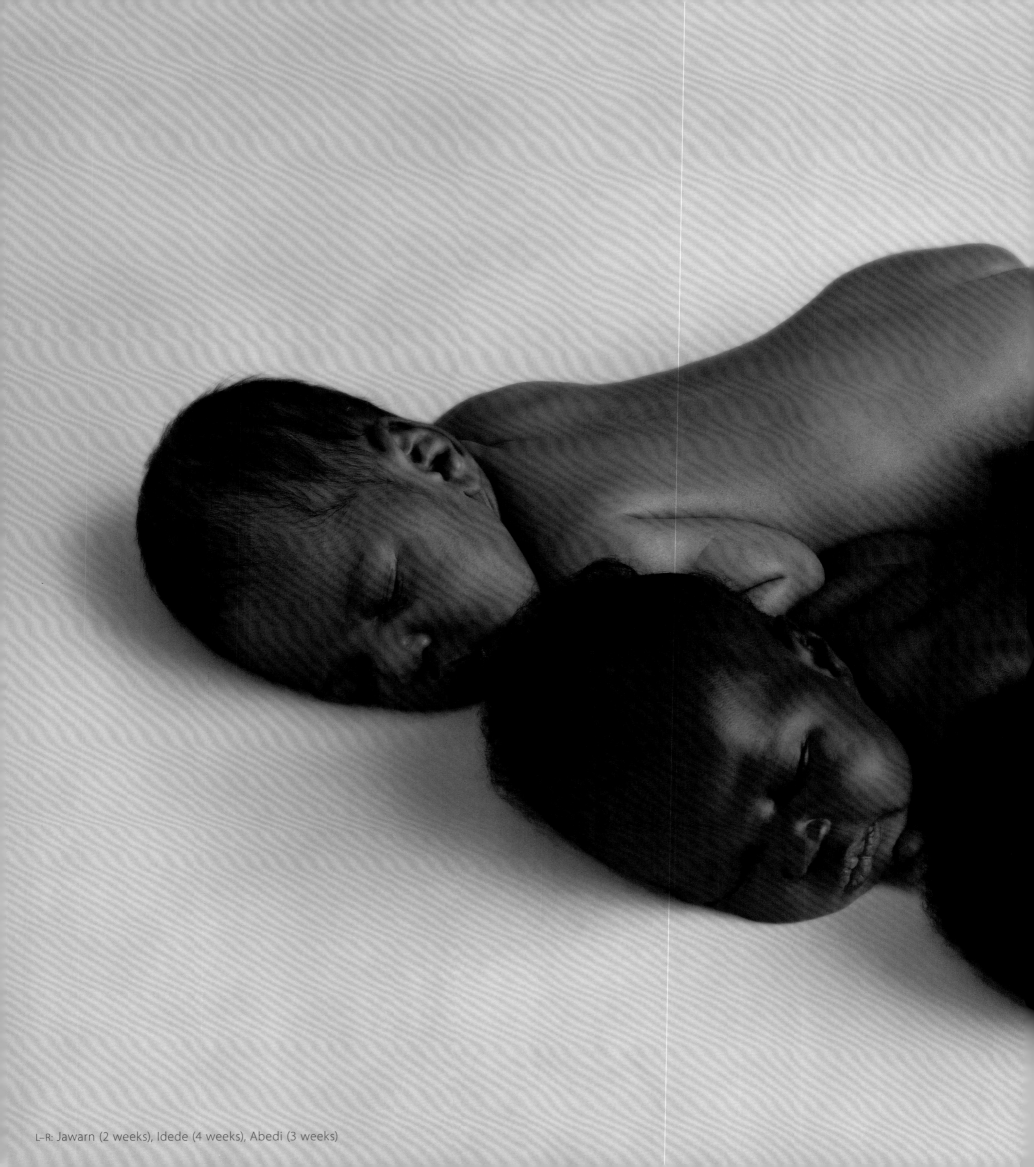

L–R: Jawarn (2 weeks), Idede (4 weeks), Abedi (3 weeks)

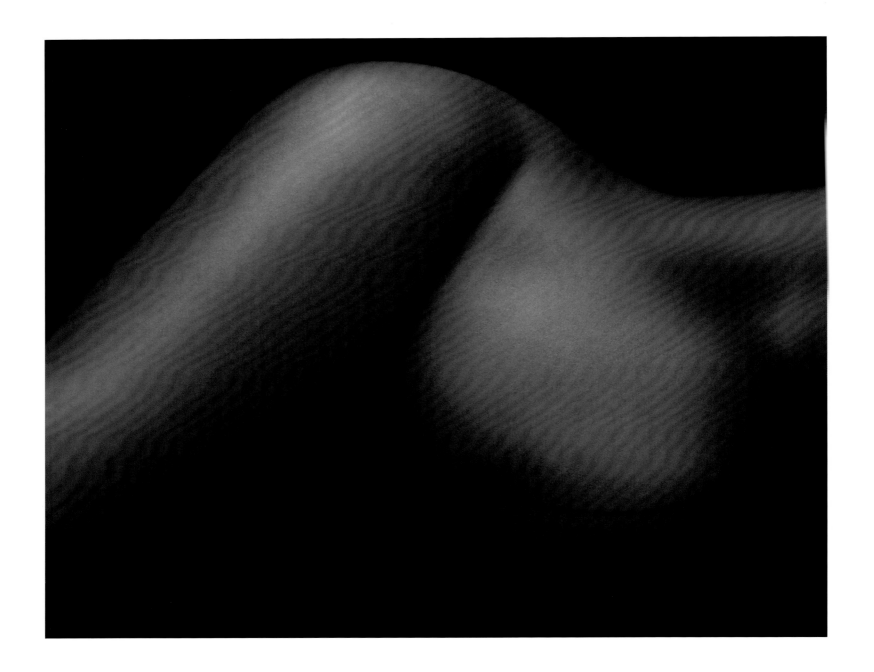

Mahawa (38 weeks pregnant)

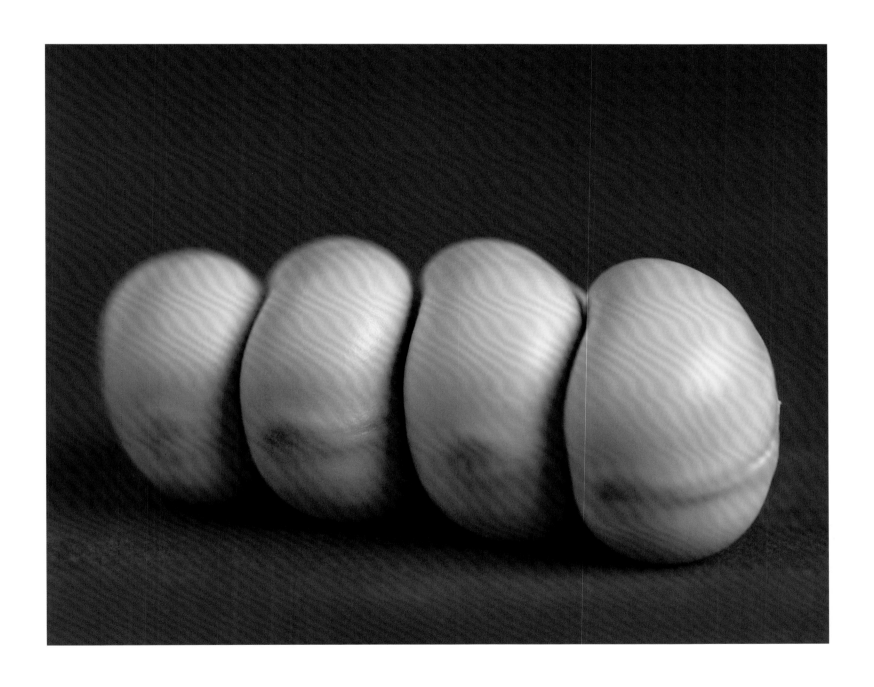

Castanospermum australe (Black bean) seeds

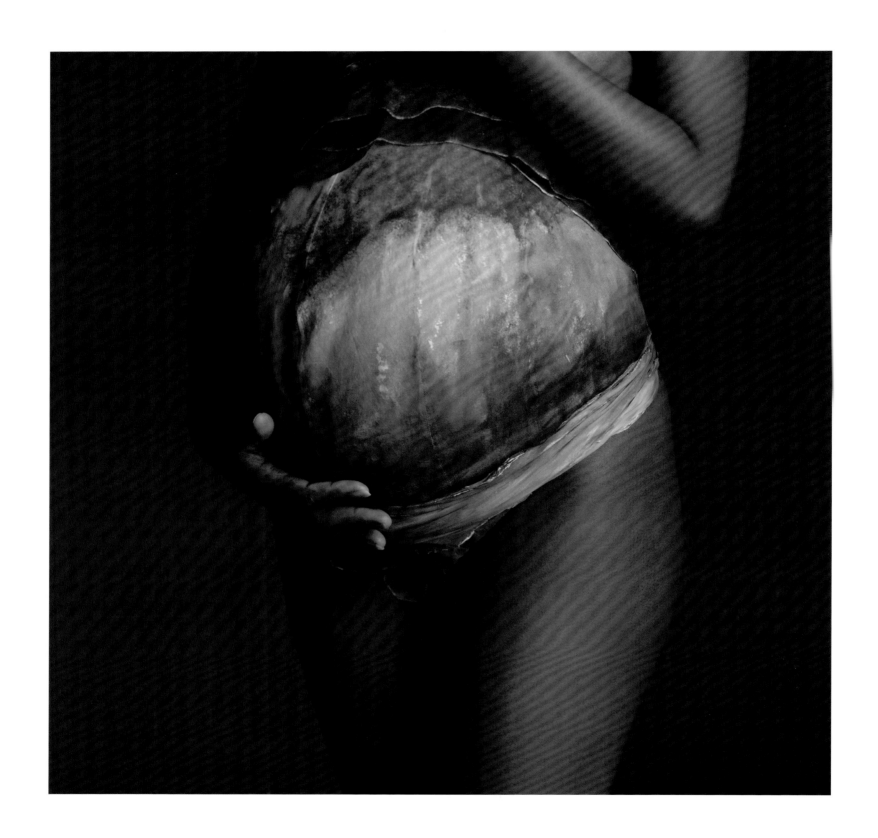

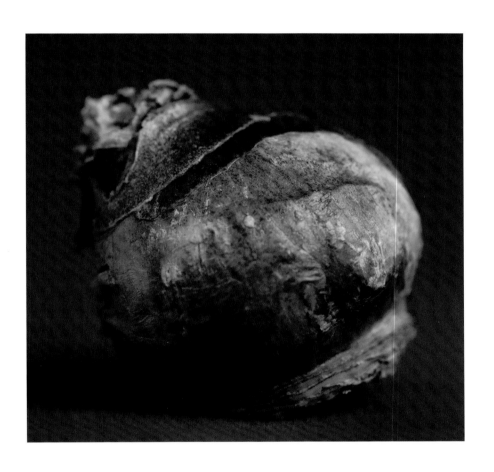

this page *Hyacinthus orientalis cv.* (Hyacinth) bulb opposite Liliana (36 weeks pregnant with twins)

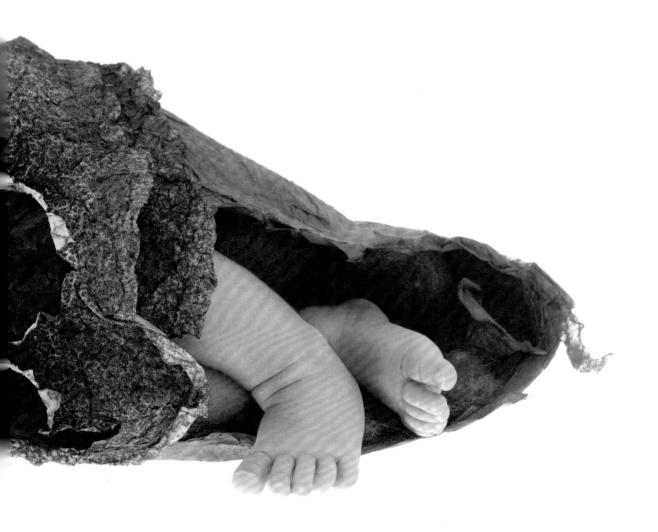

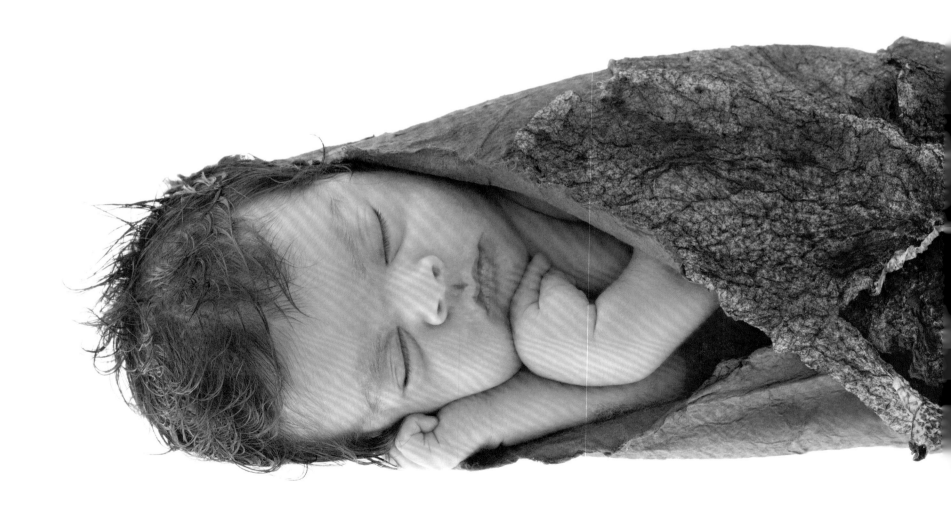

Yash (3 weeks)

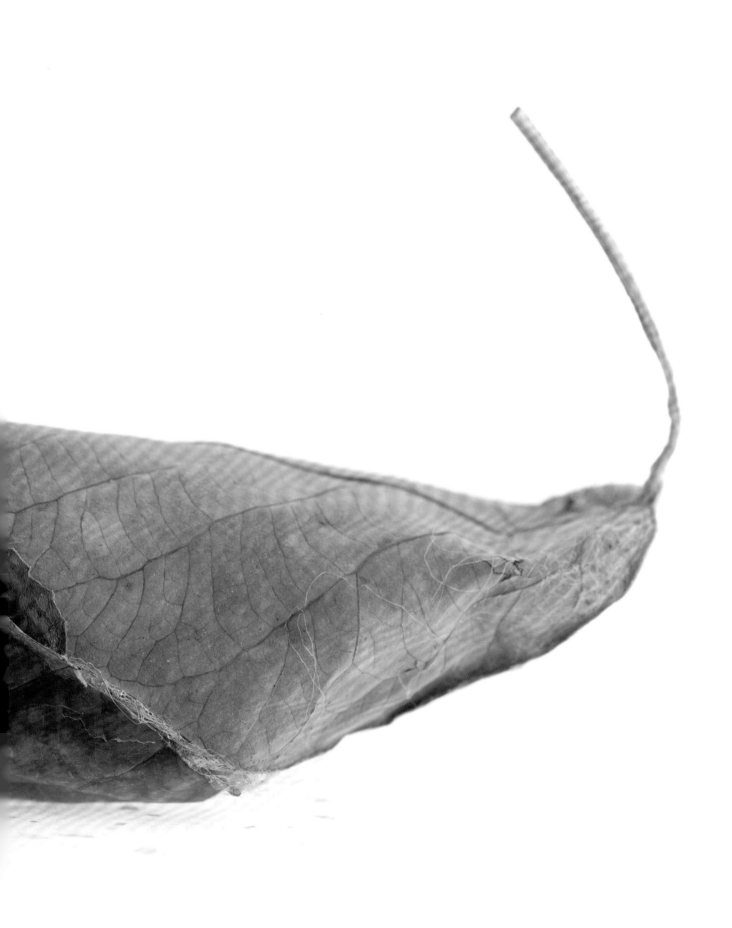

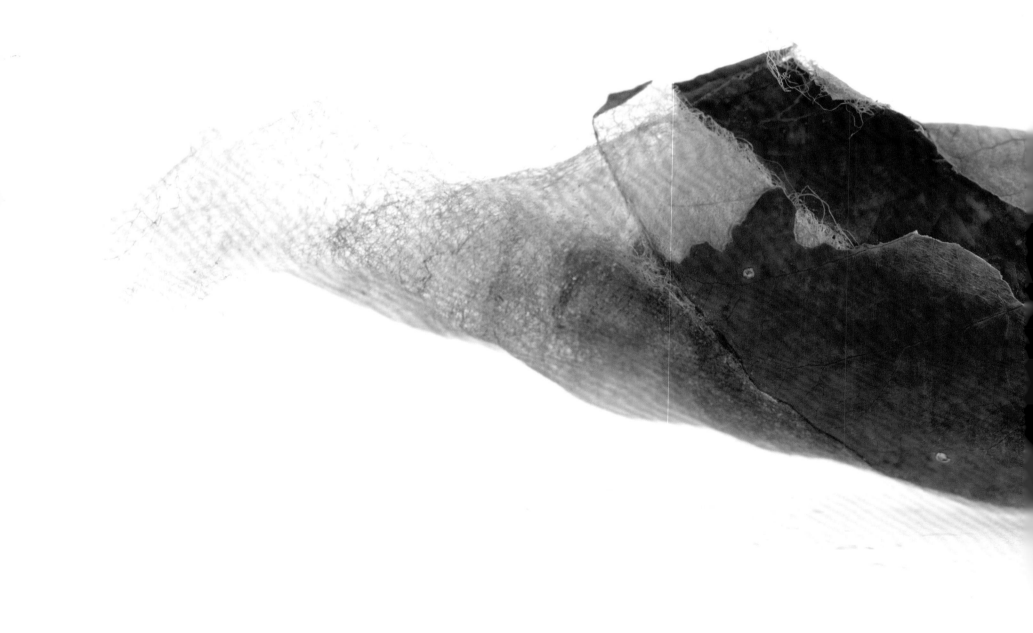

Coscinocera hercules (Hercules moth) pupa

Fam. Psychidae (Case moth) pupa

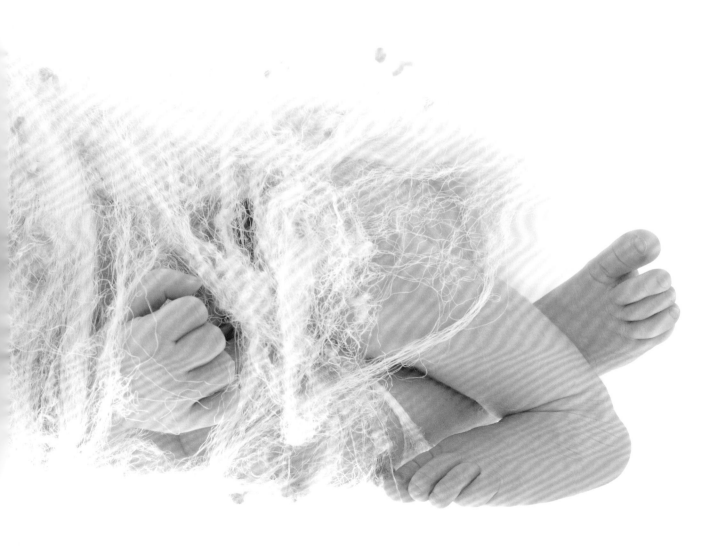

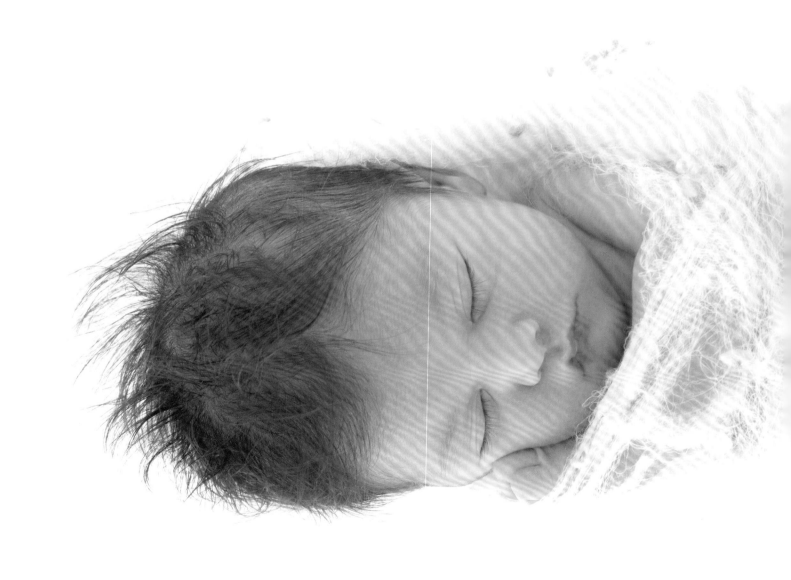

Ava (9 days)

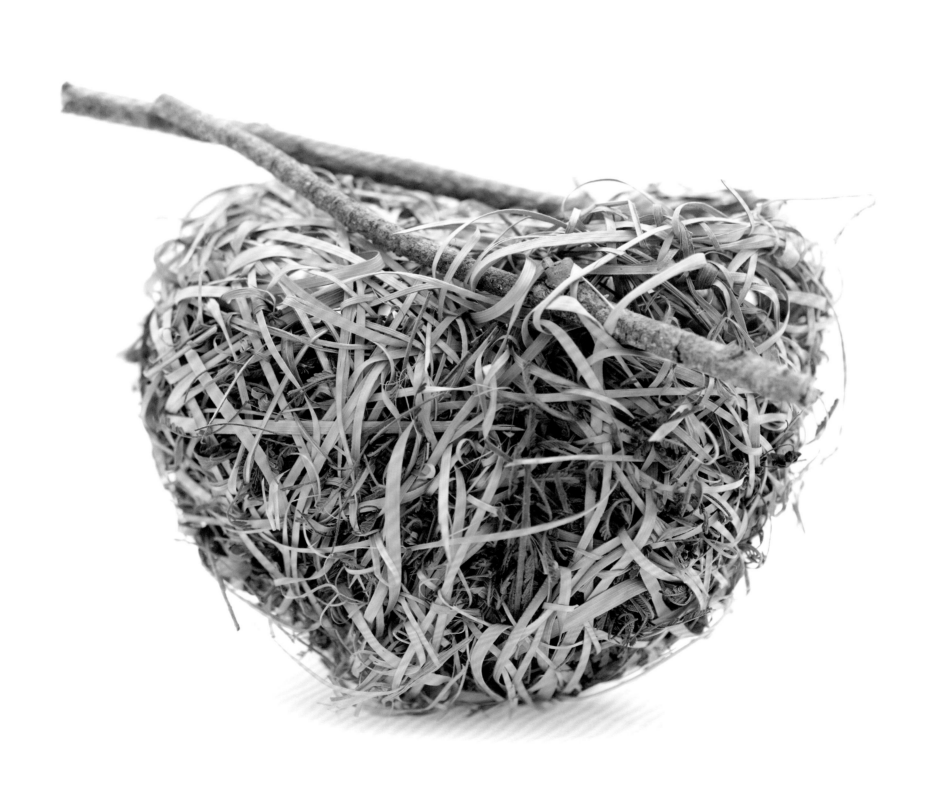

Ploceidae (Unknown Weaver species) nest, collected Lake Tanganyika, Africa, and registered into the Australian Museum collection March 1935

Coco (2 weeks)

Begonia cv. (Begonia)

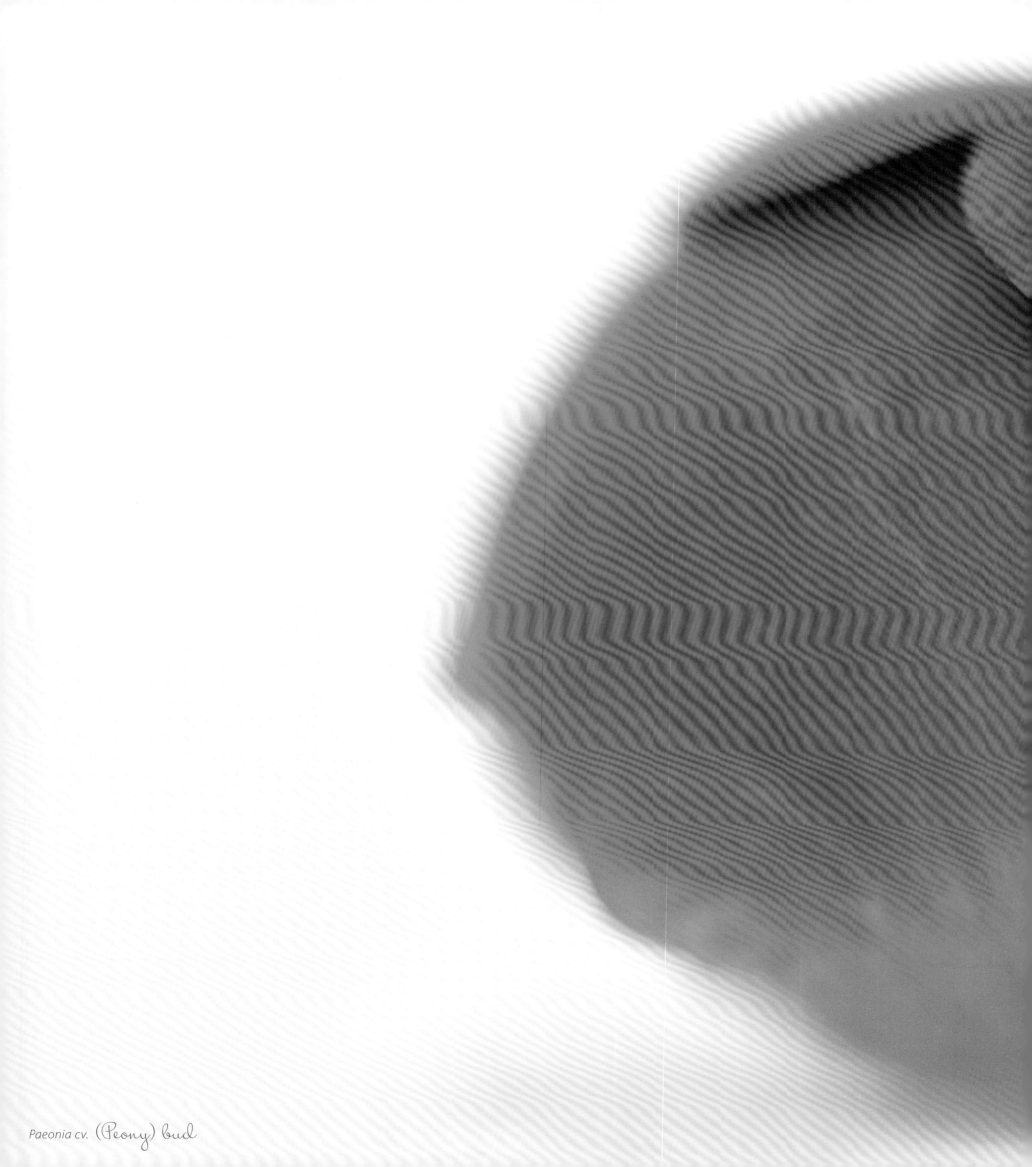

Paeonia cv. (Peony) bud

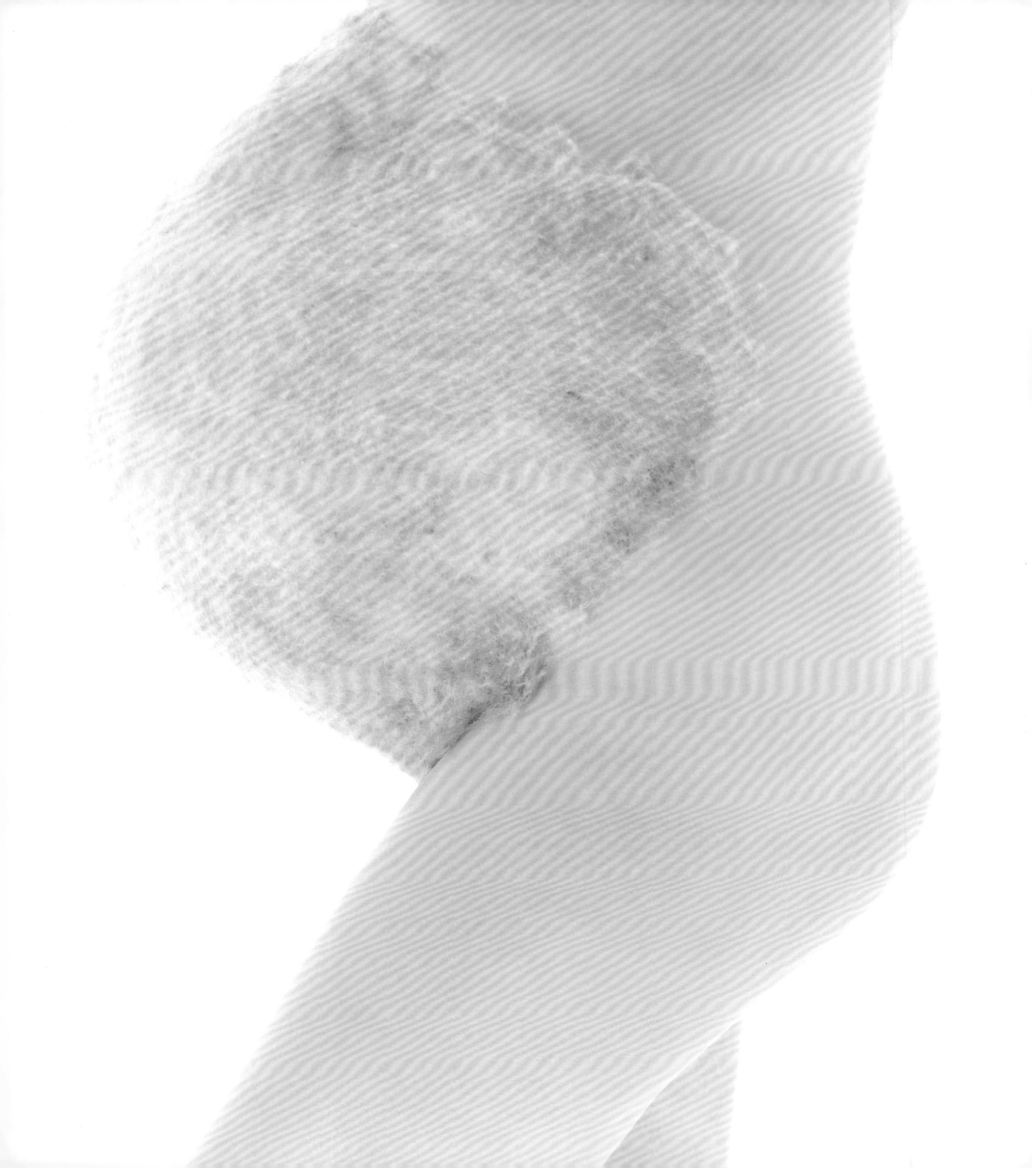

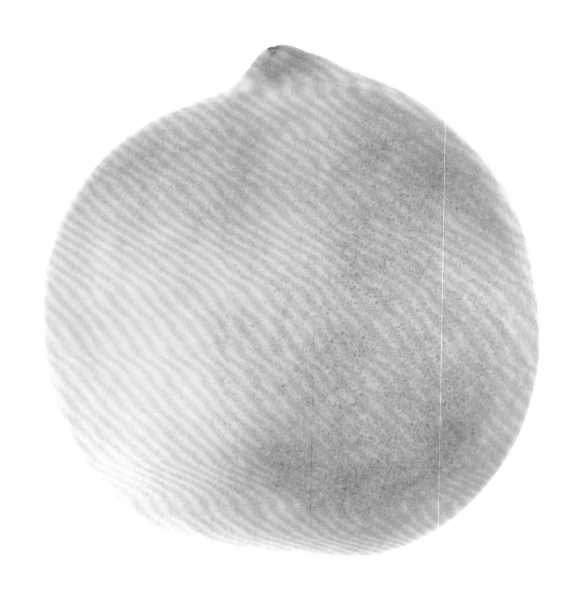

this page *Prunus persica* (Peach)　opposite Nell (38 weeks pregnant)

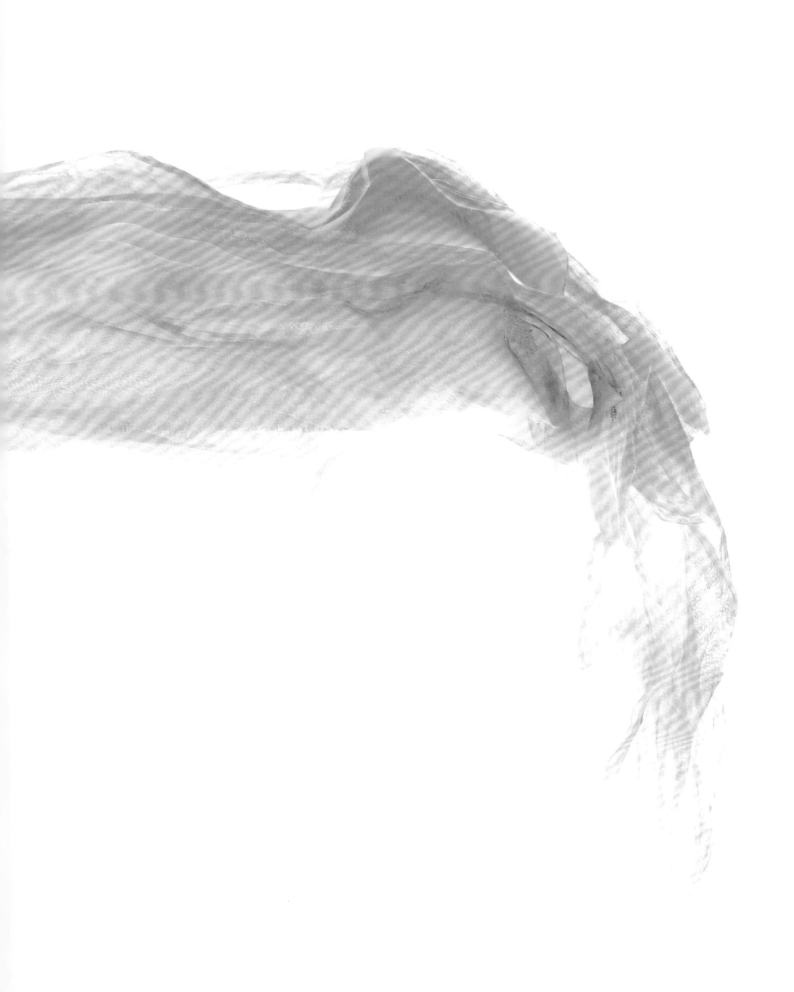

Amelia (2 weeks)

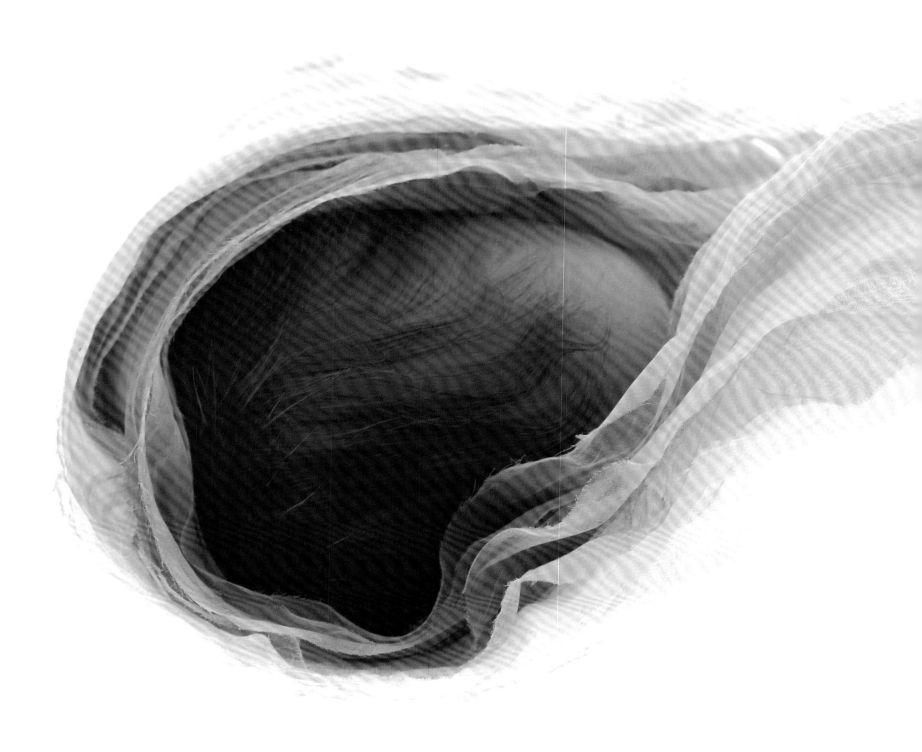

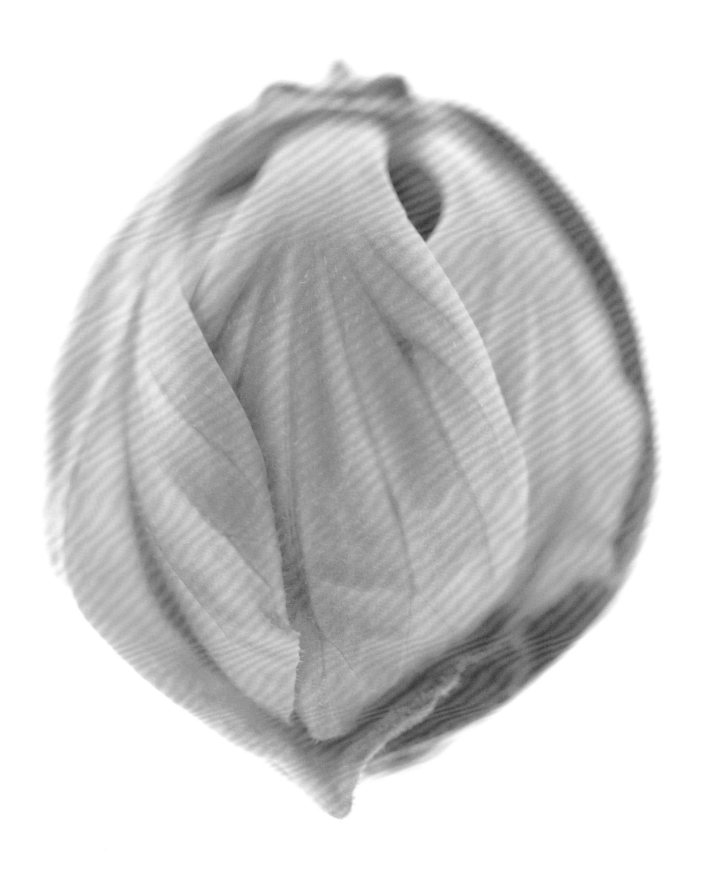

Abutilon cv. (Chinese lantern) bud

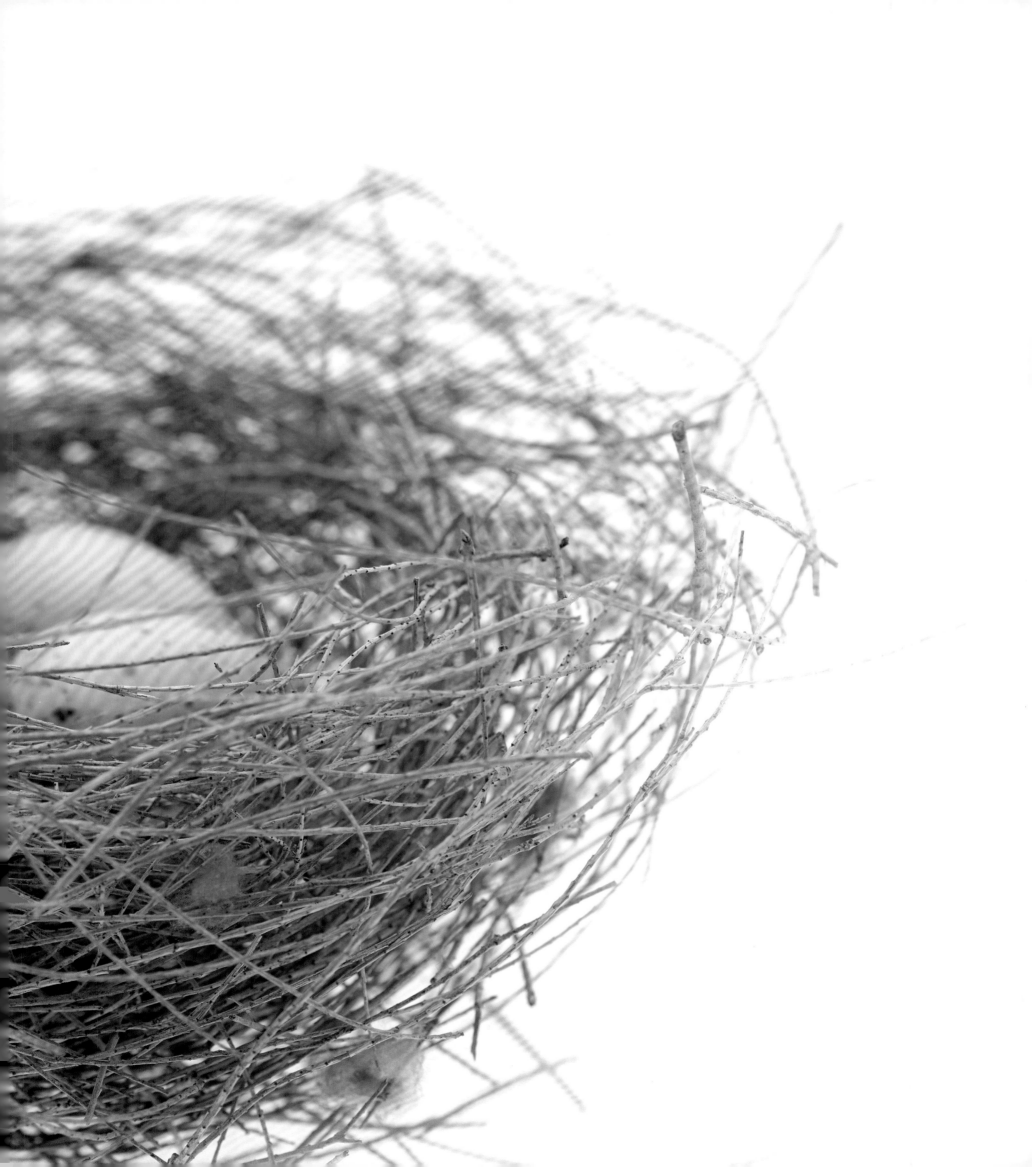

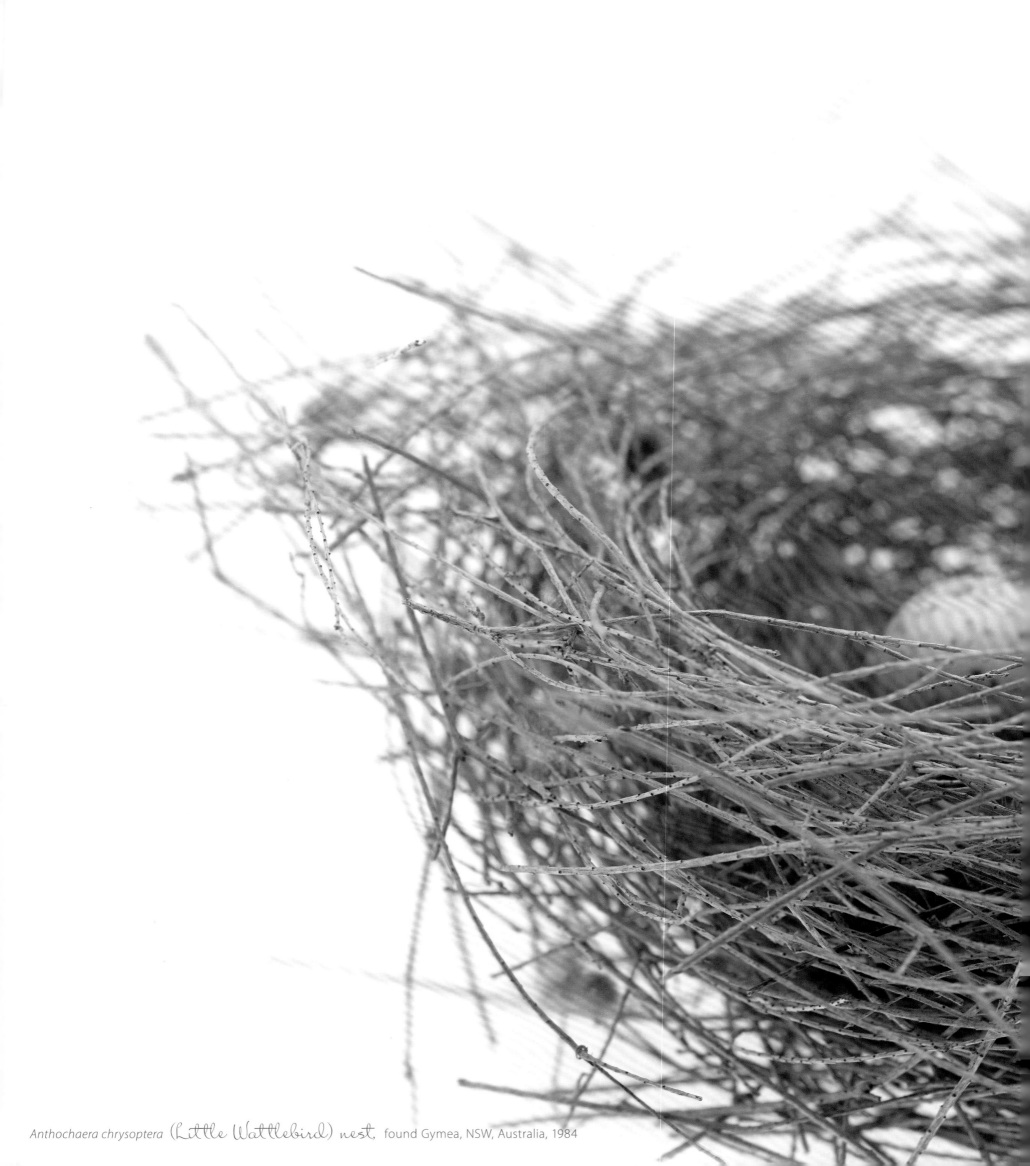

Anthochaera chrysoptera (Little Wattlebird) nest, found Gymea, NSW, Australia, 1984

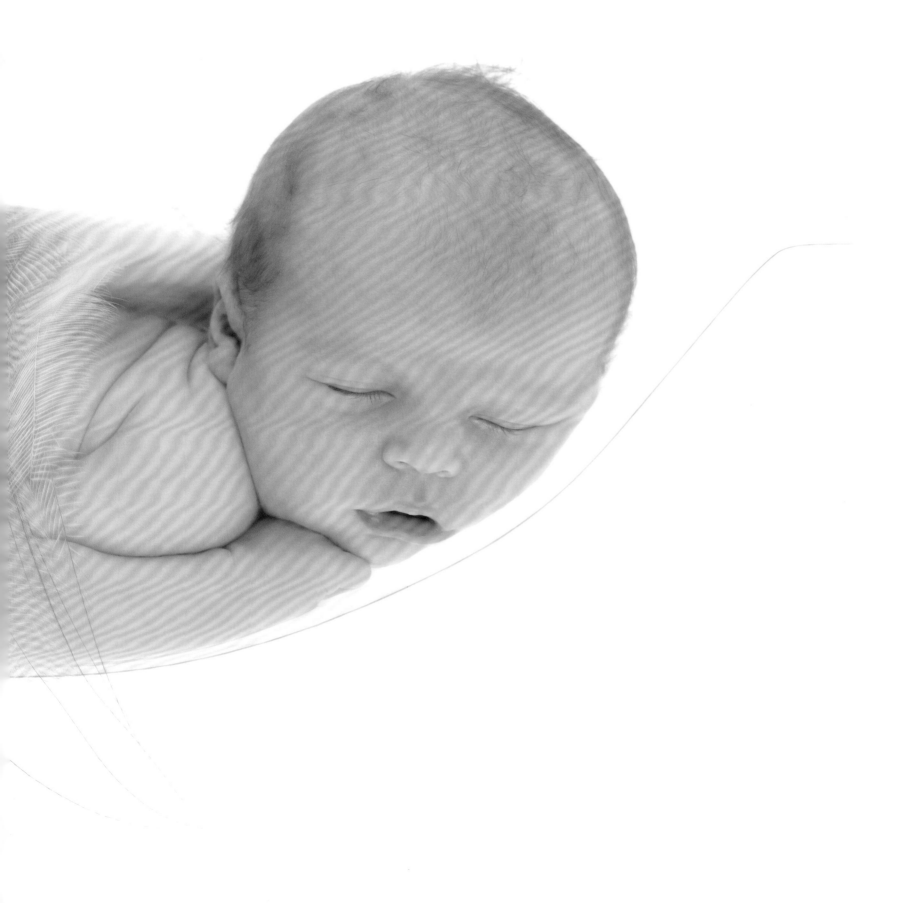

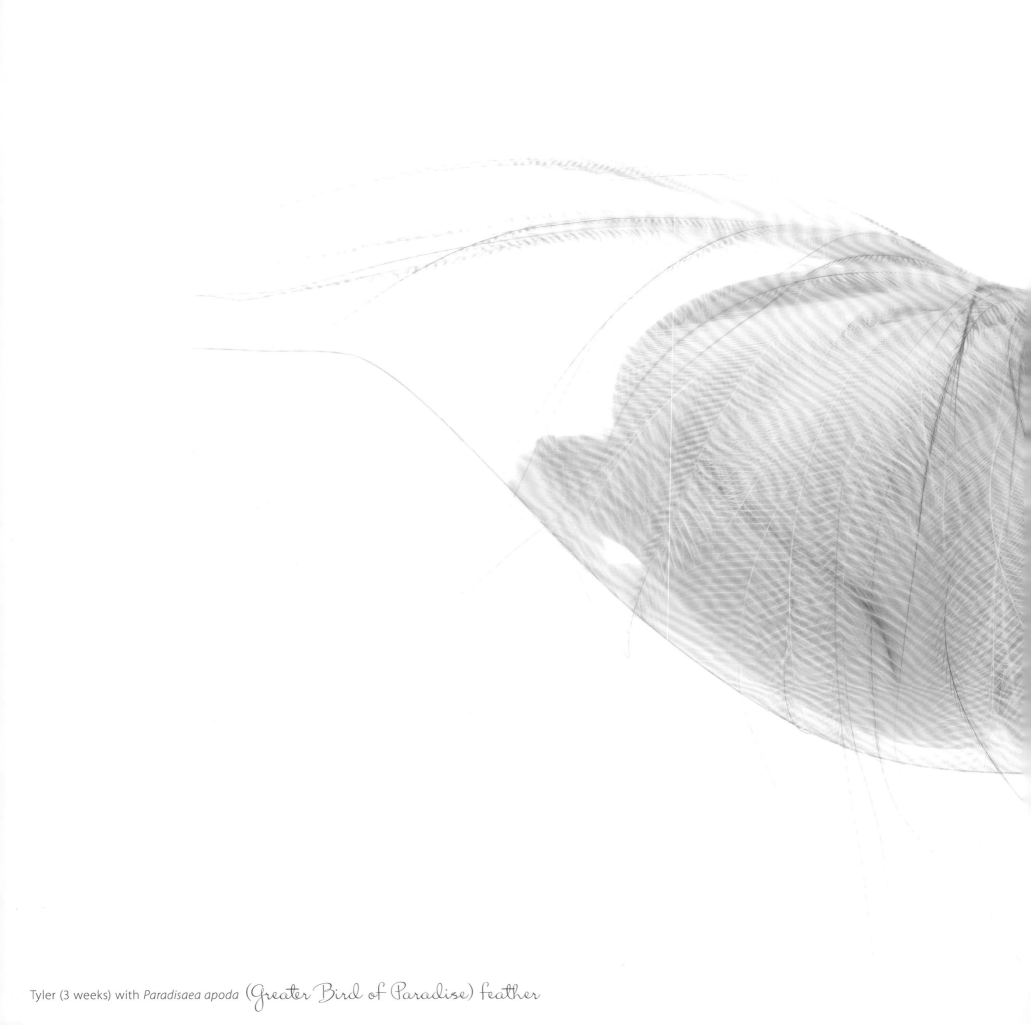

Tyler (3 weeks) with *Paradisaea apoda* (Greater Bird of Paradise) feather

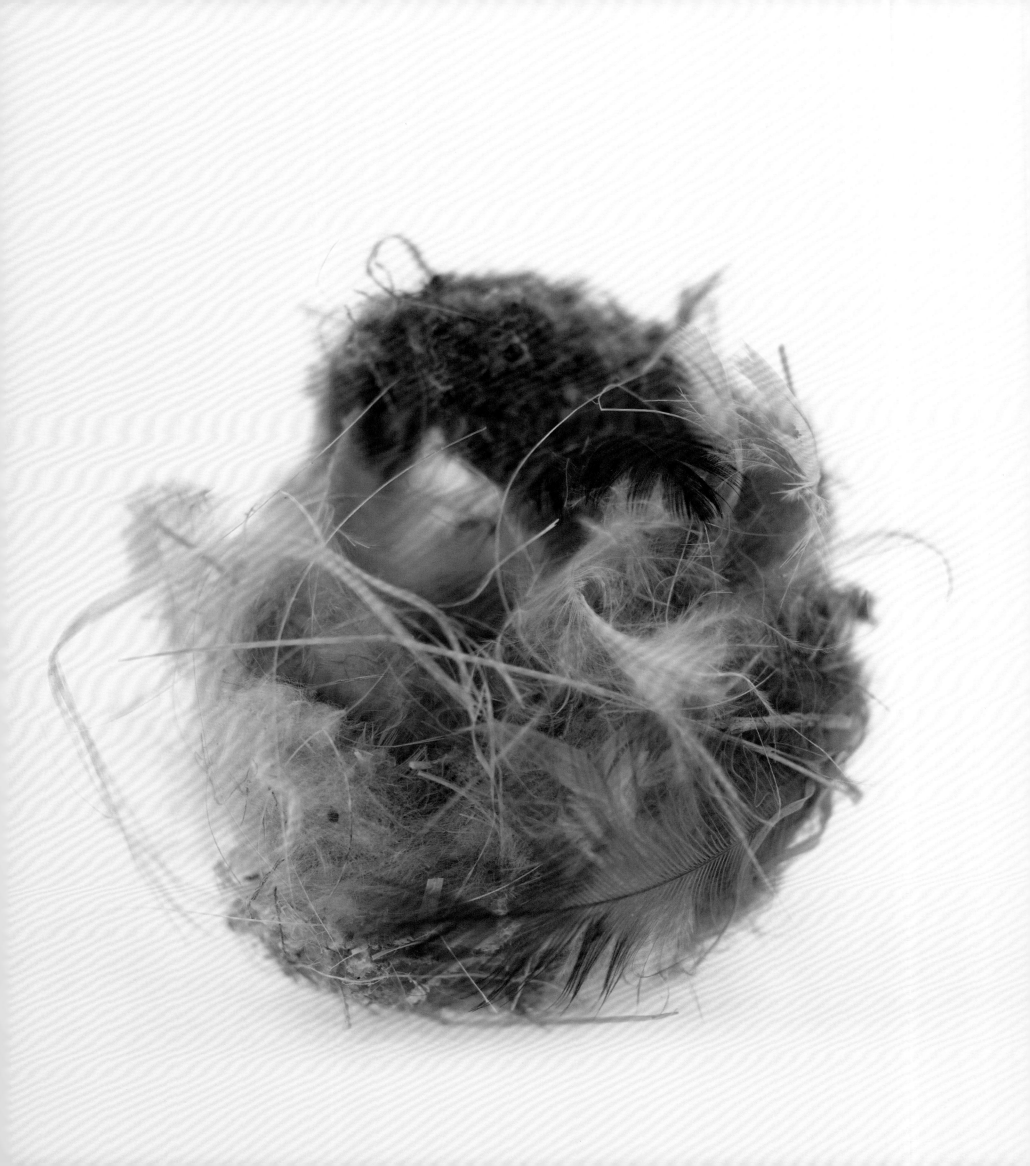

Unknown abandoned nest

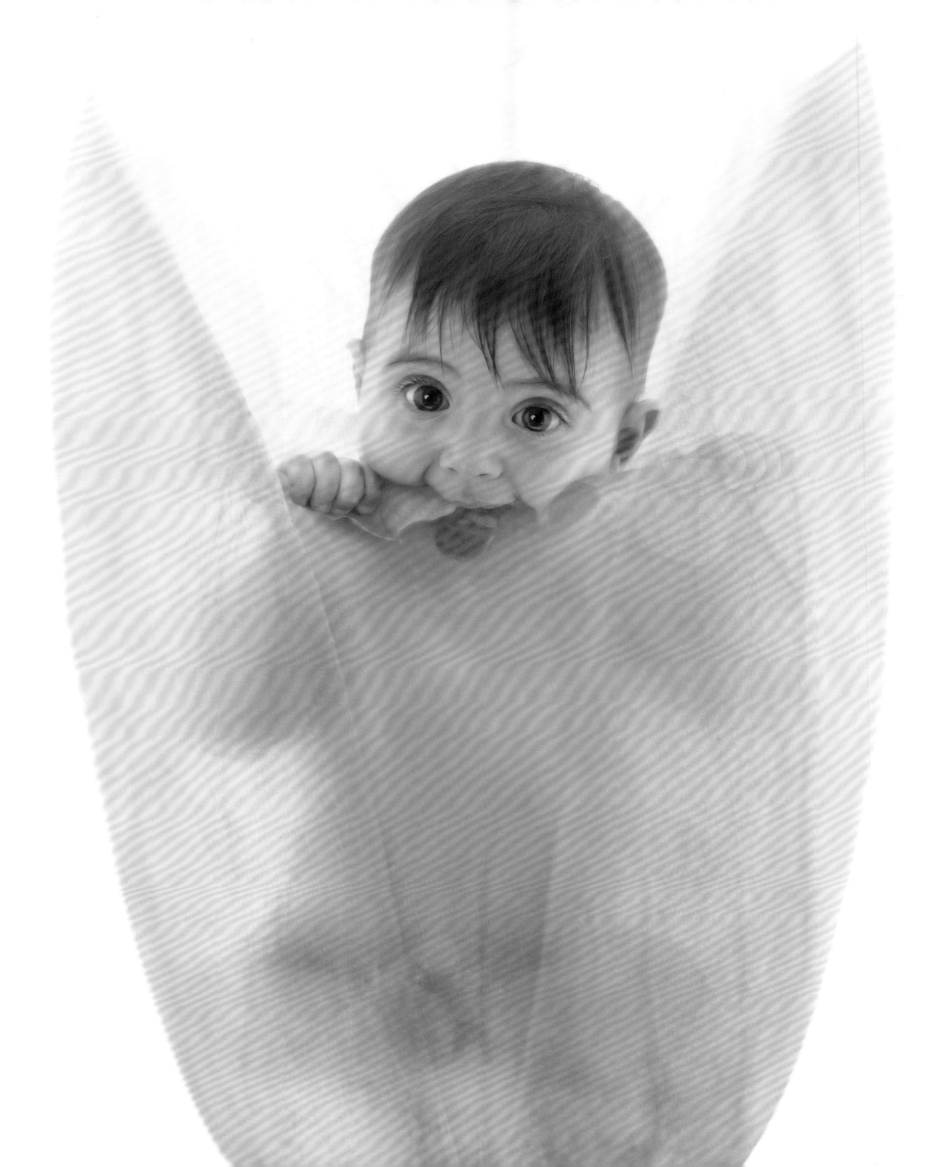

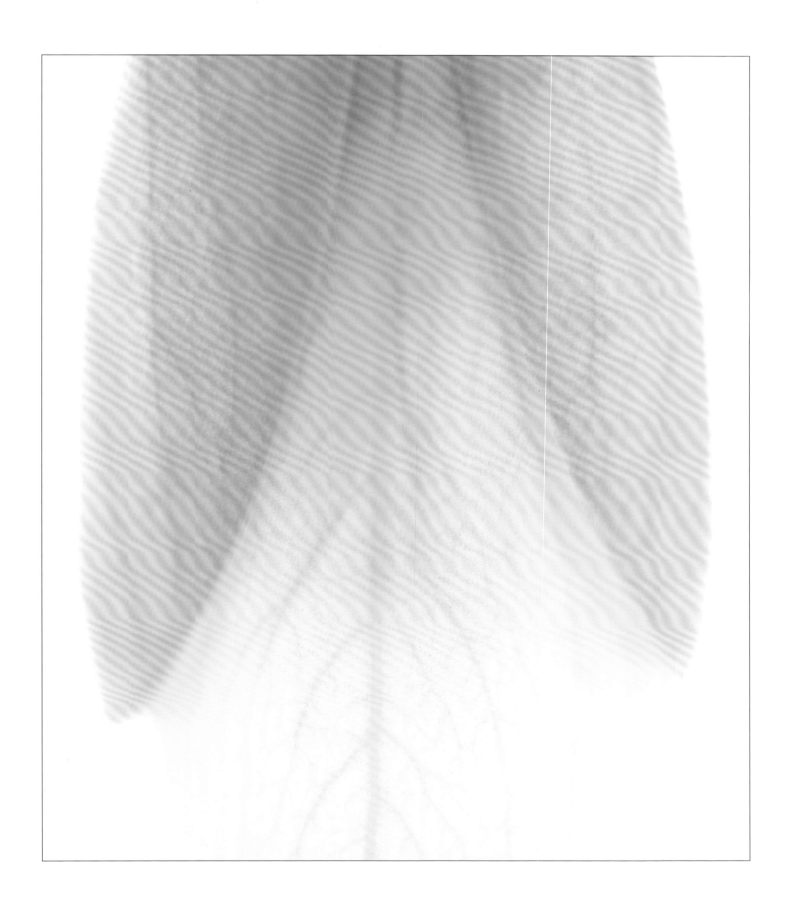

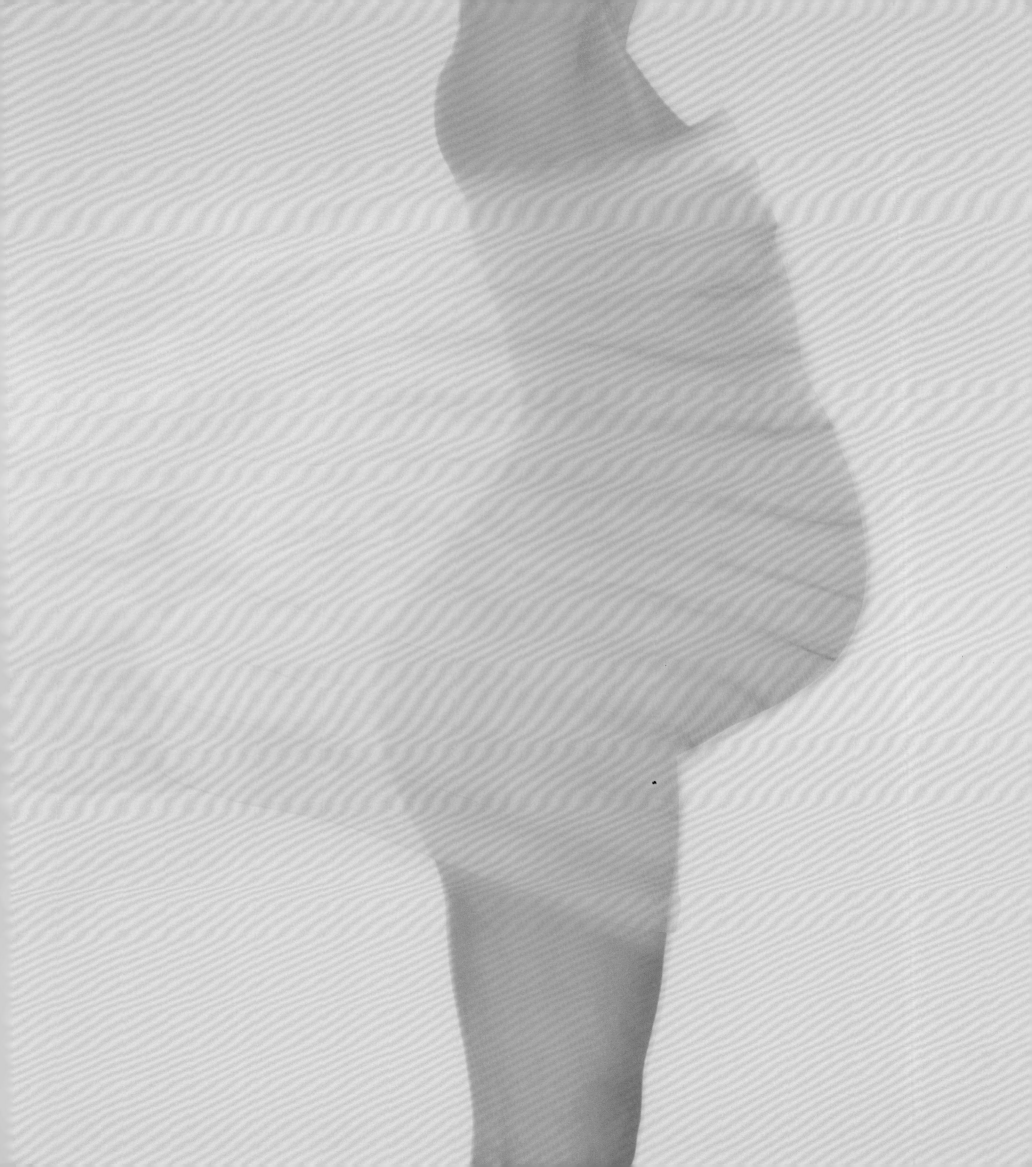

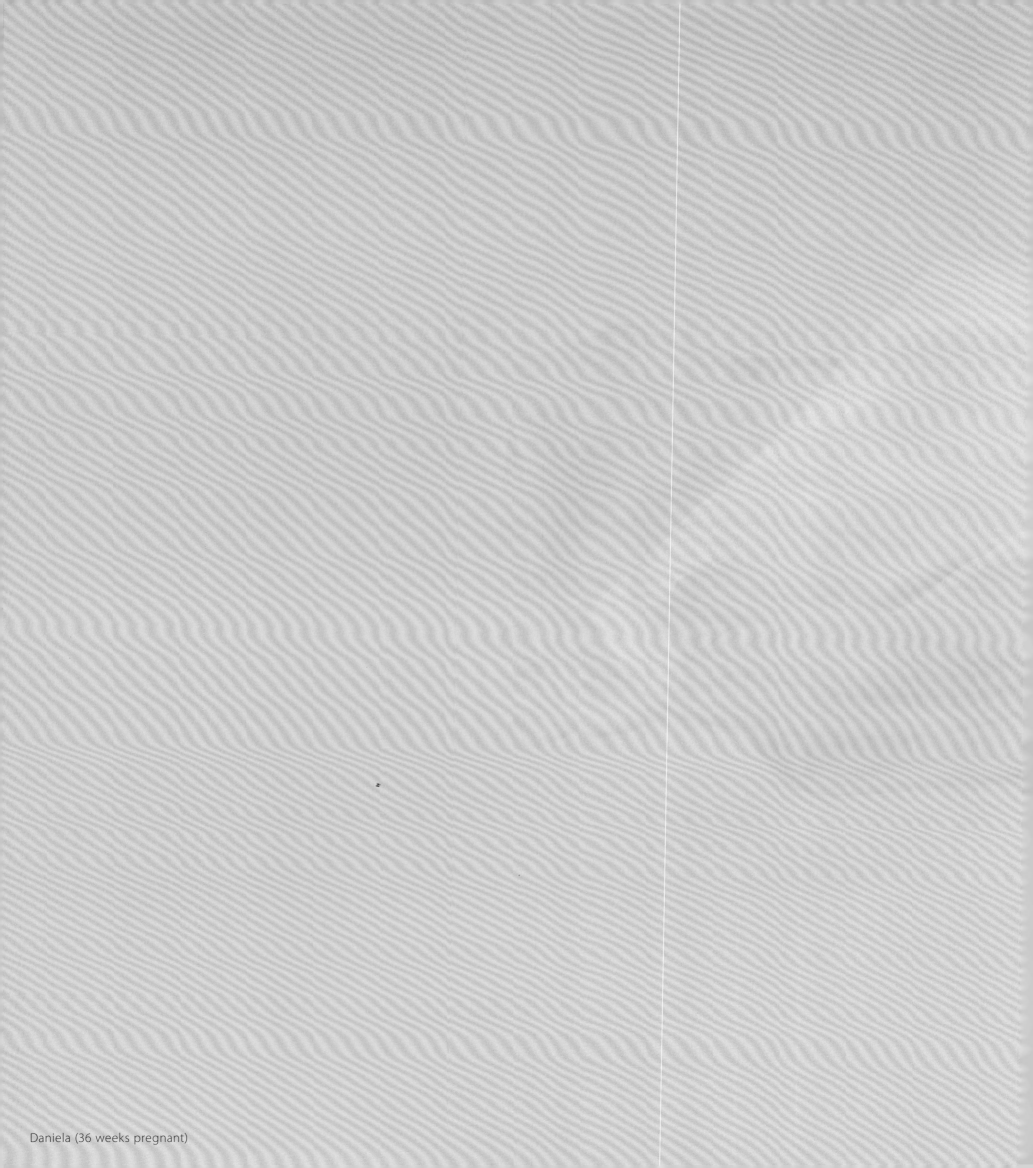

Daniela (36 weeks pregnant)

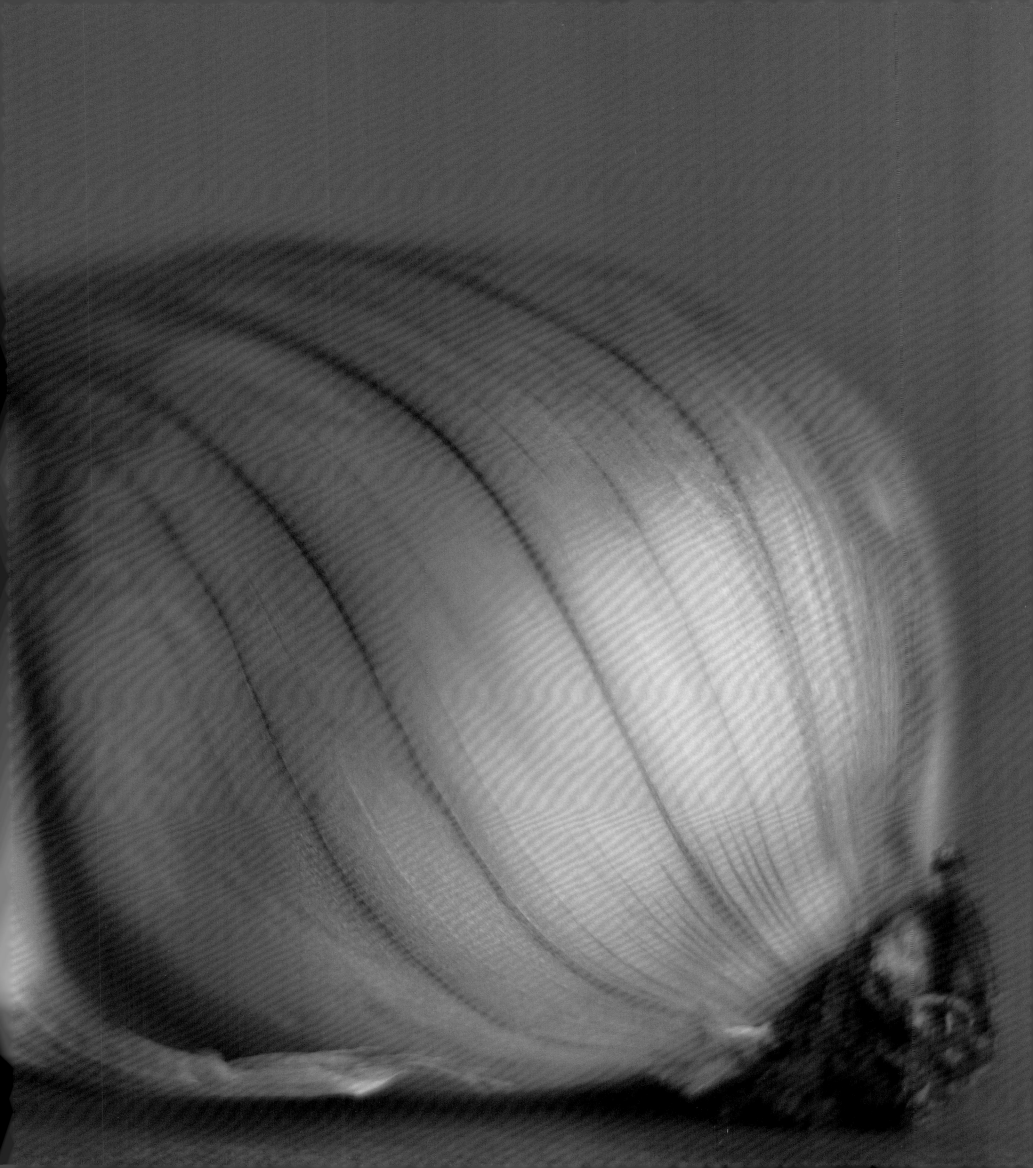

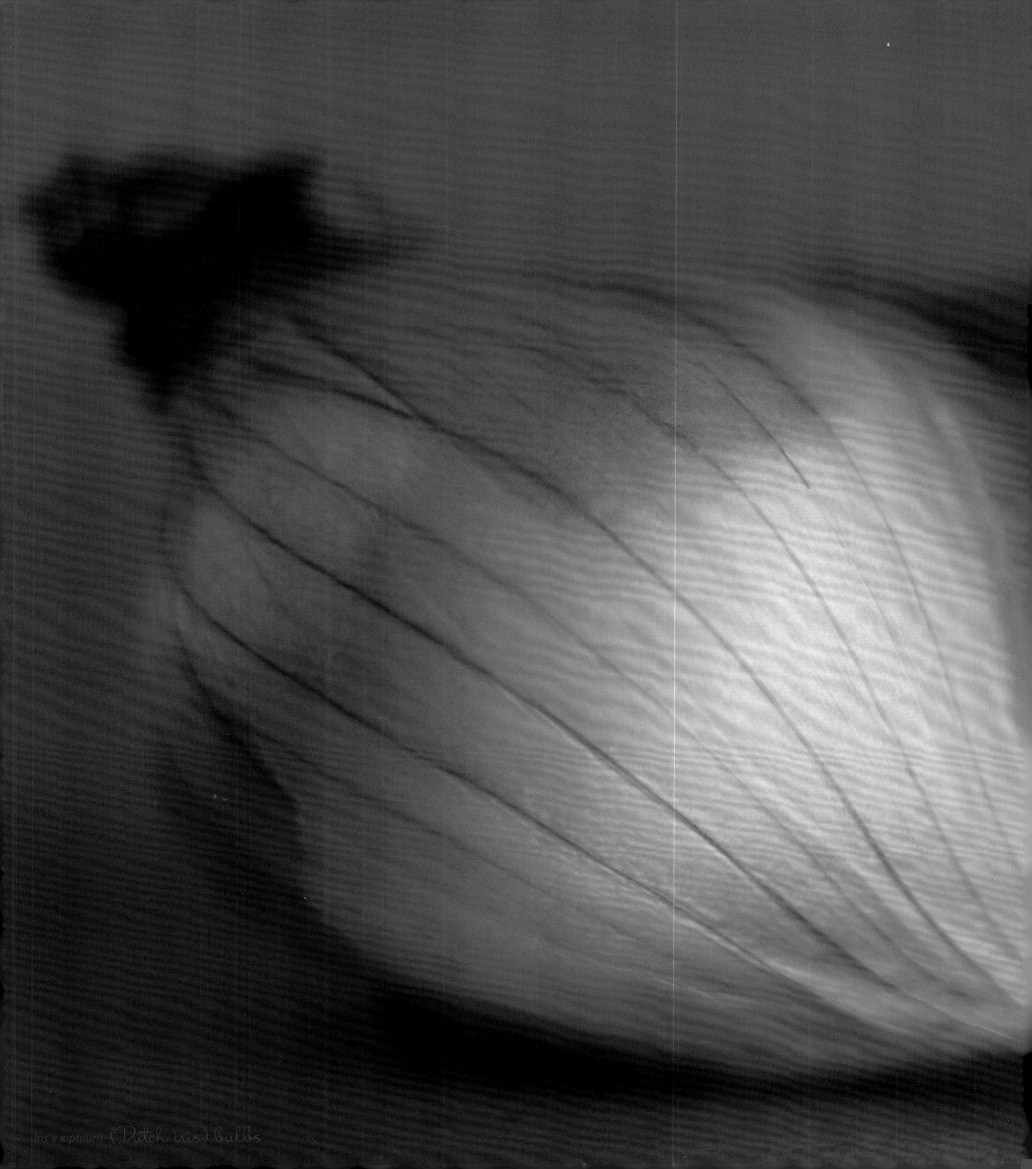

Iris x xiphium (Dutch iris) bulbs

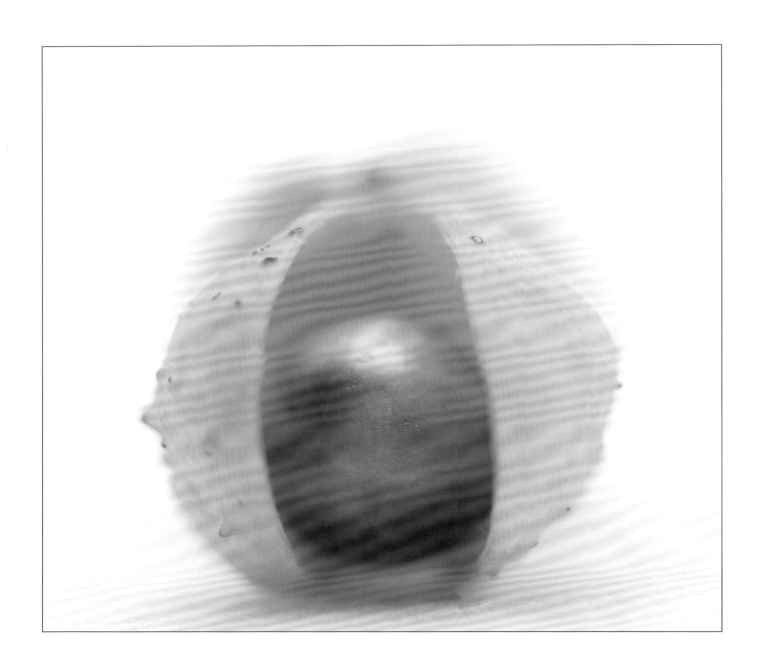

Harpullia pendula (Australian tulipwood) seed

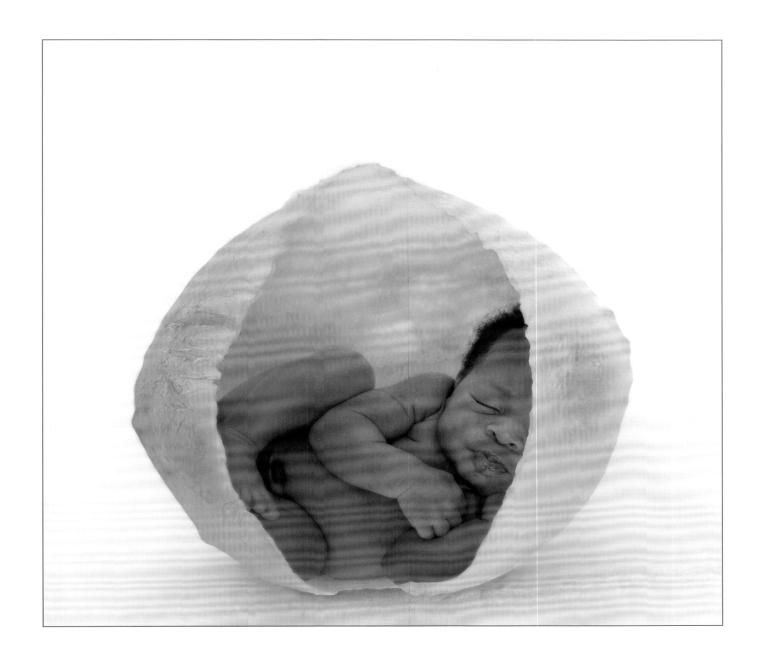

Farris (2 weeks)

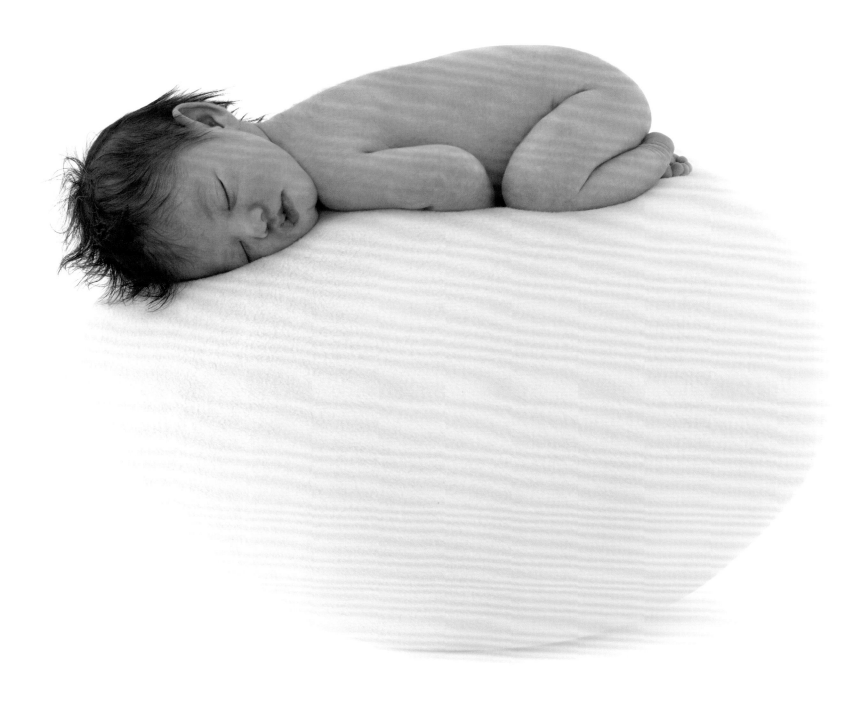

Ava (9 days)

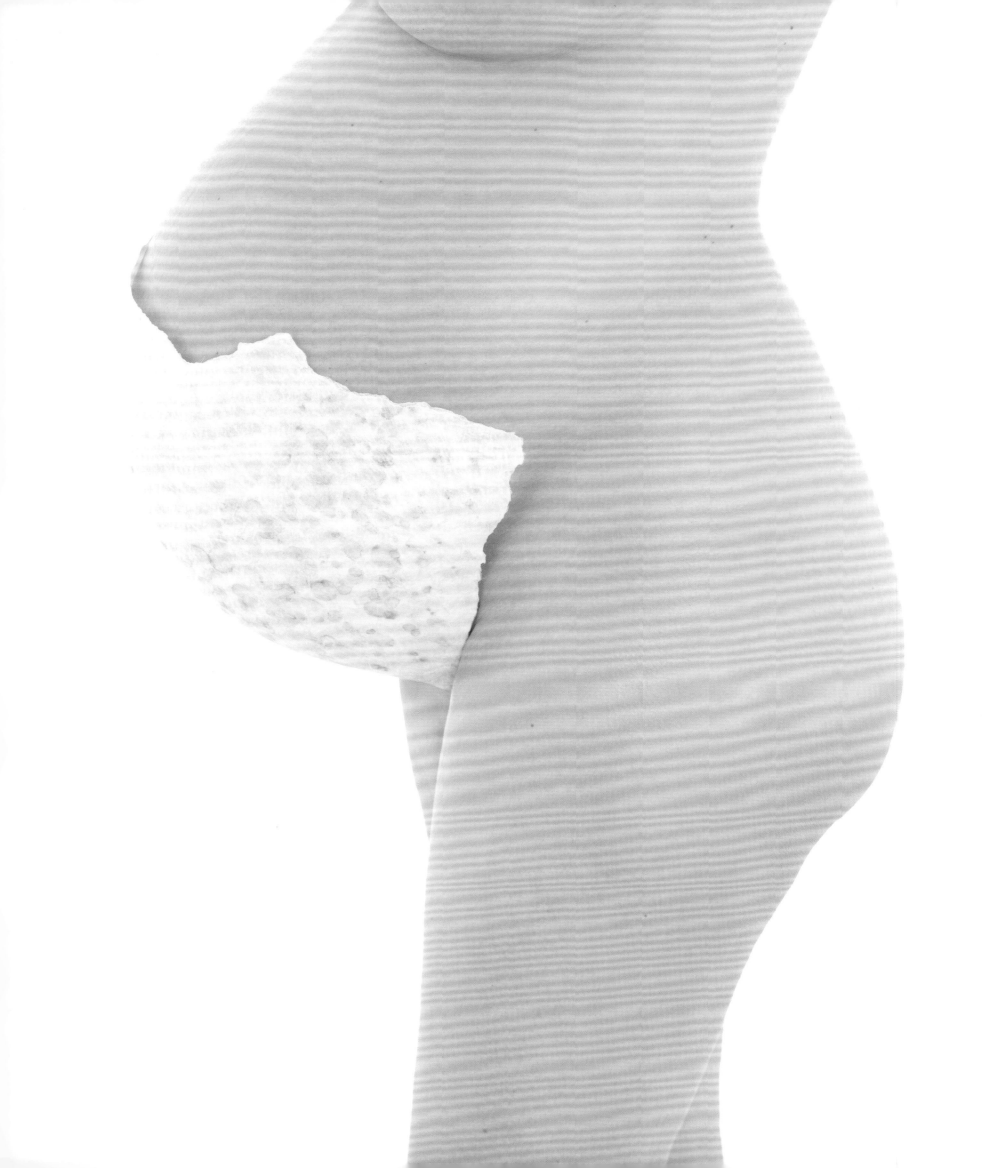

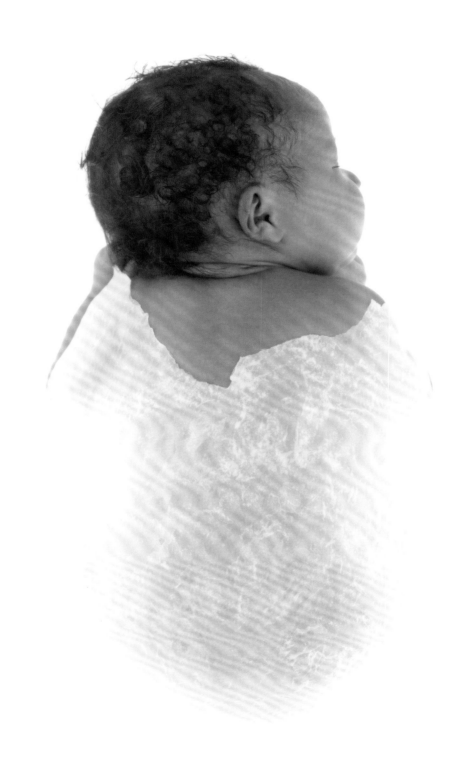

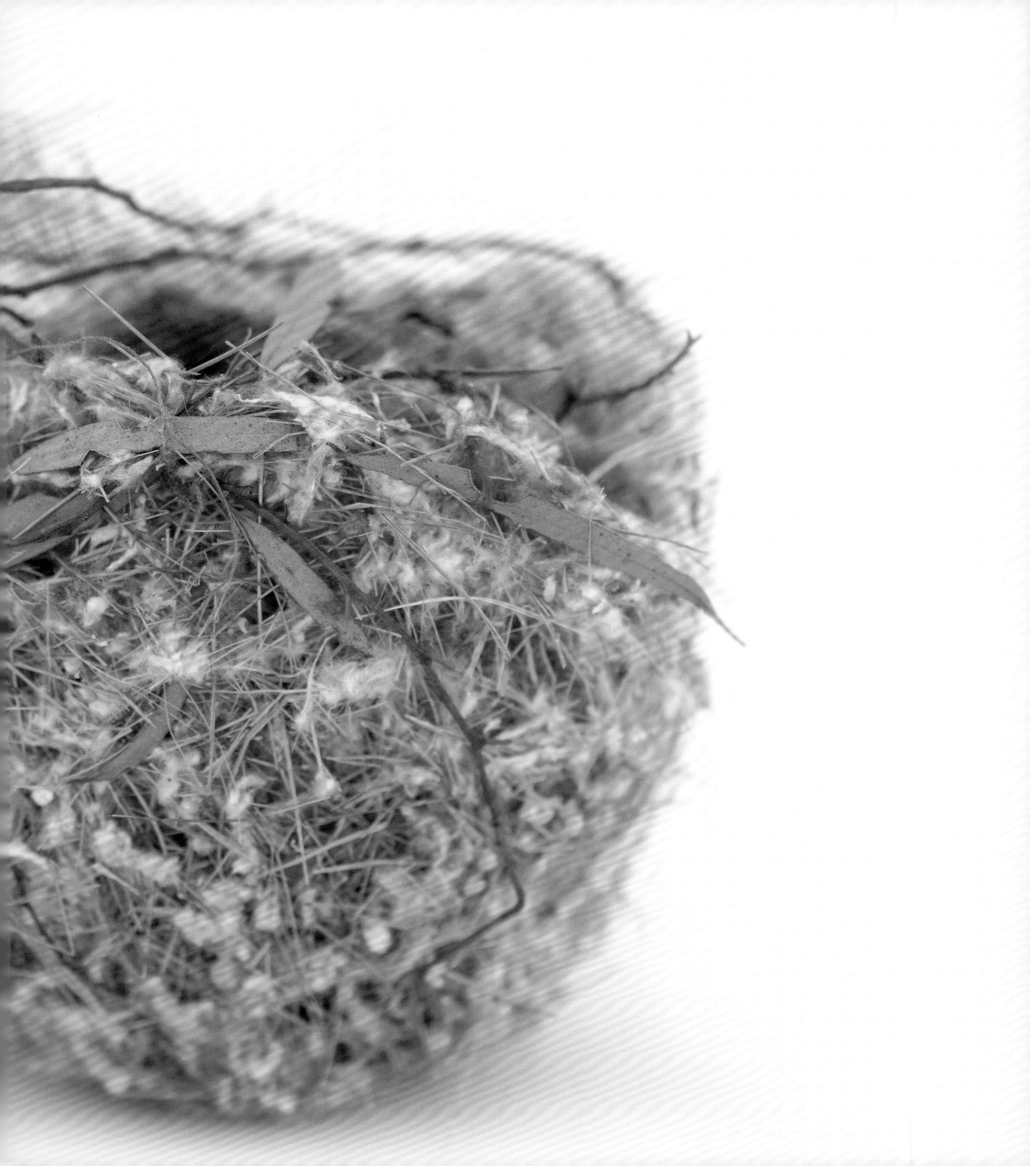

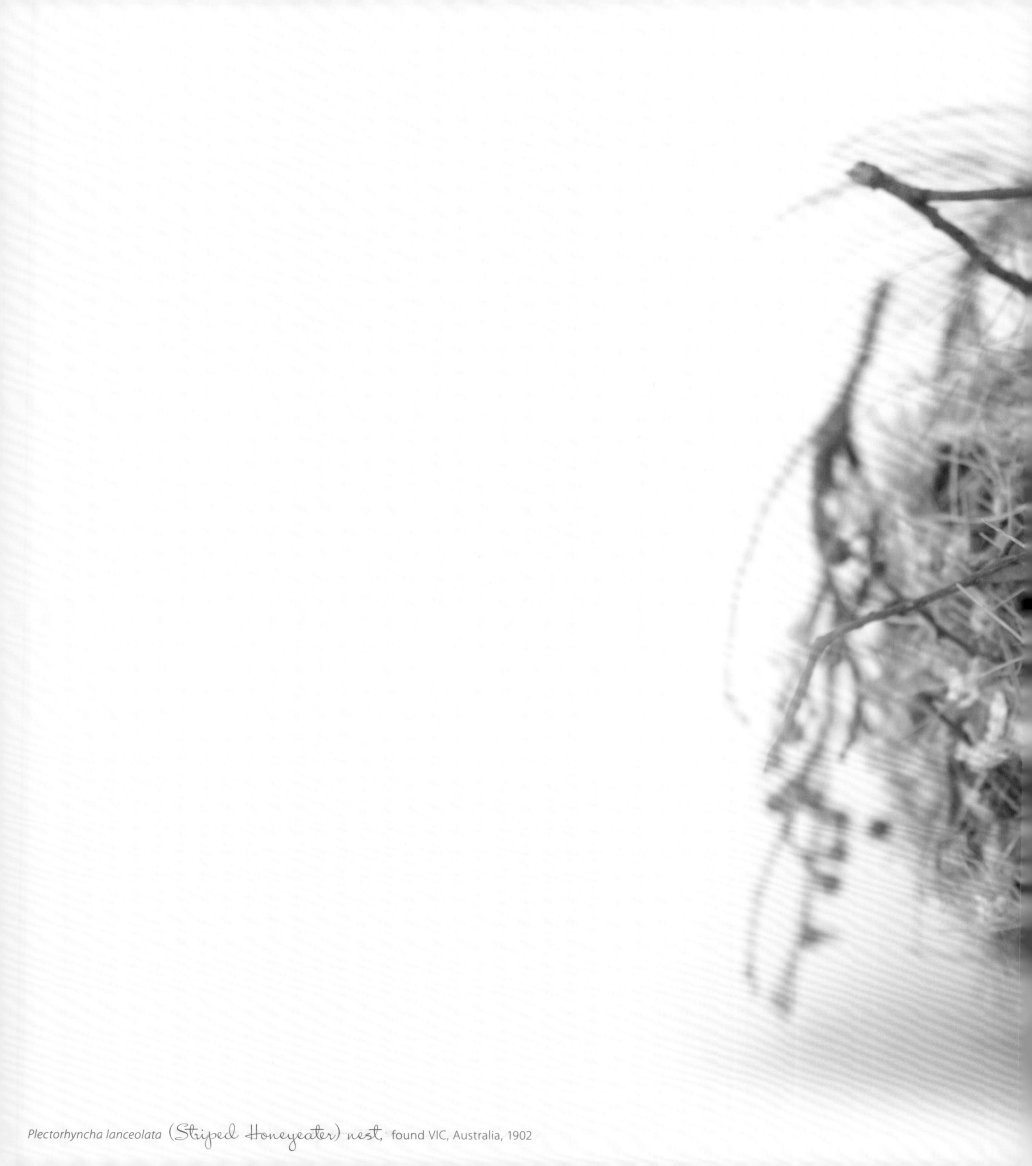

Plectorhyncha lanceolata (Striped Honeyeater) nest, found VIC, Australia, 1902

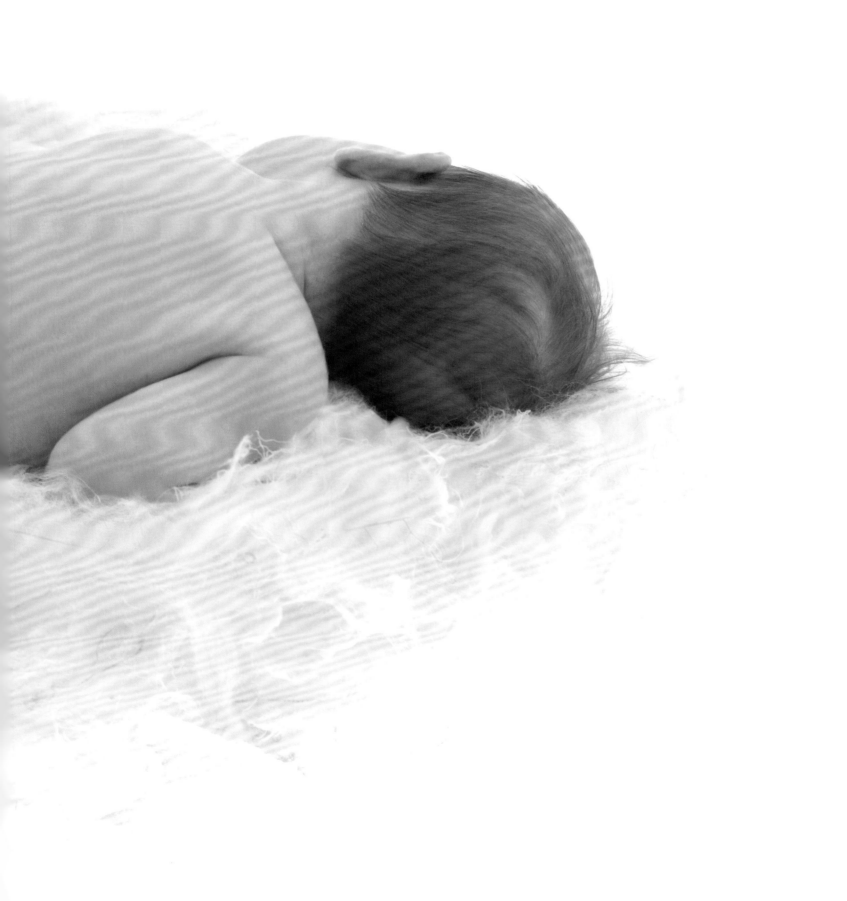

Sophie (3 weeks)

Aysha (38 weeks pregnant)

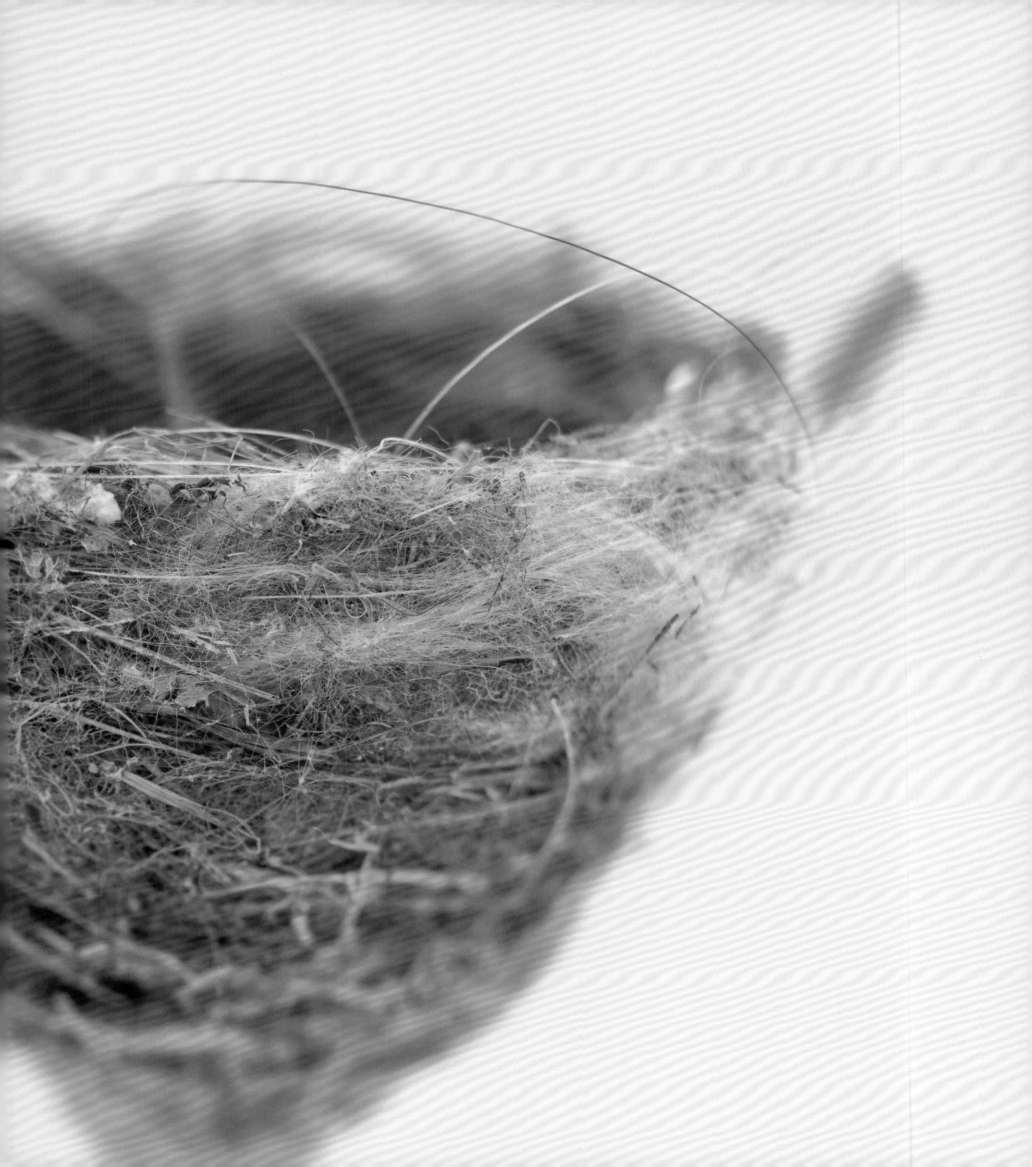

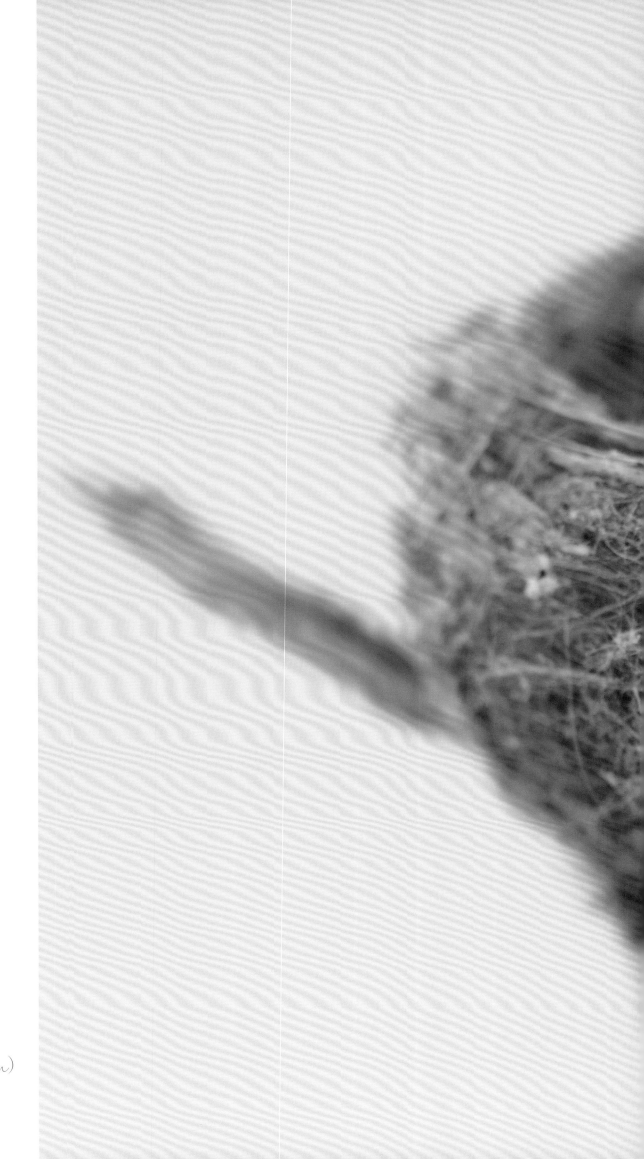

Petroica multicolor (Norfolk Island Pacific Robin) nest, found Norfolk Island, Australia, 1890. The Pacific Robin population has declined to the point where it is now listed as being vulnerable to extinction.

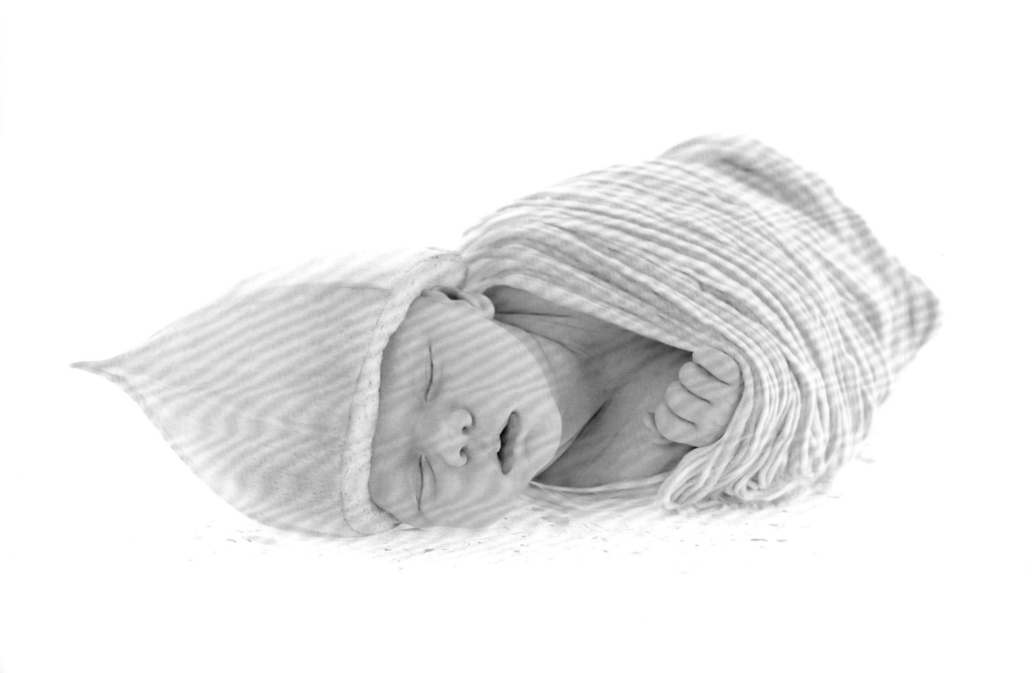

Noah (3 weeks)

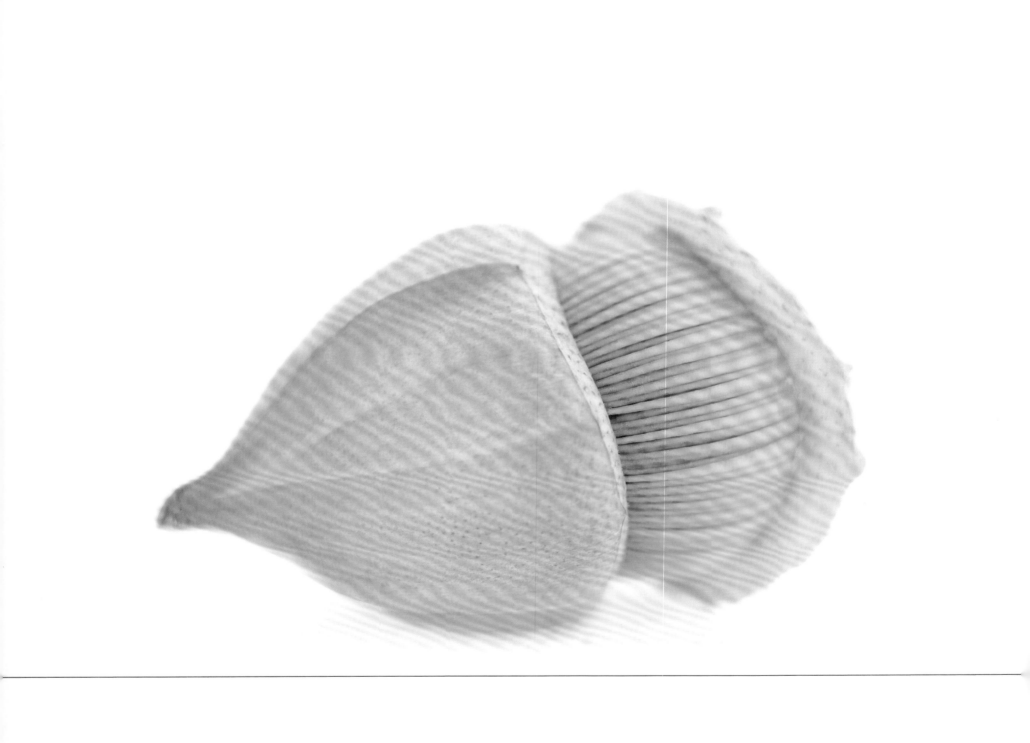

Eucalyptus sp. (Eucalyptus) bud

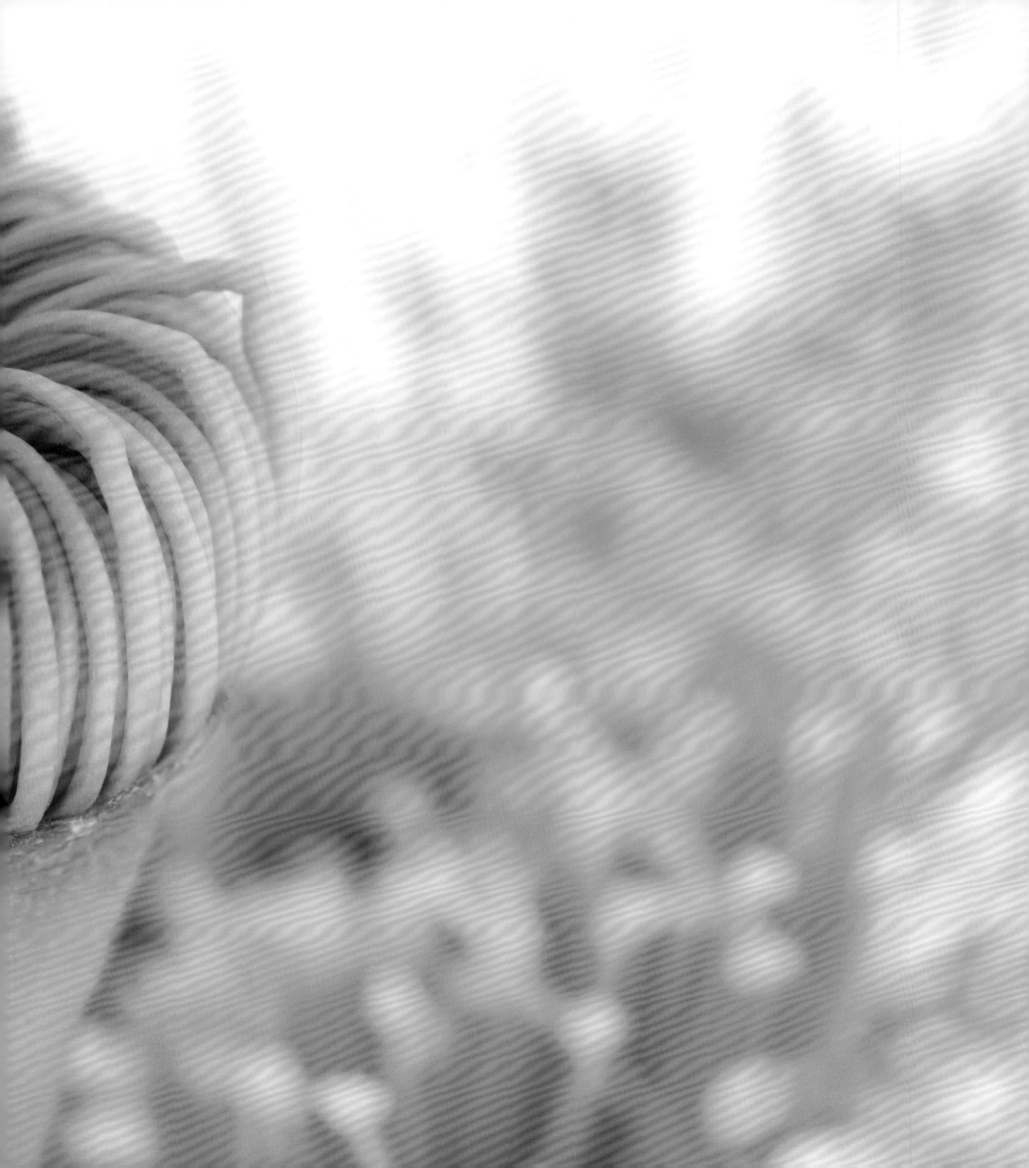

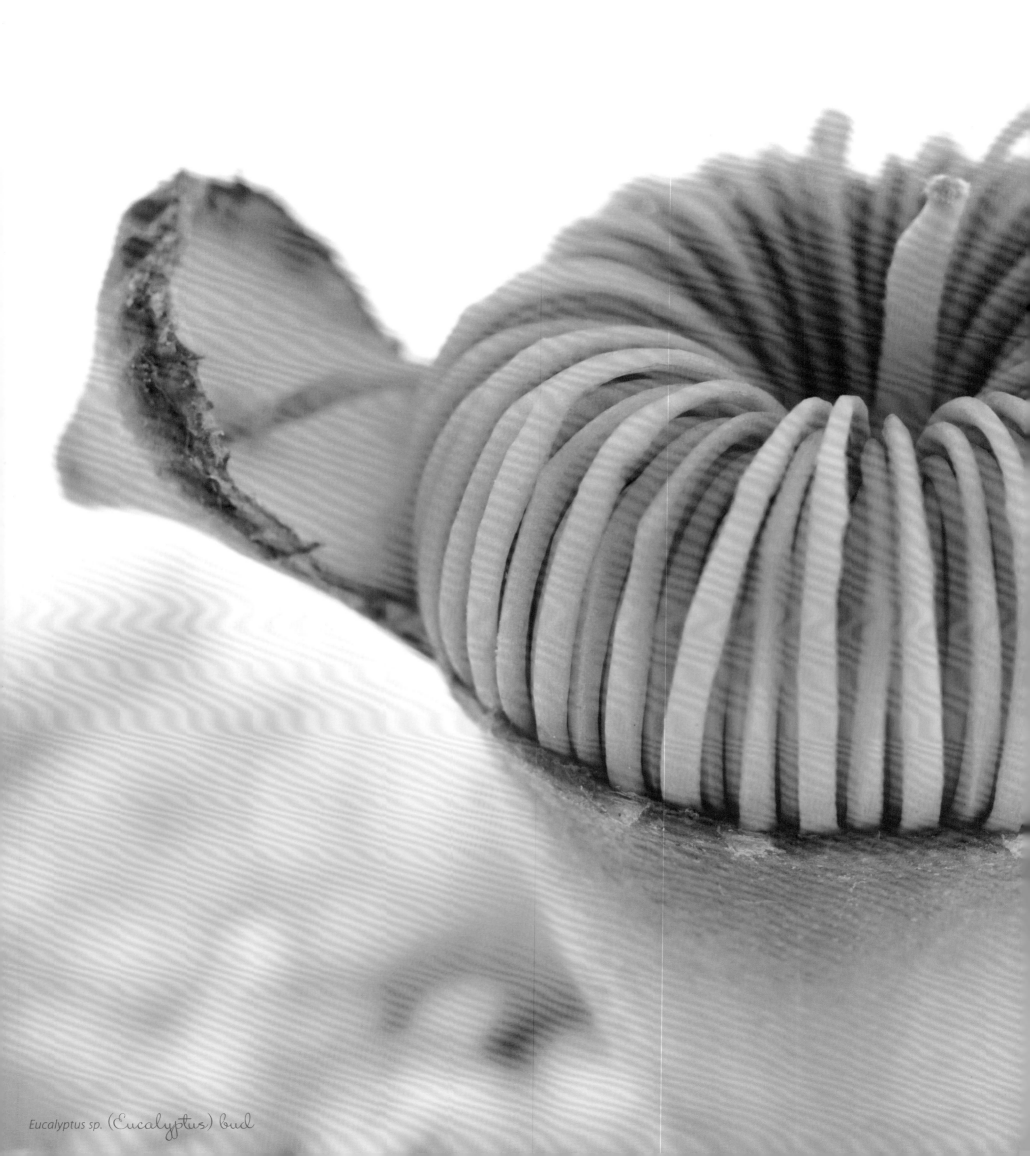

Eucalyptus sp. (Eucalyptus) bud

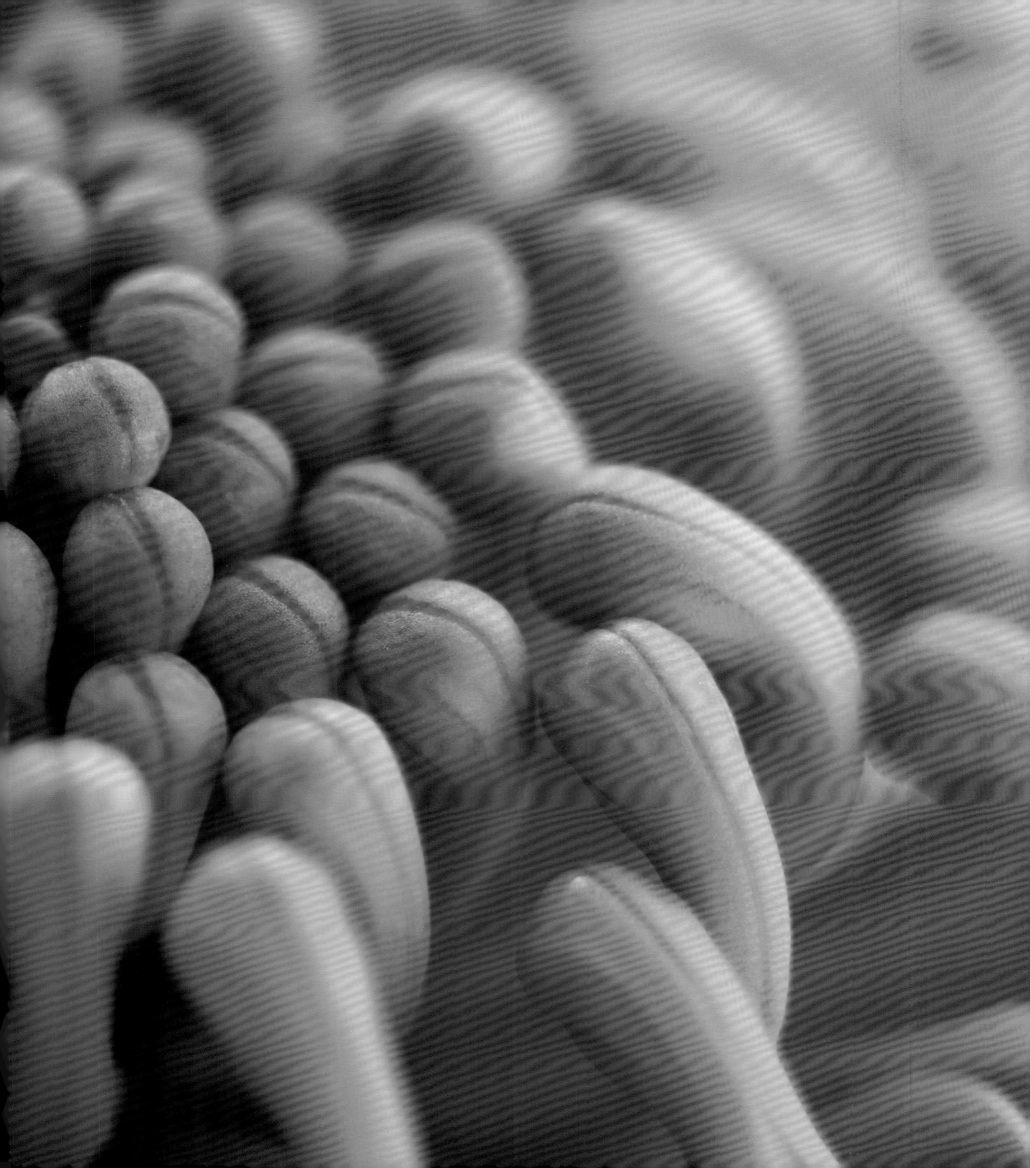

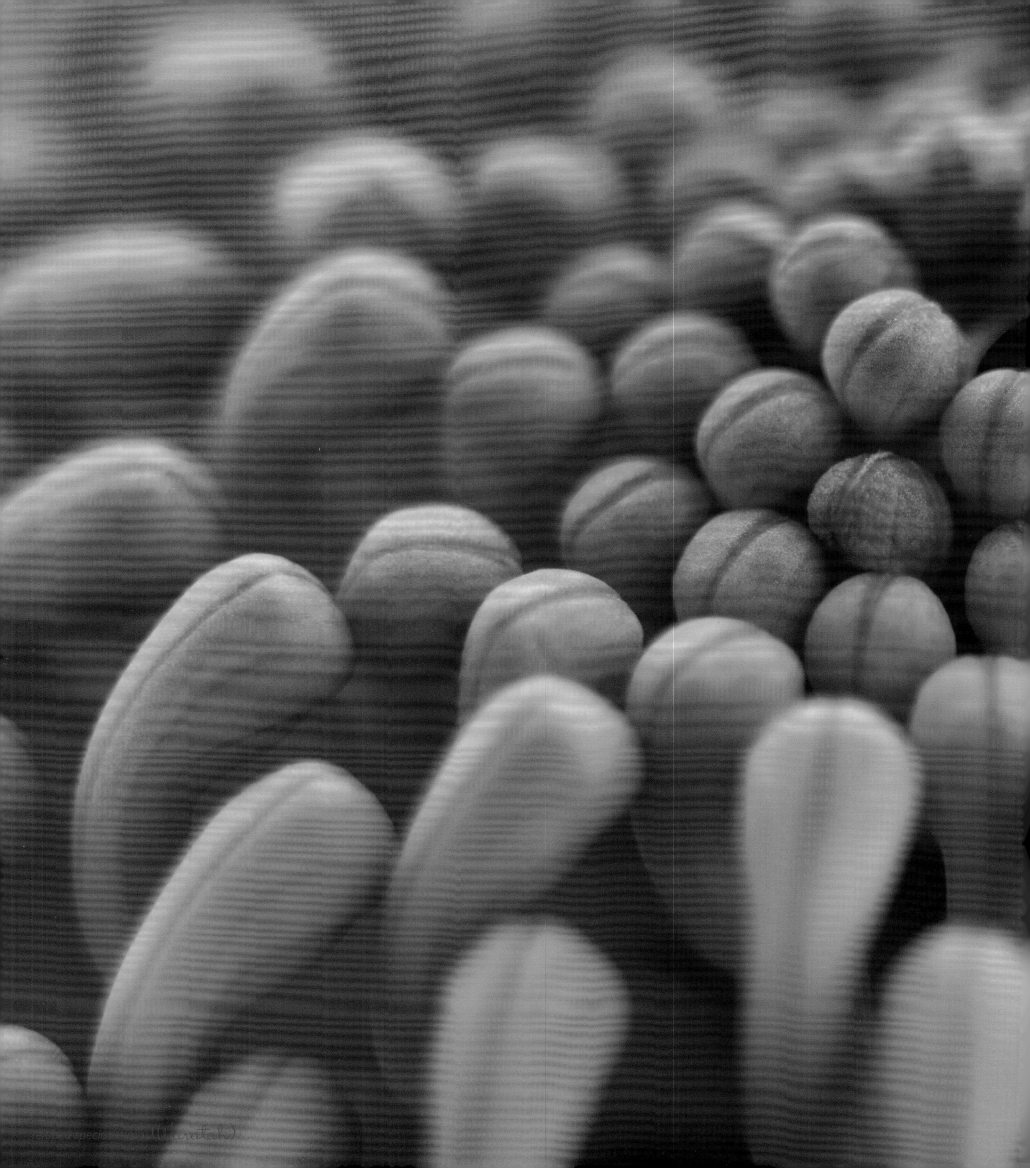

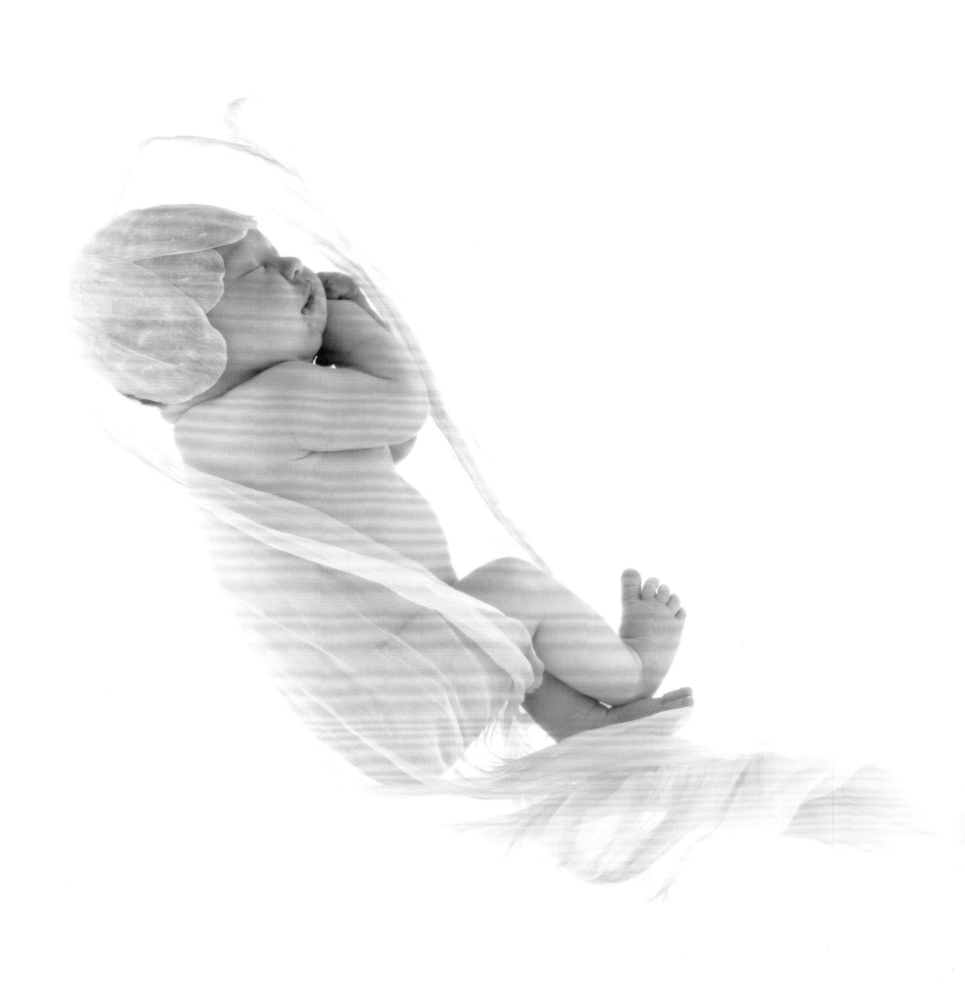

Rhia (1 week)

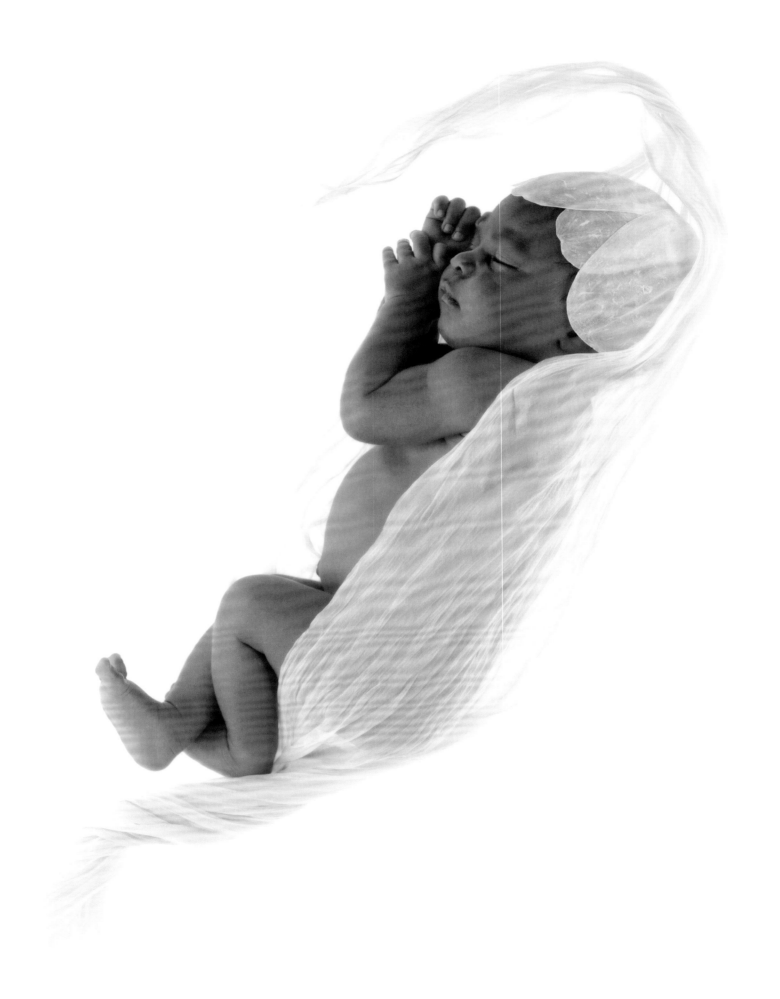

Diwan (4 weeks)

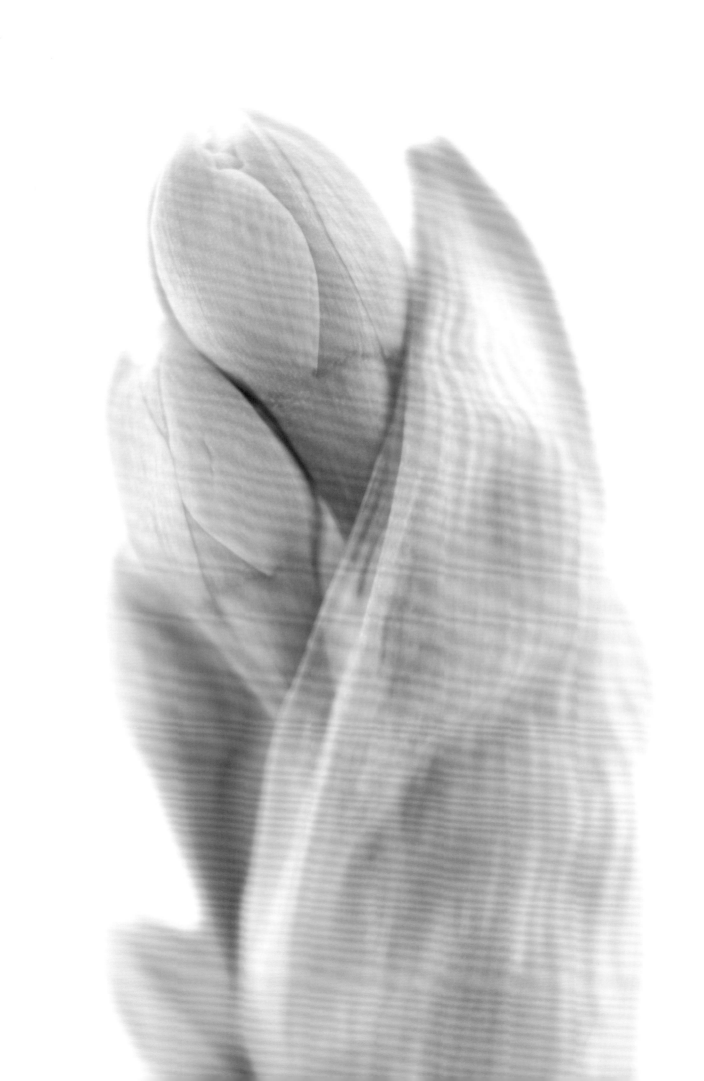

Narcissus jonquilla (Jonquil) buds

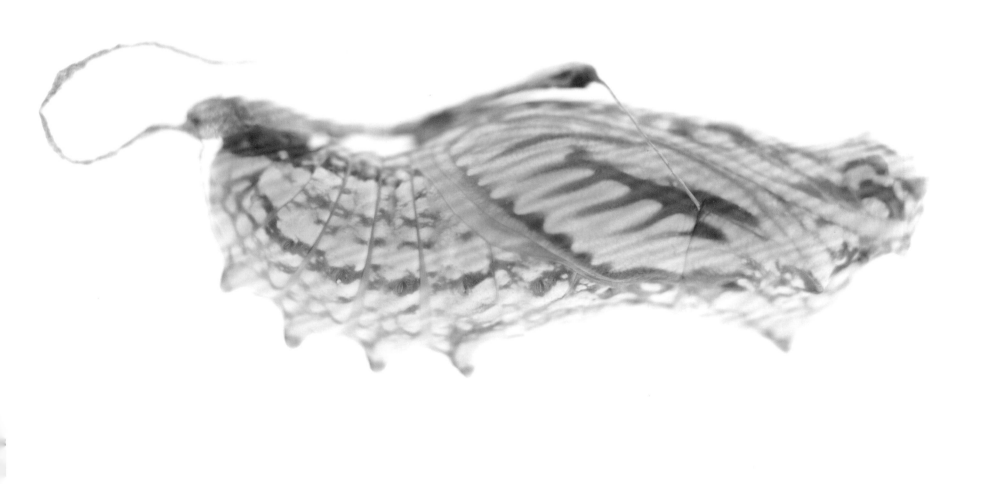

this page *Cressida cressida* (Clearwing swallowtail butterfly) pupa previous page Rachel (39 weeks pregnant)

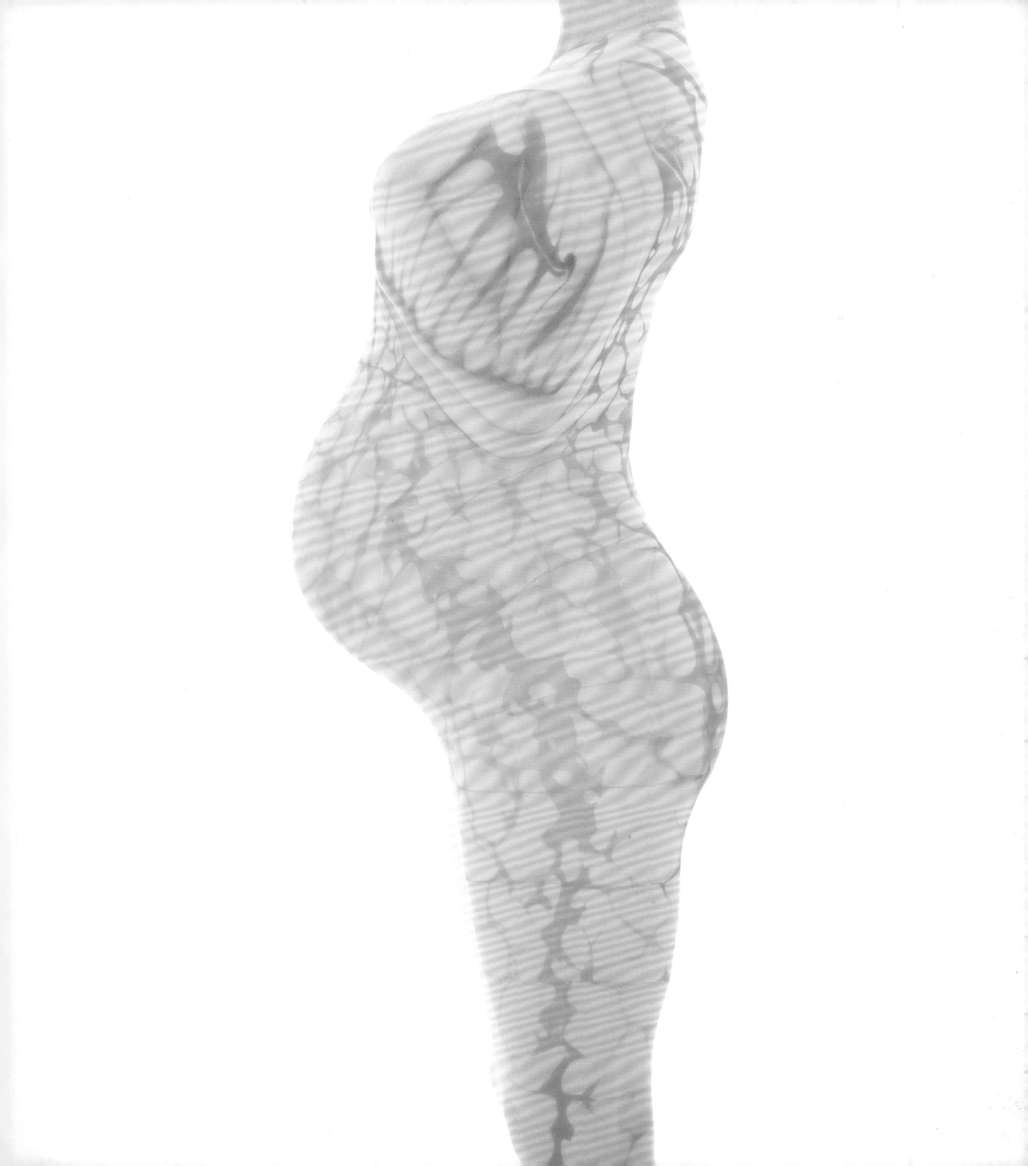

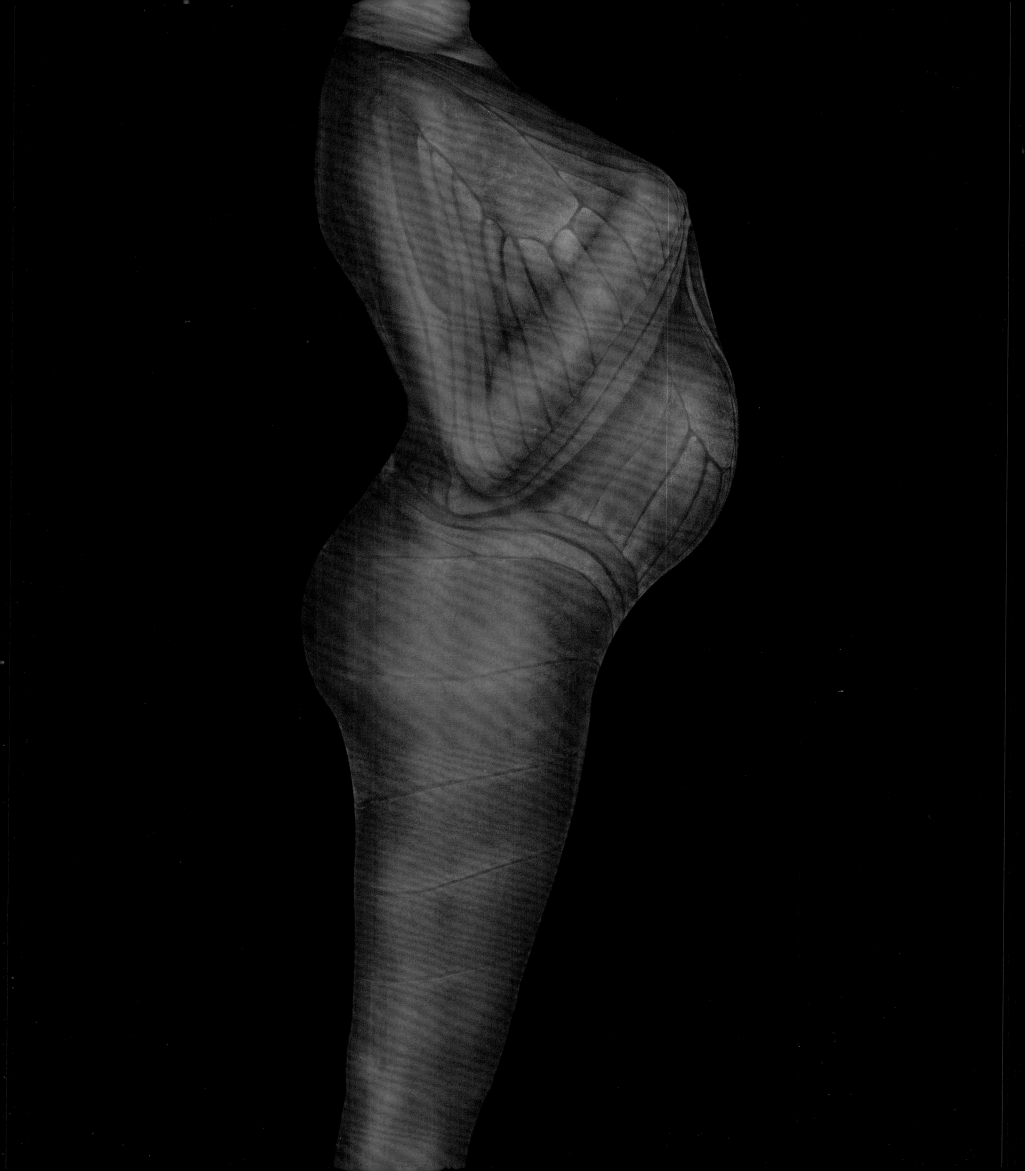

this page *Ornithoptera euphorion* (Cairns birdwing butterfly) pupa following page Abang (37 weeks pregnant)

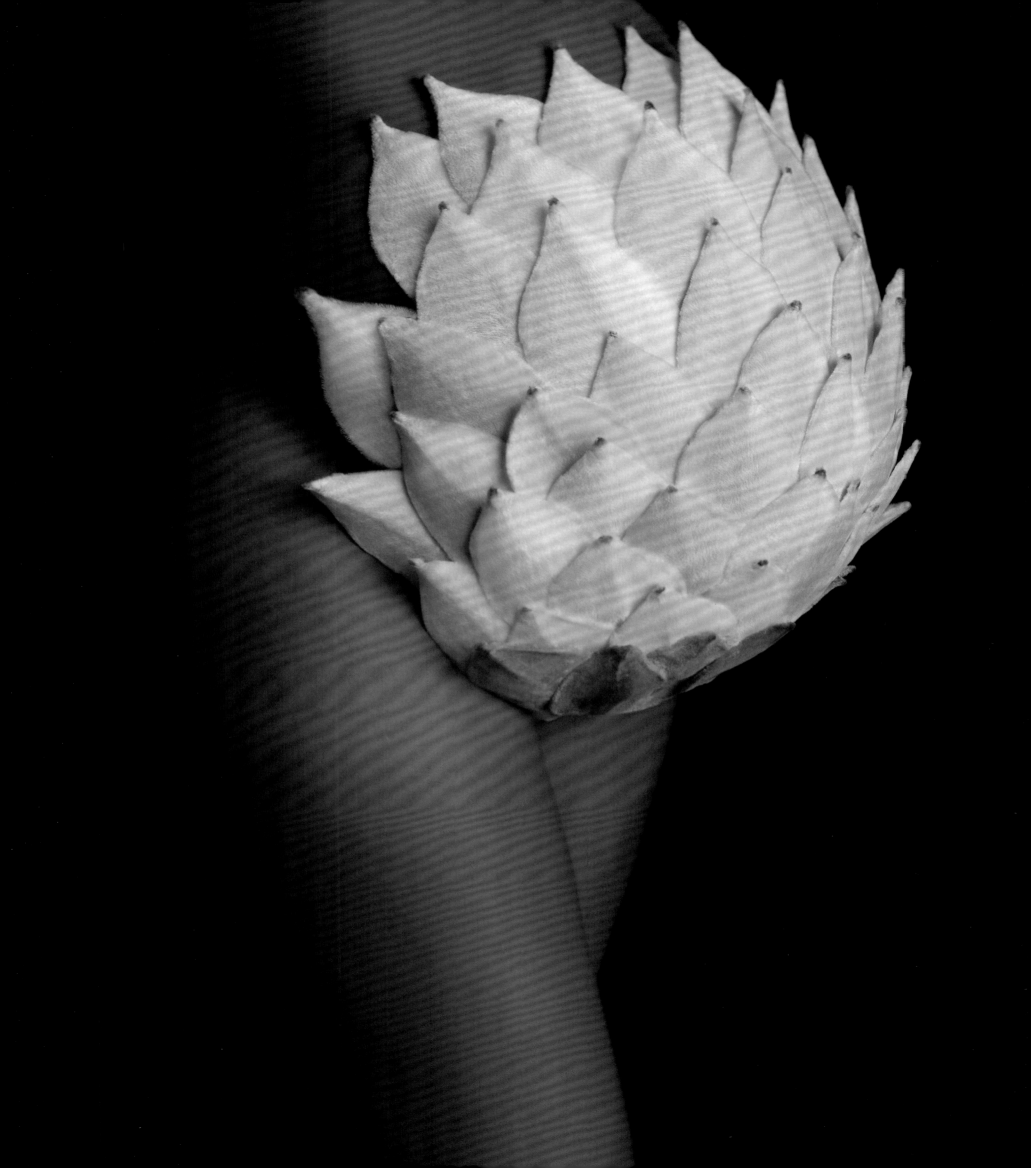

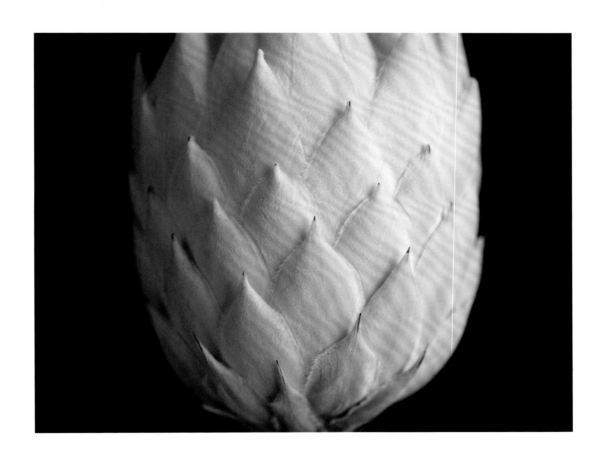

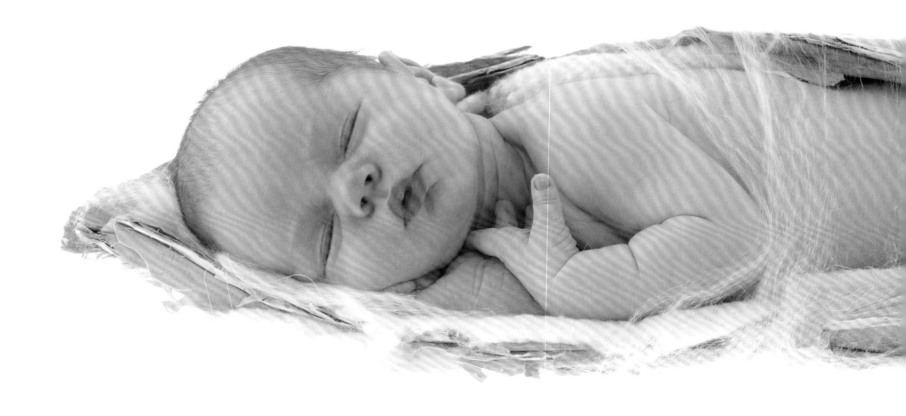

Theodore (8 days)

Coscinocera hercules (Hercules moth) pupa

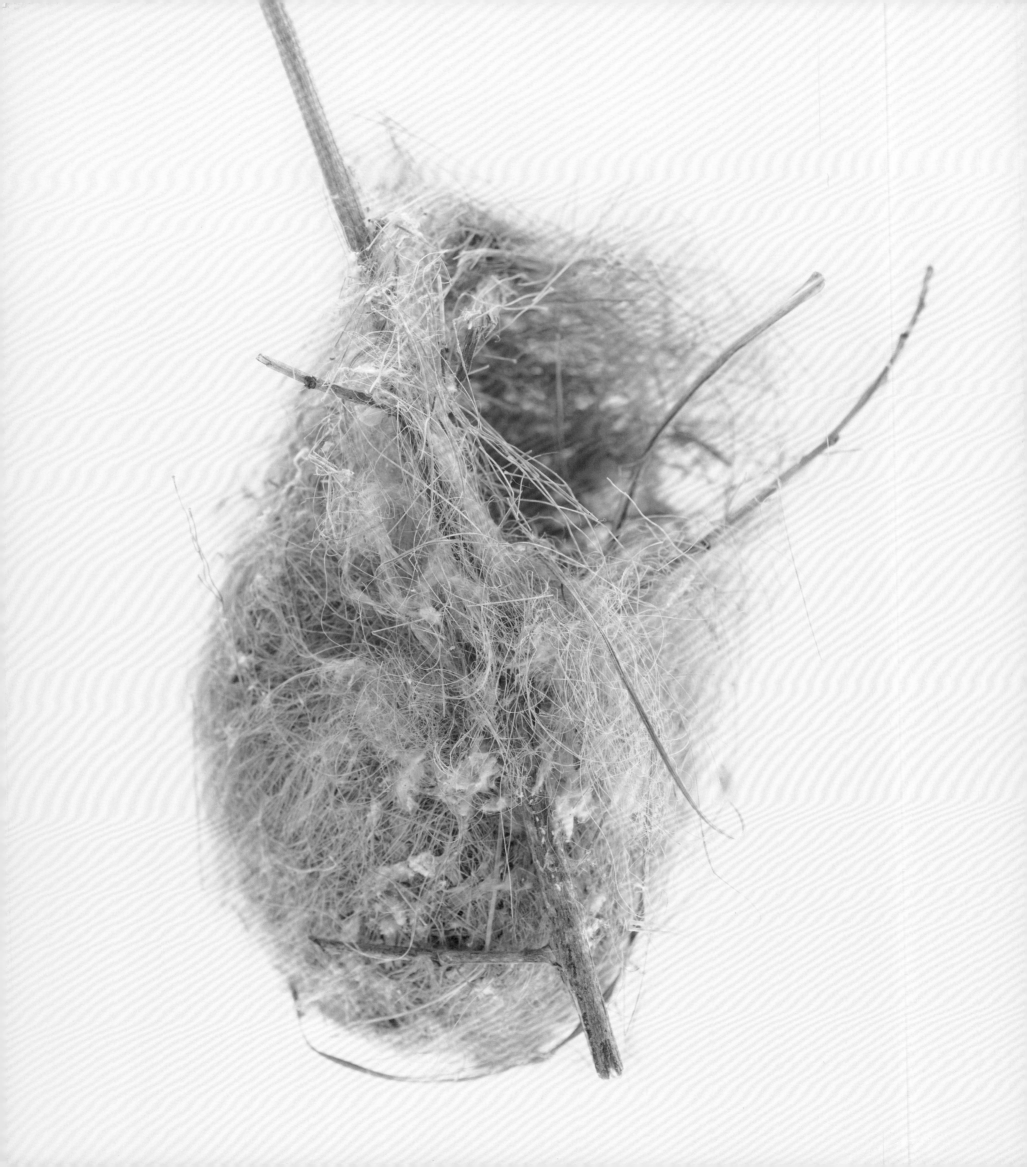